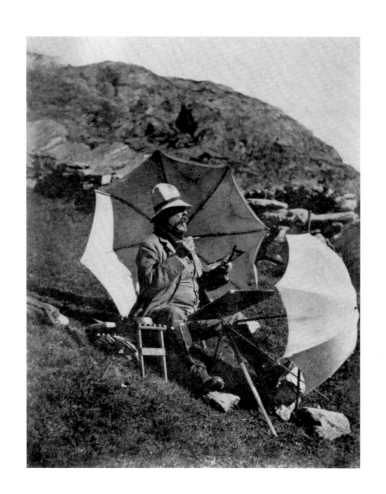

JOHN SINGER

SARGENT

The Sensualist

Trevor Fairbrother

SEATTLE ART MUSEUM

YALE UNIVERSITY PRESS

NEW HAVEN AND LONDON

This book has been published in conjunction with the exhibition

*John Singer Sargent,**

organized by the Seattle Art Museum

December 14, 2000, through March 18, 2001

John Singer Sargent has been generously supported by

Robert Lehman Foundation, Inc.
Seattle Arts Commission
Christie's
Margery Friedlander Exhibition Endowment

Additional funding for the this book has been provided by

William E. Weiss Foundation
Catherine and Paul Buttenwieser
Harry and Joan Stonecipher Exhibition Endowment

Project Manager: Zora Hutlova Foy
Editor: Suzanne Kotz
Designer: Ed Marquand
Produced by Marquand Books, Inc., Seattle
 www.marquand.com
Printed by CS Graphics Pte., Ltd., Singapore

Library of Congress Cataloging-in-Publication Data
Fairbrother, Trevor J.
 John Singer Sargent : the sensualist / Trevor Fairbrother.
 p. cm.
 Includes bibliographical references and index.
 ISBN 0-300-08744-6 (alk. paper)
 1. Sargent, John Singer, 1856–1925—Criticism and interpretation.
 I. Title.
ND237.S3 F334 2000
759.13—dc21 00-57405

Page 1: Sargent painting a watercolor, Simplon Pass, Switzerland, c. 1910
Page 2: Detail of *Madame Pierre Gautreau,* c. 1884 (fig. 3.10)
Page 5: *Artist John Singer Sargent,* January 12, 1907, Chelsea, London, England
Page 6: *Essie, Ruby, and Ferdinand, Children of Asher Wertheimer,* 1902 (fig. 5.4)

**John Singer Sargent* features *John Singer Sargent: Portraits of the Wertheimer Family,* an exhibition organized by The Jewish Museum, New York, with generous support from the State of New York; the National Endowment for the Arts; Betty and John Levin; The Morris S. and Florence H. Bender Foundation; and the David Schwartz Foundation.

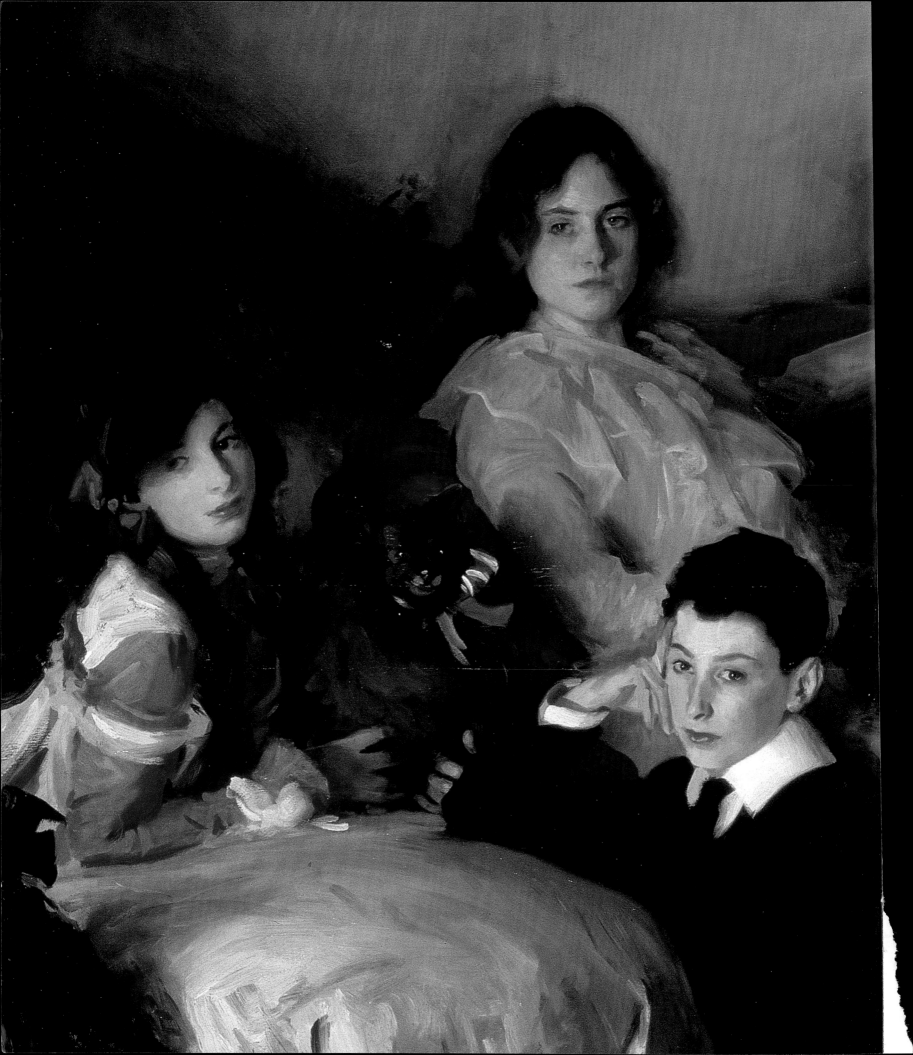

Contents

Foreword

The art of John Singer Sargent has always elicited a range of opinions. In 2000, seventy-five years after his death, Sargent remains an artist whom scholars, critics, collectors, and the public value in different ways. Although most acknowledge that he was remarkably gifted with pencil and brush, disagreements persist about the professional course he chose. Did he, for example, waste his enviable talents by pursuing fashionable portraiture and curbing his interest in the progressive art of his youth? This book, with its freewheeling tour of the sensual and showy aspects of Sargent's work, is intended to enliven the standardized accounts of a figure who is singularly hard to place in the history of French, British, and American art. *John Singer Sargent: The Sensualist* seeks to illuminate the paradox of a reserved person who made exuberant art.

The Seattle Art Museum's Sargent exhibition will offer regional audiences an unprecedented opportunity to explore firsthand the range and diversity of Sargent's remarkable work, including expressive yet exact drawings, splashy society portraits, Impressionist-influenced oil sketches, and vibrant, bravura watercolors. Our project seeks to further the Sargent debate by paying homage to some of his finest and best-known works while presenting a number of pictures that previously have not been published or exhibited.

Sargent's previous connections to Seattle are slim. He was represented at the city's Alaska-Yukon-Pacific Exposition in 1909 by two canvases: *Venetian Water Carriers* (1880–82) and *Mrs. Fiske Warren and Her Daughter Rachel* (1903). He probably passed through Seattle in the summer of 1916, when traveling by train from Boston to a painting holiday in the Canadian Rockies, but never experienced his country's West Coast. Moreover, his work previously has not been the subject of a large exhibition in this half of the United States.

It is a great honor to have received generous funding for the Seattle Art Museum's exhibition from the Robert Lehman Foundation, Inc., whose concern for innovative scholarship and visual excellence has been a source of inspiration.

Sargent at work on a portrait drawing of the actress Ethel Barrymore in Boston, 1903

Ambitious projects of this magnitude cannot happen without the generosity of institutions and individuals, and I express sincere gratitude to the Seattle Arts Commission and Christie's for their support. The museum is also privileged to have monies from two endowed funds to apply to this project: the Margery Friedlander Exhibition Endowment and the Harry and Joan Stonecipher Exhibition Endowment. Additional funding for the publication has been provided by the William E. Weiss Foundation and by Catherine and Paul Buttenwieser.

Our exhibition comes on the heels of an international Sargent retrospective, which makes us all the more grateful to those institutions and individuals who are lending to Seattle's exhibition. Their generosity is deeply appreciated.

I extend heartfelt thanks to everyone on the staff of the Seattle Art Museum. Finally, I would like to congratulate Trevor Fairbrother, Deputy Director of Art and Jon and Mary Shirley Curator of Modern Art, who initiated the idea for this exhibition and, with unequaled intelligence and expertise, realized both the publication and exhibition. A Sargent scholar, Trevor has written extensively on the artist. This, however, is his first Sargent exhibition.

Mimi Gardner Gates
The Illsley Ball Nordstrom Director
Seattle Art Museum

Acknowledgments

It is an honor to recognize the individuals and organizations who have supported this project. Their generosity has allowed the Seattle Art Museum to produce a book and an exhibition that I hope will inspire a broader understanding of John Singer Sargent and his art.

This publication would not have been possible without the encouragement of sympathetic individuals in four museums. At the Seattle Art Museum, Mimi Gardner Gates gave me creative freedom while enthusiastically encouraging our institution to be the first West Coast museum to organize a major Sargent exhibition. In 1998 Andrew Brighton and Stephen Deuchar of the Tate Gallery, London, invited me to participate in the conference "Reconsidering Sargent," which inspired my return to Sargent studies. Norman Kleeblatt of the Jewish Museum, New York, asked me to write an essay in conjunction with his landmark exhibition of Sargent's twelve paintings of the Wertheimer family. These portraits will travel to Seattle to be a key part of our exhibition. James Cuno of the Harvard University Art Museums eagerly endorsed the idea that Sargent's *Album of Figure Studies,* not previously exhibited or published in its entirety, should be another highlight of the Seattle venture.

I am deeply grateful to the Sargent scholars who have given help and advice during the preparation of this manuscript. In particular I salute Richard Ormond and Elaine Kilmurray for fielding countless queries with patience and good humor. I also give heartfelt thanks to Warren Adelson, Kathleen Adler, Jane Dini, Stephanie Herdrich, Patricia Hills, Erica Hirshler, Elizabeth Oustinoff, Elizabeth Prettejohn, Sally Promey, Kerry Schauber, Marc Simpson, Miriam Stewart, Carol Troyen, and Mary Crawford Volk.

My colleagues at the Seattle Art Museum have been a blessing. Rock Hushka was an outstanding and tireless aide in all aspects of the art historical research and curatorial planning. Zora Hutlova Foy directed the endless complications of both exhibition and book with stamina and priceless smiles; she and I had the peerless

support of Sue Bartlett and Liz Andres. The participation of exhibition designer Michael McCafferty ensured that the installation would have its own beauty. Librarian Elizabeth de Fato was a font of help and enthusiasm. During my three-month writing sabbatical, Chiyo Ishikawa headed the curatorial division with terrific finesse and dedication. To everyone else on staff at the museum, I give thanks.

Throughout this project it was delightful to work with Seattle book designer Ed Marquand. He had a sixth sense about this assignment: his splendid and engaging pages carry happy memories of wonderful discussions about Sargent. The text and character of the book benefited enormously from the expertise and clarity of thought that distinguish editor Suzanne Kotz. Christina Gimlin and Amy Cilléy handled many of the production details. At Yale University Press, Tina Weiner and Judy Metro showed strong and unwavering support.

Detail of DR. SAMUEL JEAN POZZI AT HOME, 1881 (fig. 3.4)

I am most grateful to the following far-flung people for their generous assistance: Henry Adams, Ann and Thomas Barwick, Sarah P. Boocock, David Brigham, Christopher Capozzola, Teresa A. Carbone, Faya Causey, Charles Cholmondeley, Alan Chong, Nicolai Cikovsky, Jr., Curt DiCamillo, Christine Fabre-Suver, Stuart Feld, John Fox, Hilliard T. Goldfarb, Helen Hall, David Fraser Jenkins, David Johnson, Sona Johnston, Allan Kollar, Elizabeth Mankin Kornhauser, Dominique Lobstein, Dorothy Mahon, Barbara T. Martin, Paul Martineau, Patrick McMahon, Richard Meyer, Amy Meyers, Patrick Noon, Lucy Oakley, Maureen O'Brien, Robert McDonald Parker, Roy Perkinson, Sue Welsh Reed, Jacqueline Ridge, Jane Roberts, Eric Rosenberg, Douglass Shand-Tucci, Susan Sinclair, Peter Stansky, Theodore E. Stebbins, Jr., Chris Taylor, Gary Tinterow, Lydia Vagts, Monique Van Dorp, Alfred J. Walker, H. Barbara Weinberg, and Henri Zerner.

In closing, I have some flowers to present: anemones for Freda Fairbrother, who has given me so much; roses for Katie and Paul Buttenwieser, Nancy Reynolds and Dwyer Brown, and David Martin and Dominic Zambito, whose caring made a difference; and a fine spring bouquet for John Kirk, whose commitment helped me find the strength and the words.

Trevor Fairbrother

Deputy Director of Art and Jon and Mary Shirley Curator of Modern Art
Seattle Art Museum

To the Reader
The notes often contain supporting materials that extend the arguments being made in the main text. I have taken the liberty of correcting or clarifying the grammar and spelling in some of the texts and letters I have cited. Unless indicated, the translations from the French into English are mine, as are any errors therein. I have not provided a separate bibliography since excellent ones are readily available in the monographic studies of Sargent that are cited frequently in the notes. A checklist for the exhibition is available at www.seattleartmuseum.org/Sargent.

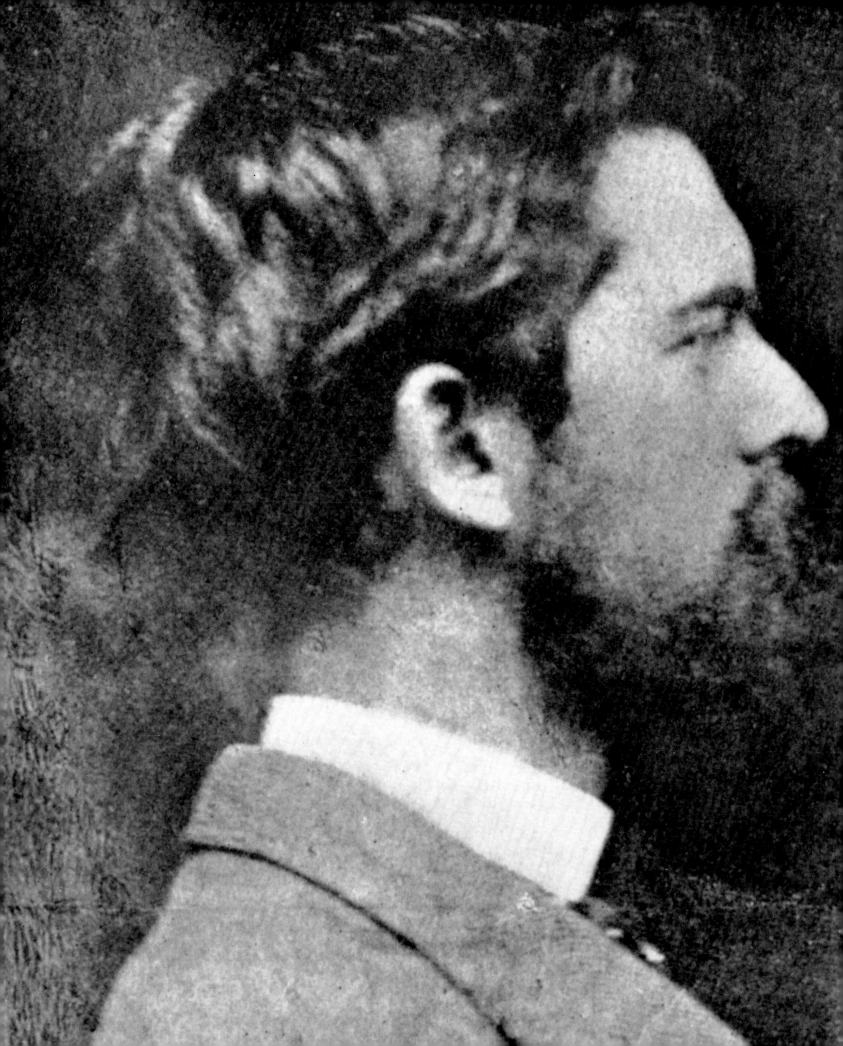

Chapter 1

INTRODUCING A COMPLICATED INDIVIDUAL

I met this last week a young Mr. Sargent, about eighteen years old and one of the most talented fellows I have ever come across; his drawings are like the Old Masters, and his color is equally fine. He was born abroad and has not yet seen his country. He speaks as well in French, German, [and] Italian as he does English, [and] has a fine ear for music. . . . Such men wake one up, and as his principles are equal to his talents, I hope to have his friendship.

—22-year-old American art student, Julian Alden Weir, writing to his mother from Paris, 1874

This book explores some of the ways in which John Singer Sargent's artistic gifts, education, and personality worked together to produce a great painter. It focuses on sensuality as a major force in his creative life, arguing that a fuller awareness of the strengths and weaknesses of Sargent's temperament can clarify the seeming disconnectedness between his bravura art and a reticent public image. Following an introduction to the man and his career, subsequent chapters examine his sensibility from different perspectives. The importance of Sargent's sensual handling of materials is assessed in relation to style and technique. Costuming and theatrical effects are shown to be crucial to his method as a portraitist. Pictures of male and female models and dancers demonstrate Sargent's attraction to extravagant body language and point to a particular interest in masculinity. The pleasurable atmospheres he conjures in later holiday pictures are considered as a special public statement of his sensual aesthetic. The final chapter puts his sensual temperament into the context of his lifelong negotiation of public and private issues, including a hidden sexuality. While the text moves elliptically back and forth through Sargent's complicated career, the book's visual arguments are more straightforward, requiring only that the reader look closely at the clusters of images.

1.1 Sargent, c. 1880

Although privileged with illustrious friends and colleagues—Gabriel Fauré, Isabella Stewart Gardner, Henry James, Claude Monet, Auguste Rodin, Robert Louis Stevenson, and Ellen Terry—Sargent remained an outsider on various counts. He was an American by birth and by preference, but he lived abroad. Commentators often sought to label his American qualities by evoking a set of stereotypical traits: the puritanical mind-set he inherited from his father's seventeenth-century New England ancestors; the quasiscientific factualness that was part of his artistic technique; and the self-reliance and independence that helped him become a national success story. Sargent's social position permitted an unusual fluidity of movement: he hobnobbed with patricians, enjoyed the power of a public figure, and indulged some bohemian instincts. Analogously, his art evidenced an eclectic and changeable blend of academic and progressive tendencies. His tremendous talent and the frothy acclaim it garnered eventually isolated him from his professional peers. According to Nicola D'Inverno, his manservant, he was a free thinker who did not "go in" for religion.[1] Like many unmarried men of the day, Sargent cloaked his sexuality with the decorous etiquette that put the issue off limits. These miscellaneous traits characterize a complicated and elusive person conducting a compartmentalized life.

Born in Italy in 1856 to American parents, Sargent spent his youth in a peregrination between European resorts and cultural capitals. Three of his parents' six children died young, and John, the eldest of the survivors, was the only boy to live to adulthood. His father relinquished his medical career to settle in Europe, and his mother and sisters were "ladies." In pursuing a career in art, Sargent became the leading male in this Victorian family. He studied in Italy and France, and eventually based his portrait business in England. Sargent followed his Parisian teacher, Carolus-Duran, in choosing portraiture as a profession. This was a sound practical decision because he was a skilled draftsman with an acute intuitive sense about external appearances. He earned a permanent place in the history of portraiture in the 1880s, when his vivid canvases drew praise on both sides of the Atlantic. He made himself an internationally celebrated figure by meeting a new market for work that mixed the stylishly modern and the grandly retro. Late in his career, when his work was hung in London's National Gallery, a cartoon in *Punch* reflected the rarity of this achievement: it depicted Rembrandt, Gainsborough, and other Old Master portraitists welcoming Sargent into the museum, and the caption dubbed him "The Young Master."[2]

The biased view of portraiture as a fashion-driven, ephemeral, or "applied" branch of art is one of various complications that have kept Sargent's achievements

from coalescing into a simple, unambiguous profile. During his early working years, Sargent had a reputation as a changeable experimenter. While it was hard to tie him to one movement, the strands of Realism, Impressionism, Aestheticism, Symbolism, and the Academic tradition slipped visibly in and out of his work. He forged a signature style from these influences while never becoming a total advocate of one school. A scholar recently observed: "As far as his art was concerned . . . Sargent apparently made a position of not taking a position."[3] Uncertainties about his national allegiances as an artist led various French and English commentators to sideline Sargent as a foreign interloper, and some Americans to pigeonhole him as an "expatriate" rather than a true "native." Such observations flourished throughout his life as America grew confident as an international power and Europeans reacted to her burgeoning cultural and political activities at home and abroad. Despite these compound tensions, Sargent proved to be a valuable national commodity for both Great Britain and the United States at the turn of the twentieth century.

Another thorny issue that has always dogged Sargent's reputation concerns his allegiance to artistic modernism. In the late 1880s he took direct public action in London, Boston, and New York to promote the then-controversial innovations of the French Impressionist painters. He was at that moment praised in London as the "arch-apostle of the 'dab and spot' school," but his trailblazing was soon taken for granted and then forgotten.[4] When he died in 1925, younger modernists did not remember that he had once helped make London more receptive to new French art; instead they turned Sargent into their convenient establishment bugaboo. The fact that Sargent valued experimentalism as a force that slowly helps traditions shift and change was easily overlooked by these young reformers who were emboldened by the dawn of a new century. One backhanded memorial essay said that Sargent might have become "an American Degas" had he not pursued success as a fashionable portraitist, thereby becoming "an inferior Raeburn."[5] Another condemned him for "emasculating" Impressionist style.[6] Modernist diatribes against Sargent flourished for decades after his death. In 1952 Meyer Schapiro oversimplified Sargent's taste when describing it as "self-consciously aristocratic [and] hostile to American customs." Driven by the new belief that all American art had been provincial before the international success of Abstract Expressionism, Schapiro further insisted that the likes of Sargent and James Abbott McNeill Whistler lacked "the originality and robustness of [contemporary] European innovators."[7]

An openness to the opposites that abound in Sargent's art and life has been slowly building since the 1950s, when a new generation of less doctrinaire curators

and critics began to reevaluate his career. For example, in 1956 the figurative painter Fairfield Porter wrote a refreshing essay arguing that the artist's "minor" works had survived with the greatest appeal: "His painting is full of discarded potentialities. When he forgot himself in the unseriousness of some work that he may not have considered important to do, as in his oil sketches and especially in his watercolors, truly called dazzling, then his abilities showed themselves. . . . These minor works are full of a light that exists in no other paintings [including the watercolors of Homer and Hopper and the paintings of the Impressionists]. . . . Sargent's light was one thing he understood and could give you his feeling for."[8]

In 1986, three decades after Porter's searching reappraisal, one critic for that monolithic American tastemaker, the *New York Times,* still seemed eager to doubt Sargent's achievements. Announcing an upcoming retrospective exhibition, he asked: "How will [the Whitney Museum of American Art] deal with a once bold artist who flattered high society, allowed himself to be flattered by it and, in the end, seems to have squandered a remarkable technical gift?"[9] Despite such valid, if punitively framed reservations, Sargent's reputation has thrived in recent years. The showiness of his portraits spoke to the materialism of the 1980s, and auction prices now regularly confirm that his art has regained the blue-chip status it held in the early twentieth century. Moreover, taking a new global perspective, younger American scholars, critics, and collectors are simply less hung-up about the fact that he was a London-based American cosmopolitan. But the *New York Times,* judging by a review of 1999, remains on the fence: "We all want to do something, almost anything, as adeptly as John Singer Sargent handled a paintbrush. . . . When you're dealing with skill on this level, its appeal becomes nearly erotic. . . . He was the gold standard during the Gilded Age. But he invented nothing; he changed nothing."[10]

GLIMPSES OF SARGENT'S PERSONALITY

In 1895 a British critic wrote admiringly about "Sargent's power of dragging the truth out of a man's superficial personality, for good or evil," and in 1957 the aged Bernard Berenson recalled his early awareness that Sargent had a gift for the "sensory revelation of character."[11] It is ironic, therefore, that a man famous for seeing through others presented a sphinxlike exterior to the world. Perhaps because he himself did not want to be judged or analyzed, Sargent offered this personal philosophy to a sitter in 1905: "I paint what I see. . . . I don't dig beneath the surface for things that don't appear before my eyes."[12] His protective habit of fending off questions became a motto: "I chronicle, I do not judge."[13] In a memorial tribute to Sargent, composer and pianist Percy Grainger stressed the "inscrutability in all

that touched his purely personal life," confirming that the artist operated behind a deftly woven curtain of propriety.[14] Jacques-Émile Blanche, a rival portraitist who shared several friends with Sargent, was also convinced that he went to great efforts "to leave no trace of his true individuality."[15]

A great deal of Sargent scholarship echoes Max Beerbohm's view of the artist by being "most sensitive and correct."[16] Despite its consideration of numerous major and minor facets of his life and work, the literature has been cautious about broaching the origins and artistic consequences of his sensual nature. This shrouding dilutes the passions that made Sargent a "real" person and a remarkable artist. His life's work celebrates the pleasures of the world by excitedly translating them into audacious passages of paint. Why is it necessary to think that a Milquetoast produced such brilliant and dazzling pictures? Exuberance and showiness are essential qualities of his art, and they deserve a more complicated accounting.

Sargent probably unsettled or daunted many of the people he encountered socially. He was tall and burly, and could seem brusque or uncommunicative. One male American acquaintance wrote: "He had a huge frame that would have done credit to a Japanese wrestler, and there was something suggestive of pride in his carriage. I liked the directness of his gaze and the simple candor of his voice, and I did not then surmise that he could be moved to tears by a Boston Symphony Concert."[17] Public occasions flustered Sargent. He hated to deliver formal remarks and generally stammered when required to make a toast. It is poignant that the man whose hand produced such fluid lines with brush and pencil was so constrained by this kind of awkwardness. Jane Emmet von Glehn, whom Sargent depicted in several informal paintings and watercolors, made this description of the artist soon after his mother's funeral: "Wil saw poor Sargent today. He is more cut up and more jerky and powerless to express himself than ever."[18] John C. Van Dyke, who encountered Sargent on a transatlantic crossing in 1903, later observed: "We played chess every day, listened to some music of which he was very fond, and occasionally dropped into picture talk. He was a little shy, even with men, and more or less embarrassed by women, but everyone liked him and, of course, everyone admired him for his work."[19] The American historian Henry Adams wrote in a letter of 1903: "At last the man I sought, the coruscating lime-light of enthusiasm, John Sargent. Holy Virgin, how useless civility is, when you have an artist to handle! Still, I did my little phrase book [made art talk], and he looked as irresponsive as ever. . . . Sargent is stodgy!"[20] The English artist W. Graham Robertson, whom Sargent painted in 1894 (fig. 6.8), later commented: "Both [Sargent and James] were fond of society, though neither seemed altogether at one with it: Henry James, an

artist in words, liked to talk and in order to talk there must be someone to talk to, but Sargent talked little and with an effort; why he 'went everywhere' night after night often puzzled me."[21]

It should not be assumed that Sargent lacked a passionate nature just because he experienced social discomforts. Passion was an important component of his private, if not his public persona. Several minor episodes in his life indicate that he held strong opinions and harbored a temper. For example, in 1890 Sargent had an argument with his friend and patron Charles Fairchild over an informal sketch of the Bostonian's daughter Sally. Sargent wanted to keep the picture for his own collection, and when the father pushed to have it for the family, the artist destroyed it.[22] In an incident the following year, in England, Sargent unwittingly damaged a field of winter wheat by riding through it. When the owner berated him, Sargent first stewed for two days and then challenged the farmer to a fight.[23]

Sargent's nature was "extremely irritable," according to his manservant. Being "an aristocrat and a gentleman to his fingertips," the limit of his cursing was "damn!" The word was such "a great comfort to him" that Sargent eventually had it reproduced on a rubber stamp. D'Inverno recalled: "When things went wrong he would stamp everything in sight with his 'damn!' 'damn!' 'damn!' 'damn!'"[24] An unusual public episode occurred at a London theater in 1895: Sargent could barely contain his rage while a hostile audience humiliated Henry James after the opening of his play, *Guy Domville*. W. Graham Robertson, his companion that evening, remembered "the violent eruption . . . of John Sargent, who had one of his rare attacks of fury and seemed about to hurl his hat at Alexander [the male lead] and leap upon the stage to rescue his friend [James]."[25]

Sargent's passions included eating. His appetite, which may have been related in a subconscious way to anxiety and irritability, drew comments from several friends and acquaintances. Mrs. Claude Beddington, who sat for him in 1914, was amazed when she first encountered Sargent at an English dinner party. "[A friend had said to me:] 'He can put away more food at a sitting than any man in London.' And I must regretfully admit the correctness of this prophecy, for my idol ate during the best part of two hours (dinners were lengthy in those days) with a steadfastness and a concentration such as I never before or since equaled at a meal."[26] The New York dealer Martin Birnbaum had this recollection of a dinner with Sargent at a home on the Massachusetts coast: "He ate his lobster with almost a peasant's gusto. How he loved his food! . . . [His eyes] began devouring Mrs. Longfellow's delicious New England dishes, even before they were served, but in every other way, he struck me as a quiet, emotionally reticent man of good breeding."[27]

Writing after Sargent's death, two artists tried to see his appetite in terms of the constant demands and aesthetic limitations of professional portraiture. William Rothenstein, portrayed in a Sargent lithograph of 1897, remarked: "I felt that something essential was lacking in Sargent. He was like a hungry man with a superb digestion, who need not be too particular what he eats. Sargent's unappeased appetite for work allowed him to paint everything and anything without selection, anywhere, at any time. . . . [In the mid-1890s Sargent] still came sometimes to lunch at the Chelsea Club, but complained that he couldn't get enough to eat there. So he often went to the Hans Crescent Hotel, where, from a table d'hôte luncheon of several courses, he could assuage his Gargantuan appetite."[28] Jacques-Émile Blanche, whom Sargent painted in the late 1880s, wrote: "'The Van Dyck of Tite Street' had to make appointments six months or a year ahead with Royal Highnesses just as occupied as he. During the season, at the grill room of the Hyde Park Hotel, he devoured his meals and gulped down his wine, [with] his watch on the table in front of him. . . . There was just half an hour for recharging the motor, for filling it with life-giving spirit, between the morning sitting and another, sometimes two, in the afternoon. Stuffed with food, smoking Havana cigars as large as logs, with bloodshot eyes, puffing, he glanced through the *Times*. There was about him something of a townsman—of Walt Whitman and a City man—though without the latter's desire for comfort."[29]

After focusing on these less appealing traits, it is important to keep some of the artist's jollier characteristics in view. In addition to a love of music, reading, and chess, one of Sargent's cousins noted his broad interest in the performing arts: "[He enjoyed] all good acting from Duse to Dan Leno, the opera, Spanish and Russian dancing, tumblers, acrobats, music hall artistes, Charley Chaplin, and such films as the delightful 'Thief of Bagdad.'"[30] Another friend wrote in a memorial: "[He had a] zest for the bizarre, the original, anything odd, funny, or ridiculous in the spoken or written word. Humor played over his whole conception of life, in Carlyle's definition, 'like sunlight on the deep sea.' . . . Too much stress is laid upon . . . [his] shyness, his capacity for silence. He was the most amusing of companions, the most entertaining of hosts."[31] Sargent was a sensitive individual whose character was more complicated than he was ever able to divulge. His evasions have made it hard to achieve a fair, comprehensive, and sufficiently nuanced picture of his accomplishments, but seeking to understand him is a rich and rewarding pursuit.

1854 Dr. Fitzwilliam Sargent (a medical practitioner and surgeon, thirty-four years old) and his wife (née Mary Newbold Singer, thirty years old) leave Philadelphia for a tour of Europe, mourning the recent death of their first child. They live abroad for the rest of their lives.

1856 John Singer Sargent is born in Florence. The Sargents have another son and three daughters, only two of whom live past childhood: Emily (born 1857) and Violet (born 1870).

Dr. Sargent abandons his medical career. Funded by modest independent incomes, the Sargents adopt an itinerant life, moving seasonally between Italy, France, Switzerland, Austria, and Germany. They improvise John's education; he occasionally studies at day schools, and his early enthusiasm for art is encouraged by his mother, an amateur watercolorist, and a few of his parents' acquaintances.

1867 Sargent's mother writes from Europe to her mother-in-law: "[John] sketches quite nicely, and has a remarkably quick and correct eye. If we could afford to give him really good lessons, he would soon be quite a little artist. Thus far he has never had any instruction."[32]

1870 Sargent's father writes to his mother: "My boy John seems to have a strong desire to be an artist by profession, a painter, and he shows so much evidence of talent in that direction, and takes so much pleasure in cultivating it, that we have concluded to gratify him and to keep that plan in view in his studies."[33]

1873 Sargent begins formal training at the Accademia delle Belle Arti in Florence.

1874 The Sargent family moves to Paris for the benefit of John's career. Aged eighteen, he joins painting classes in the private studio of a voguish society portraitist with the invented name of Carolus-Duran (Charles-Émile-Auguste Durand). Sargent passes the rigorous entrance exams to study drawing at the École des Beaux-Arts, where he excels.

1877 Sargent's portrait of his friend Fanny Watts is included in the Salon, an enormous, juried, government-sponsored exhibition held annually in Paris. This early success heralds the beginning of his rise to public acclaim in Paris. He spends the summer at the fishing village of Cancale in Brittany making studies for his next submission to the Salon.

1878 Sargent's *Oyster Gatherers of Cancale* is exhibited at the Salon. The artist summers in Naples and Capri. His studies of Rosina Ferrara, a young dark-skinned Capriote model of Greek extraction, inspire a painting for the next year's Salon: *Among the Olive Trees, Capri.*

1879 Sargent sends two paintings to the Salon: one shows a sultry Capriote peasant in a rustic setting, the other his dapper teacher, Carolus-Duran (fig. 1.2).

1.2 CAROLUS-DURAN, 1879
Oil on canvas
46 × 38 in.
Sterling and Francine Clark
Art Institute, Williamstown,
Massachusetts

1.3 THE DAUGHTERS OF EDWARD DARLEY BOIT, 1882
Oil on canvas
From *The Work of John S. Sargent,* 1903
(Museum of Fine Arts, Boston)

The jury awards an honorable mention to *Carolus-Duran.* He travels in Spain and paints copies of several works by Velásquez at the Prado Museum. The broad, economical brushwork of this Spanish seventeenth-century master inspired several Parisian artists at this time, including Carolus-Duran and the notorious modernist Edouard Manet.

1880 Sargent travels to Holland to study seventeenth-century pictures. He copies several portraits by Frans Hals. In autumn and winter he paints independent works in Venice (and returns in the summer of 1882 to sketch more local scenes).

In the early 1880s Sargent's landmark contributions to the annual Salon exhibitions begin to signal his professional independence. The jury awards him a second-class medal in 1881, when he submits two oil portraits and two Venetian watercolors. The Salon of 1882 features Sargent's *El Jaleo* (a monumental image of a Gypsy dancer and her excited accompanists, fig. 4.3) and a quaint portrait, *Lady with the Rose.* His offering the following year is *The Daughters of Edward Darley Boit,* a portrait of four charming American girls uncannily grouped in a dark Parisian interior (fig. 1.3).

1881 Sargent's friends wonder if he and Louise Burckhardt (the subject of *Lady with the Rose*) have formed a romantic attachment. His enthusiasm while creating a new Salon picture of her probably instigated the rumors, but a mutual friend learns from Sargent in 1882 that "he does not care a straw for her." Despite numerous friendships with women throughout his life, this is the only episode to cause associates to doubt his status as a committed bachelor.[34]

While Sargent's reputation grows at the "official" venue of the Salon, he makes contact with the network of more progressive artists and galleries in Paris. He attends the exhibitions of the Impressionists and begins an acquaintance with Claude Monet.

1883 Sargent leaves the Latin Quarter of Paris and rents a recently built house and studio on a fashionable stretch of Boulevard Berthier. His friend Vernon Lee says it is "so extremely pretty, quite aesthetic and English, . . . and all done up with [William] Morris [wall]papers and rugs and matting."[35]

1884 Sargent purchases two works by Edouard Manet, who had died the previous year. He exhibits his portrait of Dr. Samuel Pozzi in Brussels at the inaugural exhibition of a progressive arts group, Les XX (fig. 3.4). At the Salon his stark, elegant portrayal of Madame Pierre Gautreau, *Madame X,* unleashes a flurry of public mockery and critical grandstanding. Sensing that

he may have jeopardized his reputation in Paris, the artist reworks the picture, lifting the fallen shoulder strap of the woman's sensational evening gown to a more respectable position (fig. 1.6).

Encouraged by two brief working visits to England (1881 and 1884), Sargent submits pictures to London exhibitions and starts to make inroads into the British art world. After he meets Henry James in Paris in 1884, the writer begins to lobby for a move to England. In the aftermath of the *Madame X* episode Sargent gradually concludes that England might offer him a better career as a portraitist than France.

1885 Sargent visits Monet at Giverny and makes an oil sketch of the modern French painter at work in a meadow.

From 1885 to 1889 Sargent spends part of each summer in the English countryside, experimenting with the techniques of *plein air* painting developed by the French Impressionists (figs. 1.8, 5.7). Between 1887 and 1891 he purchases four recent works by Monet for his personal collection. In 1889–90 he helps Monet organize a successful scheme to purchase Manet's *Olympia* for the French national collection (Sargent contributes 1,000 francs).

1886 Sargent moves permanently to Tite Street, Chelsea, occupying the former studio and apartment of his senior, more progressive American colleague J. A. M. Whistler. He exhibits two paintings at the inaugural exhibition of the New English Art Club, London, where he is an active participant for

1.7 CARNATION, LILY, LILY, ROSE,
1886
Oil on canvas
From *The Work of John S. Sargent,* 1903
(The Tate Gallery, London)

several years. The artists in the group are all sympathetic to the modern
French school. One of Sargent's contributions, a small Degas-inspired com-
position of an English couple drinking port at their dinner table, had been
shown in an independent group exhibition in Paris the previous year.
He attends the Wagner festival in Bayreuth. Henry James brings Isabella
Stewart Gardner, Boston's maverick art collector, to visit Sargent in his
Chelsea studio.

1887 Sargent sparks a lively debate at the Royal Academy's annual exhibition with
the large canvas he has been working on for the last two summers, *Carna-
tion, Lily, Lily, Rose* (fig. 1.7). His twilight image of two English girls (Dolly
and Polly Barnard) lighting Japanese lanterns is a poetic vignette that hovers
between reality and reverie. It showcases some French modern trends: the
move to treat the composition as a simple, harmonious arrangement of bold
shapes and colors, and the emphasis on the chromatic complexity of light
effects. Although these French aspects rouse some suspicions at the Royal

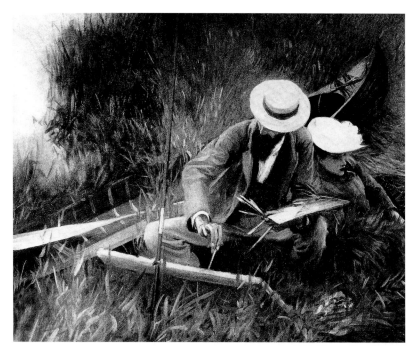

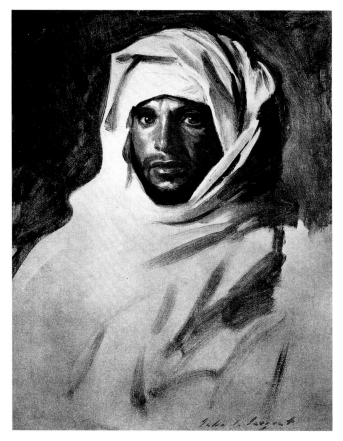

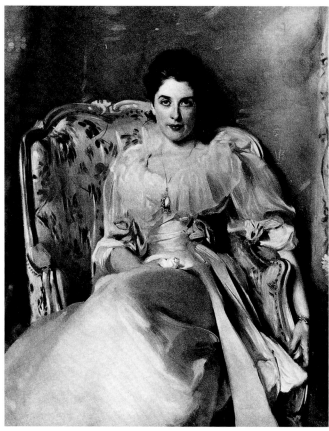

Academy, the evanescent beauty distilled in *Carnation, Lily, Lily, Rose* wins the support of people devoted to the Aesthetic movement raging in London. A special purchase fund for works made in England is used to acquire the picture for the British national collection.

1887,
1888
Sargent makes his first professional visit to the United States, painting more than a dozen formal portraits of members of high society, including Mrs. William Henry Vanderbilt of New York and Isabella Stewart Gardner of Boston (fig. 2.15). In January 1888 the St. Botolph Club, a private social organization, hosts Sargent's first solo exhibition at its fashionable new quarters in Boston's Back Bay; twenty-one oil paintings and one watercolor are shown. Long illustrated essays profiling the artist's burgeoning career appear in the United States and England: the first by Henry James in *Harper's New Monthly* and the second by R. A. M. Stevenson in the British monthly *Art Journal.*

1889
The artist's father dies in Bournemouth, England. The six portraits Sargent shows at the Exposition Universelle, Paris, bring him success. He is one of 189 American painters whose pictures hang in their country's section of the art pavilion. He receives one of the eight grand prizes awarded to non-French artists (Gari Melchers is the only other American so honored); the French government also makes Sargent a chevalier of the Légion d'Honneur.

1890
During a second portrait-painting trip to New York and Boston, Sargent is invited to design murals for a room in the new Boston Public Library. The commission stems in part from his personal friendship with the project's principal architect, Charles F. McKim, of the up-and-coming New York firm McKim, Mead & White. After choosing the history of Christianity as his subject, Sargent travels to Egypt with his mother and sisters to research Old Testament themes (figs. 1.10, 5.1, and 6.1).

1892
A year after acquiring Whistler's celebrated portrait of his mother, the French government purchases Sargent's *La Carmencita* for the national modern art collection (Musée du Luxembourg, Paris). This full-length portrait of the Spanish cabaret star dates from his 1890 visit to New York.

Between 1893 and 1902 the portraits Sargent submits to the annual exhibitions of London's Royal Academy win resounding acclaim, signaling victory over the old school British critics. *Lady Agnew of Lochnaw,* an exquisite picture of a demure yet tempting dark-haired beauty, inspires the new enthusiasm (fig. 1.11). One writer proclaims: "As a portrait, a decorative pattern, or a piece of well-engineered impressionistic painting, it tops everything in the Academy."[36] *Coventry Patmore* (shown in 1895) and *Mrs. Carl Meyer and Her Children* (shown in 1897) inspire more raves (figs. 1.12 and 1.16). The eight portraits Sargent exhibits in 1902 include *Lord Ribblesdale; The Misses Hunter; Alfred Wertheimer* (fig. 1.19); *Winifred, Duchess of Portland;* and *Mrs. Leopold Hirsch* (fig. 1.25). After visiting the exhibition, Rodin

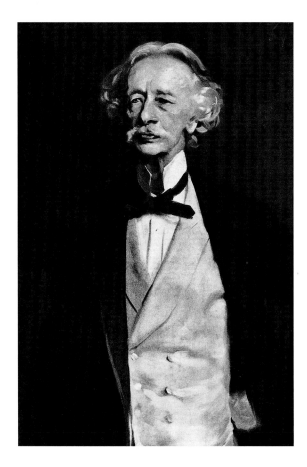

1.12 COVENTRY PATMORE, 1894
Oil on canvas
From *The Work of John S. Sargent,* 1903
(National Portrait Gallery, London)

tells a reporter for London's *Daily Chronicle* that Sargent is "le Van Dyck de l'époque."[37]

1893 Sargent shows eight portraits and a full-length nude (*Egyptian Girl,* fig. 6.1) at the World's Columbian Exposition in Chicago.

An accomplished pianist, Sargent enjoys a lifelong passion for music. Indications of his musical interests are to be found in the pictures he devotes to musicians, singers, and composers, including the Pasdeloup Orchestra (c. 1879, fig. 2.11), Gabriel Fauré (c. 1889), Sir George Henschel (1889), Léon Delafosse (1893, fig. 6.7), Johannes Wolff (1897), Mrs. George (Elsie) Swinton (1897), Mrs. George (Mabel) Batten (1897, fig. 1.13), Dame Ethel Smyth (1901), Charles Martin Loeffler (1903), Manuel Garcia (1905), Percy Grainger (c. 1905), Leonora von Stosch (Lady Speyer, 1907), and Jascha Heifetz (1918).

1895 Boston unveils its new public library, a Beaux Arts statement now acclaimed as a landmark of the American Renaissance period (1876–1917). The interior decorations include works by Sargent, his Anglo-American friend Edwin Austin Abbey, and the preeminent French muralist Puvis de Chavannes. Sargent intends to decorate the two ends of the hall on the third floor, but in 1895 only his "Hebraic End" is complete (fig. 1.14). Its opulent painted, sculpted, and low-relief elements represent diverse pagan deities, Moses, the Hebrew prophets, and the Egyptian and Assyrian "oppressors of the children of Israel." The library trustees give Sargent a new contract to produce his "Christian End" and to decorate the connecting walls. He takes a long lease on a second studio in London (on Fulham Road) which he can use exclusively for mural work.

1897 Sargent is elected to full membership of the Royal Academy, London, and the National Academy of Design, New York. He eventually teaches a few classes at the Royal Academy and works on committees to improve the selection and hanging of its annual juried exhibition.

1899 The Boston Art Students' Association presents a survey of more than 120 of Sargent's portraits and sketches, including many works from the artist's personal collection and important loans from British and American patrons. The exhibition includes: *Lady Agnew of Lochnaw* (fig. 1.11); *Henry Cabot Lodge; Mrs. Carl Meyer and Her Children* (fig. 1.16); *Robert Louis Stevenson* (fig. 3.13); *Asher Wertheimer* (fig. 3.12); and drawings of Madame Gautreau (possibly fig. 1.5), Judith Gautier (fig. 1.4), Gabriel Fauré, George Meredith, Carmencita, and Vernon Lee. Although Sargent does not attend, strong press coverage boosts his reputation in America.

1900 The artist more than doubles the size of his accommodations on Tite Street by leasing the house adjoining his studio and connecting the spaces.

1901 Sargent declines a commission to make a painting of the coronation of Edward VII, writing the king's equerry: "The fact of my entire dependence

1.13 MRS. GEORGE BATTEN, 1895

Oil on canvas
From *The Work of John S. Sargent,* 1903
(Art Gallery and Museum,
Kelvingrove, Glasgow)

1.14 SARGENT HALL, BOSTON
PUBLIC LIBRARY, 1895

Illustration by Ernest C. Peixotto
from *Scribner's Magazine,* 1896

1.15 STUDY FOR "FRIEZE OF THE
PROPHETS," BOSTON PUBLIC
LIBRARY, C. 1893

Oil on canvas
47¼ × 74¼ in.
Fogg Art Museum,
Harvard University Art Museums,
Cambridge, Massachusetts, gift of
Mrs. Francis Ormond

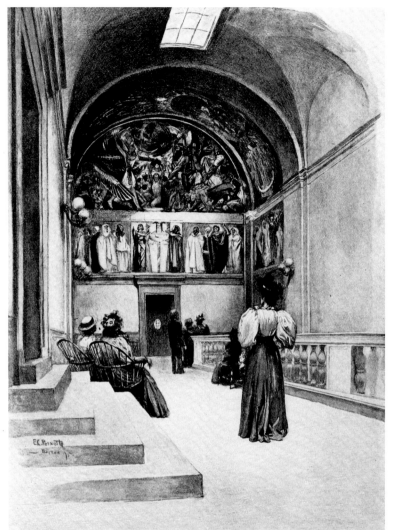

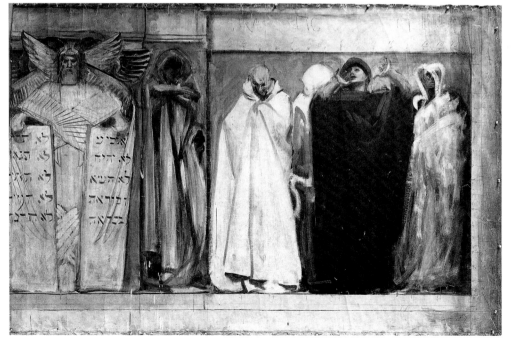

1.16 MRS. CARL MEYER AND HER CHILDREN, 1896

Oil on canvas
From *The Work of John S. Sargent,* 1903
(Private collection)

1.17 GEN. SIR IAN HAMILTON, 1898

Oil on canvas
From *The Work of John S. Sargent,* 1903
(Scottish National Portrait Gallery, Edinburgh)

1.18 MRS. CHARLES HUNTER, 1898

Oil on canvas
From *The Work of John S. Sargent,* 1903
(The Tate Gallery, London)

1.19 Detail of ALFRED WERTHEIMER, 1902

Oil on canvas
From *The Work of John S. Sargent,* 1903
(The Tate Gallery, London)

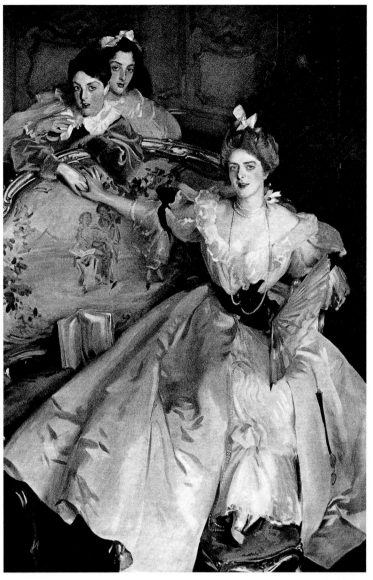

Opposite, from top left:
1.20 GEN. SIR IAN HAMILTON, 1898

Oil on canvas
From *The Work of John S. Sargent,* 1903
(The Tate Gallery, London)

1.21 MISS DAISY LEITER, 1898

Oil on canvas
From *The Work of John S. Sargent,* 1903
(Collection of English Heritage)

1.22 THE WYNDHAM SISTERS: LADY ELCHO, MRS. ADEANE, AND MRS. TENNANT, 1899

Oil on canvas
From *The Work of John S. Sargent,* 1903
(The Metropolitan Museum of Art, New York)

1.23 THE HON. VICTORIA STANLEY, 1899

Oil on canvas
From *The Work of John S. Sargent,* 1903
(Private collection)

1.24 LORD RUSSELL OF KILLOWEN, 1900

Oil on canvas
From *The Work of John S. Sargent,* 1903
(Lincoln's Inn, London)

1.25 MRS. LEOPOLD HIRSCH, 1902

Oil on canvas
From *The Work of John S. Sargent,* 1903
(Private collection)

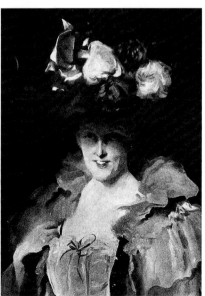

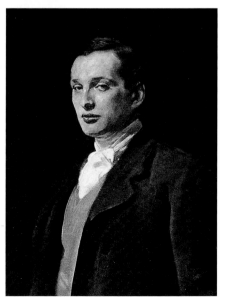

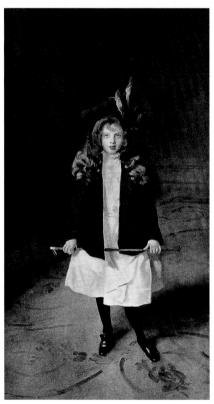

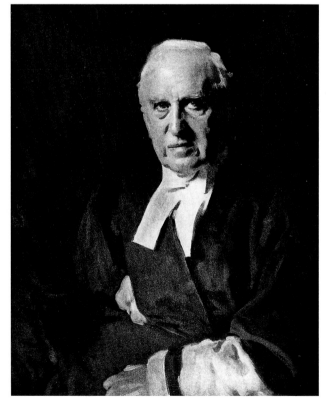

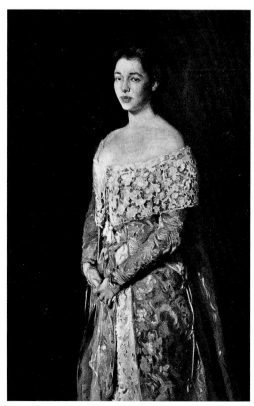

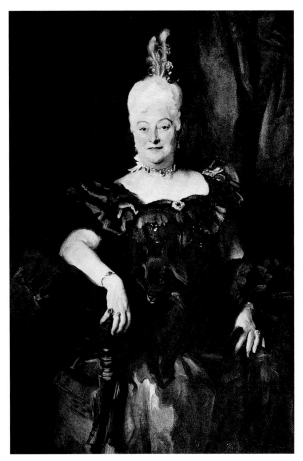

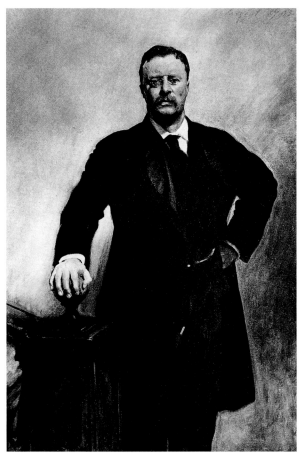

on nature, both for likeness and qualities of painting, makes me particularly unfit for this high task."[38]

Sargent's reputation soars at the beginning of the new century. He prepares a volume of sixty-two photogravures of his art, which is published in London and New York in 1903. In the "Introductory Note" to this imposing tome, the artist's friend Alice Meynell pronounces Sargent "one of the family of Velásquez, and no less than his chief heir." He is slowly heaped with honors, including numerous exhibition medals and degrees from the University of Pennsylvania (1903), Oxford University (1904), Cambridge University (1913), Yale University (1916), and Harvard University (1916).

1903 Sargent delivers a second section of murals to the Boston Public Library. A large painted sculpture of the crucifixion is the focal point of his "Christian End," which faces the "Hebraic" ensemble he installed in 1895. While he paints portraits in Boston, New York, Philadelphia, and Washington, a small commercial operation in London, the Carfax Gallery, mounts Sargent's first solo exhibition in Europe—a group of studies in oil, drawings, and watercolors. *Art Amateur* reports that the artist "refuses to part with one of these sketches" and notes that his efforts as an exhibitor and portrait

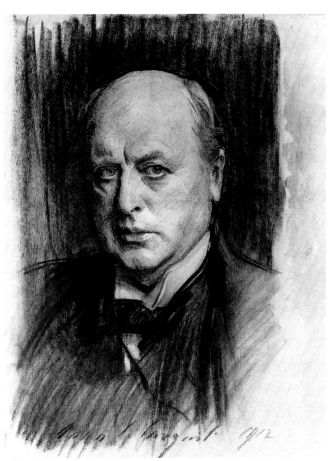

1.28 VASLAV NIJINSKY IN
LE PAVILLON D'ARMIDE,
1911
Charcoal on paper
24¹⁄₁₆ × 18⅝ in.
Private collection

1.29 HENRY JAMES, 1912
Charcoal on paper
20¹³⁄₁₆ × 13¹⁄₁₆ in.
The Royal Collection, London

painter are "breaking the record."[39] Sargent makes a holiday trip to Spain, Portugal, and Italy.

Eminent people jockey to be painted by Sargent. His *President Theodore Roosevelt* (1903) hangs in the White House (fig.1.27). *The Marlborough Family* (1905) graces the Red Drawing Room of Blenheim Palace, hanging opposite an equally stately group portrait painted by Joshua Reynolds in 1778. Some people begin to suspect Sargent's popularity and criticize his role as the favored painter of Edwardian plutocrats. Younger artists with a modernist agenda link him with the shallowness and brashness of the new ruling class. Even Sargent's friend Henry James privately considers the new king "an arch-vulgarian."[40]

1905 *American Art News* observes: "Sargent is one of the busiest men in the world. . . . He declines to take any more orders for portraits because he has taken all that he can possibly complete in his lifetime."[41] Recent watercolors dominate Sargent's second solo exhibition at the Carfax Gallery, London. Against the consensus, Roger Fry writes an unsigned negative review; while calling the execution "almost miraculous," he finds the colors crude and the inspiration poor: "What a place Queluz must be! and yet Mr. Sargent's

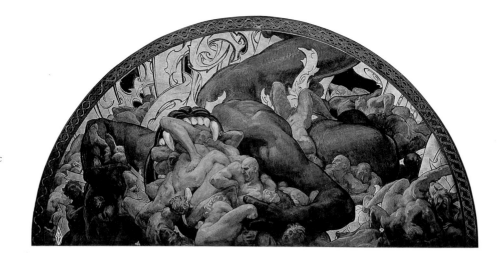

1.30 HELL, 1916
Mural decoration at Boston Public
Library; oil and gilding on canvas
Width: 202 in.
Courtesy Trustees of the Public
Library of the City of Boston

rendering would do equally well for some scenic effect at Earl's Court
[Theater]."[42] Count Robert de Montesquiou, the doyen of French aes-
thetes, reviews Sargent's recent volume of photogravures and pronounces
his attention-grabbing virtuosity a terrible shortcoming.[43]

1906 While Sargent is in Syria and Palestine conducting research for his murals,
his mother dies in London. The art dealer Joseph Duveen donates Sargent's
Ellen Terry as Lady Macbeth (fig. 3.11) to the British national collection. A
cartoon in *Punch* jokes about the "upheaval" whereby Sargent "got sulky"
and gave up painting "Portraits of all the Grand People"; *Punch* suggests that
he enter politics as a cabinet minister.[44]

By 1907 Sargent does enforce a drastic reduction in the load of painted
portraits but still paints a handful every year. To satisfy the status-driven hun-
ger to be the subject of a Sargent, he offers charcoal portraits that can be
completed in a single morning or afternoon sitting. (He makes more than
six hundred of these drawings—which he nicknames "mugs"—between
1900 and 1925; see figs. 1.28, 1.29, 1.32.) Sargent now plans holidays to be
both productive of informal pictures and diverting. Whenever possible he
rents or borrows historic villas where he can entertain friends, including
artists who enjoy painting with him. In addition to regular stops in the Alps
and Venice, the destinations include Frascati and Rome (1907), Mallorca
(1908), Corfu, (1909), Florence and Lucca (1910), Seville and Granada
(1912), and San Vigilio, on Lake Garda (1913).

1907 When King Edward VII recommends him for a knighthood, Sargent de-
clines, arguing that his American citizenship renders him ineligible.

1909 Knoedler & Co., New York, presents an exhibition of watercolors by
Sargent and his friend Edward Darley Boit. The Brooklyn Museum
purchases eighty-three of the eighty-six Sargents for about $240 each.
This coup inspires other American museums to buy groups of watercolors.

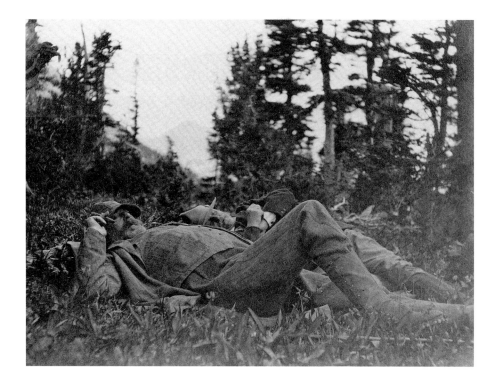

1.31 Sargent and Col. Thomas Livermore in Montana, 1916

In 1912 the Museum of Fine Arts, Boston, purchases forty-five examples from Sargent; the Metropolitan Museum of Art, New York, buys ten in 1915; and the Worcester Art Museum acquires eleven in 1917 (paying $250 each).

1910 The modern British artist Walter Sickert publishes a revisionist essay called "Sargentolatry": "I herewith convict almost the whole critical press of this country . . . of craven abjection to a social and commercial success."[45]

1911 Sargent takes exception when Roger Fry publishes his name as a supporter of Post-Impressionism. Rather tactlessly, Sargent admits his low opinion of the movement in a letter to *The Nation*.[46] A large Ingres exhibition in Paris heightens Sargent's interest in French classicism. When Diaghilev's Ballets Russes performs in London, he makes charcoal drawings of two star dancers, Tamara Karsavina and Vaslav Nijinsky (fig. 1.28). During an Italian holiday he produces an unusual group of pictures at the marble quarries outside Carrara.

1913 Sargent paints his friend Henry James as a seventieth-birthday gift, which is one of the honorifics bestowed by James's closest admirers.

1914 Sargent is in the Austrian Tyrol on holiday with British artist friends when Britain and France declare war on Germany.

1915 Sargent shows thirteen oil paintings at the Panama Pacific Exhibition in San Francisco: the six portraits include *Madame X* and *Henry James;* the seven informal pictures include *Egyptian Girl* (fig. 6.1).

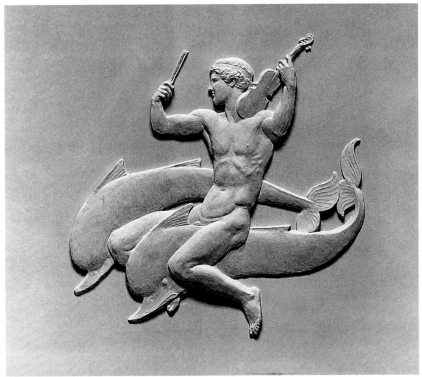

1.33 ARION, 1921
Bas-relief in the rotunda of the
Museum of Fine Arts, Boston;
painted plaster
Museum of Fine Arts, Boston

1.32 MRS. RICHARD D. SEARS,
1916
Charcoal on paper
24½ × 18⅛ in.
Private collection

1916 The artist travels to the United States after an absence of thirteen years,
bringing a large new group of decorations for his hall at the Boston Public
Library (fig. 1.30). This civic project confirms his burgeoning ambition to
transcend professional portraiture by realizing a Renaissance harmonization
of painting, sculpture, and architecture. Sargent wants to be deemed an heir
to Michelangelo rather than Sir Joshua Reynolds.[47] He accepts a commis-
sion to paint mural decorations for the rotunda of the Museum of Fine Arts,
Boston. Sargent takes a painting holiday in the Canadian Rockies; he vis-
its Glacier Park, Montana, en route (fig. 1.31). He sells *Madame X* to the
Metropolitan Museum of Art, New York. His charcoal portrait of Bostonian
Eleanor Sears (fig. 1.32) is a fond echo of that landmark painting.

1917 Sargent paints two portraits of John D. Rockefeller, one in Miami, Florida,
and the other in Tarrytown, New York. He travels to Washington to paint
President Woodrow Wilson on a special commission from the National
Gallery of Ireland. (Two years earlier Sir Hugh Lane had persuaded Sargent
to commit to a portrait by donating ₤10,000 to the Red Cross Society. It

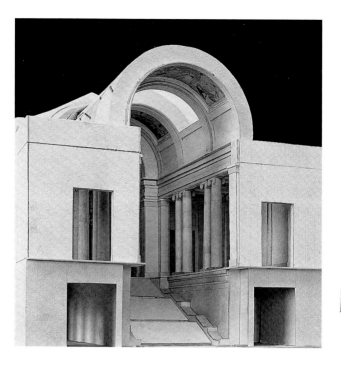

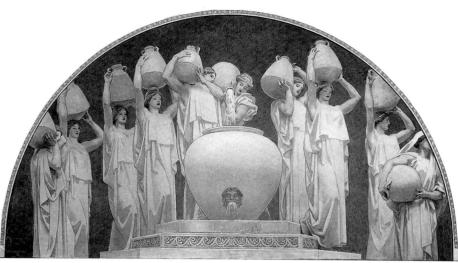

remains unclear how and why President Wilson was chosen, but the picture symbolizes American, British, and Irish unity during a time of war.)

1918 Sargent's beloved niece Rose-Marie Ormond (fig. 5.8) is killed in Paris during a German bombardment. Near the end of their long sojourn in Boston, Nicola D'Inverno, Sargent's manservant since the early 1890s, leaves his service. The artist returns to England alone. Pressed by Prime Minister Lloyd George, he accepts a commission from the British War Memorial Committee of the Ministry of Information to produce a painting for a projected Hall of Remembrance. During a four-month visit to France, assigned to the Guards Division, he spends time near Arras and Ypres at the Western Front. He decides to re-create a scene he witnesses at a makeshift medical center where several hundred victims of mustard gas assemble for treatment. Sargent declines to become president of the Royal Academy.

1919 Working in his Fulham Road studio, Sargent completes the monumental painting *Gassed.* It is exhibited at the Royal Academy before entering the institution now known as the Imperial War Museum. He makes his last contributions to his hall at the Boston Public Library: *The Synagogue* and *The Church.* In London he responds again to official pressure and agrees to paint another war memorial—*Some General Officers of the Great War*—for the National Portrait Gallery, London. Completed in 1922, the canvas measures about 10 by 17 feet and includes full-length portraits of twenty-two generals.

1921 Sargent installs an elaborate decorative scheme in the rotunda of the Museum of Fine Arts, Boston. His neoclassical-style paintings, bas-reliefs, and architectural ornaments present an assortment of mythological subjects (figs.

1.33–1.35). He now agrees to extend these decorations over the staircase leading from the grand entrance to the rotunda. He also accepts a commission from Harvard University to paint two mural panels commemorating Harvard men killed in World War I.

1922 Sargent installs his paired mural panels at Harry Elkins Widener Memorial Library, Harvard University: *Entering the War* and *Death and Victory*. While generally well received, the Harvard murals attract some criticism for their visual kinship with images used for military propaganda and popular advertising. Meanwhile, after two years of controversy regarding the anti-Jewish associations of the medieval imagery that Sargent adapted for the Boston Public Library's *The Synagogue,* the governor of Massachusetts signs a bill for the removal of the painting. No immediate action is taken, and the bill is repealed two years later.

1923 The National Gallery, London, displays the nine portraits by Sargent given to the nation in 1922 by the widow and children of Asher Wertheimer. Between 1898 and 1908 this leading art dealer of the Edwardian period commissioned twelve portraits from Sargent, who was a frequent guest at the family's grand house at Connaught Place. The National Gallery displays the nine pictures in the same room, following the terms of the gift; a few historic English portraits by Reynolds, Gainsborough, Opie, Lawrence, and others are included to show the history of portraiture in England. The museum has never before given a living artist attention of this sort, and antagonism results. During a parliamentary question session Sir Charles Oman asks if "these clever, but extremely repulsive, pictures" might be hung in "a special chamber of horrors" that was not so close to the beloved paintings of J. M. W. Turner.[48] No immediate action is taken.

American mural projects dominate the last years of Sargent's life. He produces most of the individual parts in London and crosses the Atlantic to oversee their installation. He maintains a studio in Boston, with Thomas A. Fox as his architectural collaborator. Sargent quietly abandons the Boston Public Library project by choosing to leave the space between *The Synagogue* and *The Church* with no painting or decorative treatment. He now sees his decorations at the Museum of Fine Arts as a culminating statement: gracious in spirit and innocuously classical in theme, they occupy the heart of a building dedicated to art (figs. 1.33–1.35).

1925 Working in London, Sargent finishes the remaining mural sections destined for the Museum of Fine Arts, Boston. A few weeks later, he dies on the eve of his journey to Boston, and his colleague Thomas Fox oversees the installation. A postmortem indicates heart failure caused by arterial sclerosis. A public memorial service is held in Westminster Abbey. Three different memorial exhibitions are organized in Boston, New York, and London.

Sargent's primary benefactors are his sisters: Emily (unmarried) and Violet

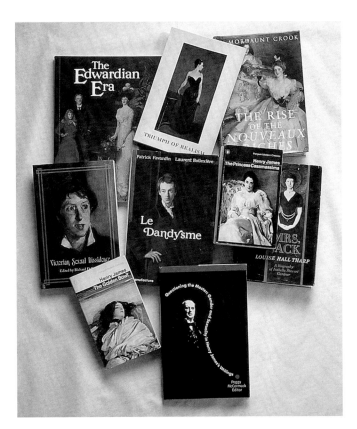

(who married a Swiss businessman, Louis Francis Ormond, in 1891). In 1925 they invite Christie, Manson & Woods to auction some of Sargent's collection of art, furnishings, and books in three sales in London. The art auction (two-thirds of it works by Sargent) is a tremendous financial success.

1926 A "Sargent Room" is established at the Tate Gallery (then known as the National Gallery of British Art). It includes the Wertheimer portraits, other pictures in the national collection, and works borrowed from private lenders. A bronze cast of Sargent's *Crucifixion* (part of his decorations at the Boston Public Library) is installed in the crypt of Saint Paul's Cathedral, London, a memorial gift from his sisters. Throughout the rest of their lives they donate roughly two thousand works by Sargent to numerous British and American museums.

Sargent's status plummets after his death, when modernism holds greatest sway. Since the 1960s shifting assessments of representational art, studies of the Victorian and Edwardian periods, and broader art-historical methodologies all help him emerge from obscurity. His savvy ability to produce progressive art and society portraiture in the grand manner is now appreciated as a singular achievement. The covers of books from diverse intellectual arenas reflect the renewed interest in Sargent as an intriguing historical figure (fig. 1.36), and soaring sales prices confirm that his pictures are once again trophies in our new Gilded Age.

Chapter 2

A PRODIGIOUS TALENT,
A SENSUAL EYE

Sargent is not only a painter's painter; the ultra realism of his portrayal of life appeals equally to the Philistine. His method is easily explained: it is based upon true vision, and has the simplicity of greatness; it is eclectic, including that which is best in previous schools. In it are passages of color, exactly like and equal to those of Velásquez; passages of modeling equal to Rubens's; and passages of chiaroscuro equal to Rembrandt's. It is a luxurious method, opposed to the sparseness of the pre-Raphaelites; there is nothing symbolic in his compositions, all are straightforward and uncompromising. The process by which the effect is gained consists in imitating with a full brush the main spots of color seen in nature, with true regard to their exact value in their proper plane.

—American art critic Ernest Knaufft (*Art Interchange,* February 1899)

While Sargent was shy in public, his pictures were not. Art released him from the Victorian propriety of his drawing-room self. He asked his viewers to dwell on sensual enchantments: the idle distraction of lounging in a lovely setting, the excitement of donning exotic finery. He delighted in the challenge of capturing a fleeting moment of beauty: a smile lighting a face; the radiance of a stylish or confident person; the play of sunlight and shadow on surfaces as different as marble statues in Italian gardens and canvas tents in the Canadian wilderness.

Sargent's art appeals to the senses in two ways. First, it depicts and celebrates sources of pleasure—enchanting places, intriguing objects, and striking individuals of diverse types and classes. Second, Sargent's way of painting is itself sensual. The conspicuously worked, physically appealing surfaces of his pictures are the visible remains of the pleasure he derived from wielding his brushes. The following recollection by someone who watched Sargent paint a portrait evokes the excitement and gratification the artist experienced while working: "His method was to glance at his subject [then] dash at his canvas with curious circular motions of

his hand, rather like a boxer seeking an opening in his opponent's defense. He made his stroke and retreated, working with amazing speed, never erasing, though often painting over. All the time he smoked delicious, fragrant Egyptian cigarettes."[1]

DRAFTSMANSHIP

Drawing was the foundation for Sargent's prodigious talent. He was blessed with a keenly observant eye and the most dexterous hand. Two drawings from his teens (figs. 2.1, 2.2) and one from his early sixties (fig. 2.3) convey his delight in close looking and confirm that the habit of sketching persisted throughout his career. The early examples show Sargent tackling ambitious subjects—a vast Alpine glacier and a fanciful sundial on a Gothic cathedral. He controls his pencil carefully and lovingly, capturing crucial details with thin hard lines while rendering peripheral passages with soft, generalizing marks. Works of this type became part of the portfolio Sargent assembled as an aspiring artist. In the later drawing, he confined himself to the essential lines of a motorcycle and the shadow it cast on the ground. It is one of hundreds of sketches Sargent made in France in 1918 while serving as a war artist for Great Britain. Although cursory, it confirms his unflagging enthusiasm for exactitude. The image of the antique sundial and that of the motorcycle both scrutinize elaborate functional objects but from radically different epochs— one sustained by artisans, the other newly engulfed by mechanization. The pairing reminds us that Sargent lived through massive cultural and political changes: he was born at the end of the Romantic era, with its longing for the historically picturesque, and he grew old in the revved-up dawn of the twentieth century, when anything too Victorian raised hackles.

Sargent's parents nurtured his visual and manual gifts. To make him a "close observer," Dr. Sargent encouraged the boy to compare real birds and seashells with those illustrated in books. Mrs. Sargent, an enthusiastic amateur watercolorist, often took him sketching. He collected illustrations and photographs and liked to arrange them in albums; in a letter of 1869 he mentions one devoted to Greek and Roman poets, the first Caesars, and classical statues.[2] When the Sargents encountered artists, they solicited comments on their son's talents. During a winter in Rome (1869–70) they allowed him to help in the studio of Carl Welsch, a German-American landscape painter. Sargent copied some of Welsch's watercolors, and then joined him for an Alpine sketching trip in the summer of 1871. He eventually enrolled as an art student at the Accademia delle Belle Arti in Florence, in 1873, where he followed the time-honored tradition of drawing plaster casts of classical sculptures. But the school's unreliable schedule quickly forced Sargent and his parents to conclude that Paris offered the best education for a serious art student.

2.1 GLACIER ON THE ORTLER, 1879
Pencil and watercolor on paper
10⅝ × 14⅜ in.
The Metropolitan Museum of Art, New York, gift of Mrs. Francis Ormond, 1950

2.2 ANGEL WITH SUNDIAL, CHARTRES, after 1874
Pencil on paper
13¾ × 10³⁄₁₆ in.
The Metropolitan Museum of Art, New York, gift of Mrs. Francis Ormond, 1950

2.3 SKETCH OF A MOTORCYCLE WITH SHADOW, 1918
Pencil on paper
7¹⁄₁₆ × 5⅛ in.
Corcoran Gallery of Art, Washington, D.C., gift of Miss Emily Sargent and Mrs. Violet Sargent Ormond

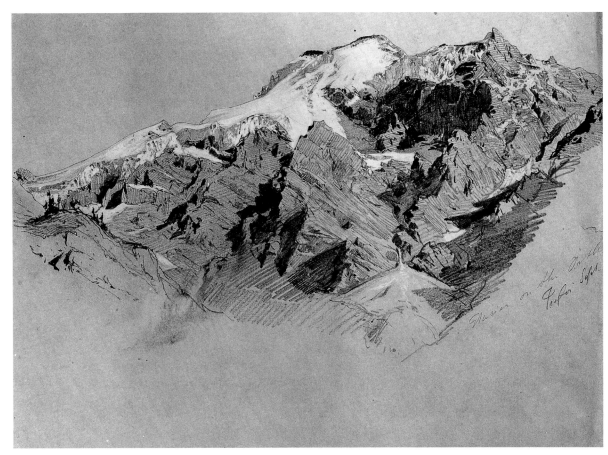

Glacier on the Aiguille
Perfin Sept.

Chartres

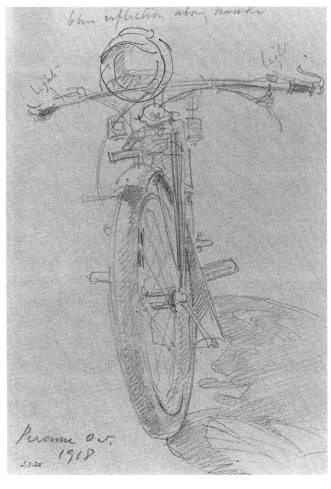

blue reflection along handles

light light

Peronne Oct.
1918
J.S.24.

In May 1874 Sargent had a successful interview and portfolio review with the dapper thirty-six-year-old portraitist Carolus-Duran. The Frenchman invited him to join the private atelier where he taught painting to about twenty students. Concurrently, Sargent competed to study drawing at the state-run École des Beaux-Arts. In October 1874 he endured three weeks of exams in perspective, anatomy, ornament design, and life drawing at the École and won a place in the classes supervised by Adolphe Yvon. Sargent ranked ever higher in successive qualifying exams at the École. In the spring of 1877 he took second place among 179 competitors: the highest rank awarded to an American and to any of Carolus-Duran's students during that period. During his student years he took occasional classes in the atelier of Léon Bonnat, another portraitist, and every summer he pursued independent studies on sketching trips.

The choice of Carolus-Duran as a painting instructor was well considered. When the Sargent family made the rounds of Paris in 1874, they were looking for a talented individual who would not shirk the responsibility of teaching. At the end of the process Sargent wrote a friend that he had eliminated the government-sponsored ateliers of Jean-Léon Gérôme and Alexandre Cabanel because they seemed crowded and unruly.[3] He said that Gérôme's pictures disappointed him: "They are so smoothly painted with such softened edges, and such a downy appearance as to look as if they were printed on ivory or china." Carolus-Duran, on the other hand, practiced a technique of painterly painting that excited the young American: "[He] has a very broad, powerful, and realistic style." (Any method of painting directly onto the canvas with a loaded, broad brush may be termed *au premier coup* in French, *alla prima* in Italian, and painterly painting in English.) Sargent's letter characterized Carolus-Duran as "a young and rising artist whose reputation is continuously increasing. He is chiefly a portrait painter." Carolus-Duran visited his students twice a week in their communal studio, where he took time to criticize each person's work and make short demonstrations. Betraying a mixture of studiousness and superiority, Sargent judged his classmates to be "gentlemanly, nice fellows," with the exception of "two nasty little fat Frenchmen." Sargent thrived as a pupil of Carolus-Duran and soon outstripped his master. By the turn of the century he was the world's most renowned painter of society portraits.

Carolus-Duran's "very broad, powerful" application of paint, so admired in 1874 by Sargent, had a kinship with Baroque art and more recent expressive techniques favored by artists of the Romantic and Realist movements. Sargent's teacher had risen to fame in the late 1860s, benefiting from battles recently fought by the

2.4 HEAD OF AESOP, AFTER VELÁSQUEZ, 1879
Oil on canvas
18⁵⁄₁₆ × 14⅝ in.
Ackland Art Museum, University of North Carolina at Chapel Hill, Ackland Fund

leading Realists. Courbet and Manet in particular presented artistic challenges to the style and values of the academic establishment, upheld by Gérôme, Cabanel, and Bouguereau. Thus Sargent was gravitating to a left-of-center position in the Parisian art world, for he admired painters who resisted the "official" Salon-mediated obsession with smooth, glossy, painstakingly detailed finishes. Manet, for example, claimed the freedom to paint any subject from contemporary life in a manner that favored individuality over academic orthodoxy. In their enthusiasm to endorse a painterly pursuit of vivid effect, the Realist innovators kindled a revival of like-minded painters from sixteenth-century Venice and seventeenth-century Holland and Spain. They revered Velásquez.

Painted in 1879, at the beginning of Sargent's professional independence, *Head of Aesop, after Velásquez* (fig. 2.4) exemplifies the *alla prima* method he developed during his years as Carolus-Duran's pupil. The technical goal was to get the greatest visual effect from a minimum of painterly flourishes, so that the brushstrokes and splashes of pigment would blend into a strikingly realistic image when viewed from

across a room. Working on a canvas painted a neutral color, Sargent sometimes began by mapping in the vaguest coordinates of the form in thin paint or charcoal. Then, taking a brush generously loaded with a medium-toned flesh color, he laid down the main planes of the face. He now applied darker flesh tones to articulate the shaded contours and recesses of eyes, nose, and mouth. To finish the face, he touched in the lightest tones, dabbing on lively highlights and steering his firm brush so that it thickened certain edges. When painting Aesop's neck, Sargent thinly applied darker tones, making it recede into shadow. To mediate the lights and darks, and for the technique to be fully suggestive, it was advantageous in some passages to allow the neutral undertone to show. The illusion of a vividly three-dimensional head resulted from the accuracy of Sargent's tonal and textural shifts: some were subtle, and others, such as the transitions from neck to chin and from cheekbone to dark shadow, bestowed visual drama. From a distance, pictures painted in this manner are more lifelike than those treated to a more conventional academic finish.

The young British painter William Rothenstein, who befriended Sargent in the 1890s, made this useful description of his method:

> He drew with his brush, beginning with the shadows, and gradually evolving his figure from the background by means of large, loose volumes of shadow, half tones and light, regardless of features or refinements of form, finally bringing the masses of light and shade closer together, and thus assembling the figure. He painted with large brushes and a full palette, using oil and turpentine freely as a medium. When he repainted, he would smudge and efface the part he wished to reconstruct, and begin again from a shapeless mass. He never used what was underneath.[4]

Sargent's *Head of Aesop, after Velásquez* is a detail from a famous full-length painting (fig. 2.5) and one of ten copies he made at the Prado Museum, Madrid, in 1879 during a landmark journey to Spain and Morocco. Eight paintings were after Velásquez, one after Titian, and one after Rubens. This pilgrimage to the Prado's incomparable collection of works by Velásquez marked Sargent's professional coming of age. In keeping with his painterly approach, he did not make a stroke-for-stroke replica of the head: his broad, sketchlike summary of the original made the head taller and thinner and heightened the contrasts of light and dark. Although working through and reliving the main technical decisions that Velásquez made when he painted *Aesop*, Sargent subjected them to the questioning, contemporary mind-set of the French Realist movement. The poet Paul Valéry would later stress "promptness, freedom, and immediacy" as hallmarks of Manet's modern

2.5 Diego Rodriguez Velásquez
Spanish, 1599–1660
AESOP, C. 1639–1640
Oil on canvas
70½ × 37 in.
Museo del Prado, Madrid

48

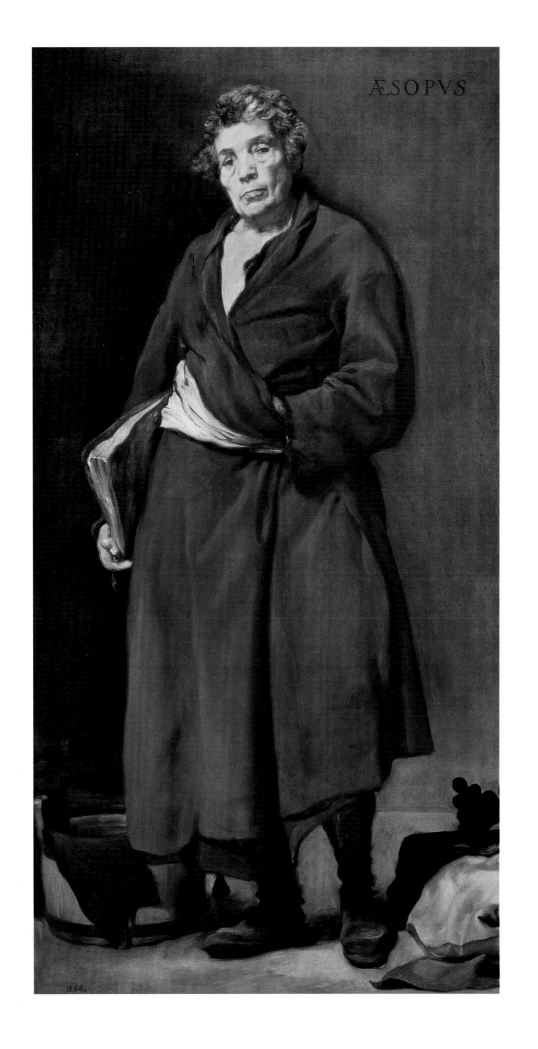

ÆSOPVS

254.

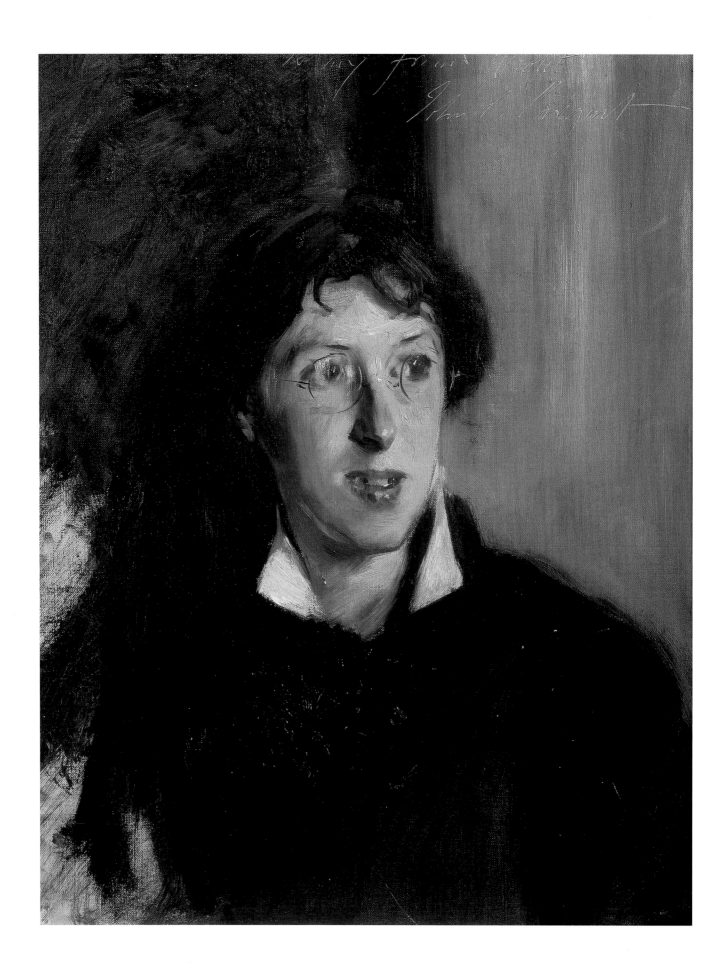

approach to portraiture. He explained that swift observation and rapid execution were crucial because modernity in the 1870s involved "acting on the impression before it fades."[5] Sargent applied this new simplifying spirit to the face from a historic portrait when he painted *Head of Aesop*. A year later, in 1880, he would make a pilgrimage to Haarlem to study and sketch portraits by Frans Hals, another god of the painterly painters.

Sargent adjusted his bravura technique to the needs of the work at hand, making the painterly flourishes more or less overt according to professional circumstances. While he doubtless felt obliged to give careful detailing to the faces of certain commissioned portraits, he enjoyed erring on the sketchier side on more casual occasions, as in his portrait of Vernon Lee (fig. 2.6). Vernon Lee was the professional name of Sargent's longtime friend Violet Paget, an English writer whose individualist nature stemmed in part from her lesbian identity. Lee apparently called Sargent her "twin," for he repeated the term back to her in a letter of 1880.[6] Sargent painted Lee in a single three-hour sitting, about a year and a half after he had copied the Velásquez head at the Prado. She immediately wrote her mother: "The sketch is, by everyone's admission, extraordinarily clever and characteristic; it is of course mere dabs and blurs and considerably caricatured, but certainly more like me than I expected anything could [be]."[7] It was indeed a most direct and modern portrayal, which, according to Sargent, "consternated many people" when he sent it to a group exhibition at a gallery in Paris late in 1882. One French critic who appreciated this sketch wrote: "[In his painting] of a woman looking askance through her spectacles . . . Sargent proves himself a first class impressionist; he expresses perfectly the look of a face viewed in passing . . . [with] lips and teeth that seem to be joining and moving apart at the same time. And, to save time, the background is only half filled in."[8]

SARGENT'S EARLY EXPLORATIONS OF THE SENSUAL

From the beginning of his career Sargent maintained a balance between portraits he painted on commission and genre pictures he produced independently. Portraiture was his chosen source of income, but he wanted the public to know that he created other types of work. With the word "Tangier" inscribed in red after Sargent's signature, *Fumée d'Ambre Gris* (fig. 2.7) was his first large, overtly sensual independent picture. It proved to be a strategic success at the Salon of 1880, both as a technical tour de force and as a demonstration of his ability to transform a striking woman into a painted dream. This picture also announced Sargent's desire to test the market for Orientalist art, a type of picture that exoticized North Africa and the Near East in ways that allowed Christian culture to satisfy its escapist

2.6 VERNON LEE, 1881
Oil on canvas
21⅛ × 17 in.
The Tate Gallery, London,
bequeathed by Miss Vernon Lee
through Miss Cooper Willis

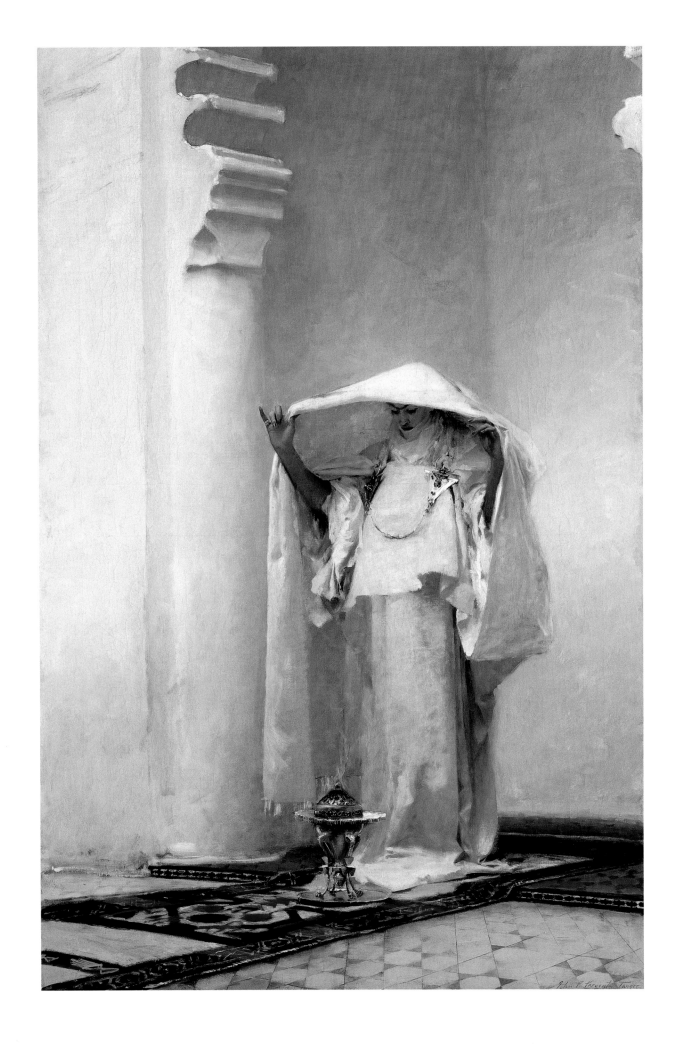

2.8 SKETCH OF A BUILDING
WITH ENTRANCE OF THREE
OGIVAL ARCHES, TANGIER,
1879–80
Pencil on paper
9¹³⁄₁₆ × 13½ in.
Fogg Art Museum, Harvard University Art Museums, Cambridge,
Massachusetts, gift of Mrs. Francis
Ormond

fantasies and repressed urges for passion. Orientalist art and literature began to flourish early in the nineteenth century after the European expansionist forces of colonialism, commerce, and tourism brought direct contact with Islamic cultures. The inability of Western observers to separate Eastern realities and fantasies at this time is evident in a remark made by the American writer Mark Twain during travels in the Holy Land: "The pictures [Orientalist paintings] used to seem exaggerations—they seemed too weird and fanciful for reality. But behold, they were not wild enough. . . . Tangier is a foreign land if ever there was one, and the true spirit of it can never be found in any book save *The Arabian Nights*."[9]

Sargent conceived *Fumée d'Ambre Gris* during a two-month visit to Morocco in 1879–80, immediately following his tour of Spain. The sketches he made on location prior to producing the Salon picture in his Paris studio illuminate his way of researching such genre pictures. One drawing records the architectural features of a courtyard (fig. 2.8), probably near the house he had rented in Tetuán. It conveys the contrast between the large plain masses of the buildings and the complex decoration of key constituent parts, including arches and capitals. (One of the arches in this courtyard may be the one depicted at the top of *Fumée d'Ambre Gris*.) Sargent's architectural drawing also reveals his fascination with the dark mysterious interiors that lie beyond this radiant outdoor setting. In another drawing (fig. 2.9) he gives specific information about a model's body, namely the refined manner in which she stretches her headdress between the tips of her extended fingers and

2.7 FUMÉE D'AMBRE GRIS, 1880
Oil on canvas
54¾ × 35¹¹⁄₁₆ in.
Sterling and Francine Clark Art
Institute, Williamstown, Massachusetts

thumbs. Throughout his life Sargent was intrigued by the gestures of hands, fingers, and wrists, and he relished the technical demands of depicting their profiles, shadows, and foreshortened forms.

Fumée d'Ambre Gris depicts an anonymous, but presumably wealthy woman perfuming her clothes. For her this was probably an ordinary act, but Sargent saw great theater in it. Adorned in white, cream, and orange fabrics, covered with makeup, and encrusted with silver jewelry, she pulls her headdress into a canopy to capture the smoky gray fumes of ambergris that waft up from an ornate censer. The charming, dusky, stately Mohammedan (Henry James's words for her in 1887) stands on a tiled and carpeted floor in front of bright white walls. In showstopping mode, Sargent switched effortlessly between impeccably precise passages (the ruled lines of the tiled floor and the detailing of the jewelry) and others that are loosely sketched (the walls and much of the costume). Although he chose a subject related to the Orientalist art produced by Gérôme and others at the time, Sargent used an eclectic style that was a modern departure from their "academic" standards of finish.

Reveling in exotic trimmings, sensual associations, and the allure of a self-possessed woman in a bright white world, *Fumée d'Ambre Gris* distills mood. Sargent wrote Vernon Lee that "the only interest of the thing was the color," implying that he undertook the painting solely for the formal challenge of rendering countless whites, creams, and pale grays.[10] He did relish the picture's unusual coloristic challenge, for his experiments also encompassed a watercolor version (fig. 2.10). It is much smaller than the Salon picture and inevitably makes a more summary treatment of the exotic detailing. Sargent adjusted his white-on-white goals to the medium at hand: transparent washes of watercolor over white paper. His handling of the radiant aura of light reflecting back and forth between the pale figure and bright setting achieved a luminosity that was not possible with opaque oil pigments.

Sargent often drew attention to strange, weird, and fantastic things. Vernon Lee laid an emphasis on his early passion for anything "enormously picturesque and still unspoiled." He had, she believed, an "instinct for the esoteric," and she noted that the adjective "curious" was Sargent's "dominant word for many years." In keeping with this particular approach to music and literature, the individuals who most appealed to him, she recalled, possessed an "exotic, far-fetched quality."[11] The allusive aspects of *Fumée d'Ambre Gris* cause viewers to speculate about the woman, to imagine the perfume's fragrance and supposedly aphrodisiac powers, and to dream of inhabiting the hot, dazzling, fantastic setting. Although Sargent captured a place and a way of living that were different from bourgeois Christian life

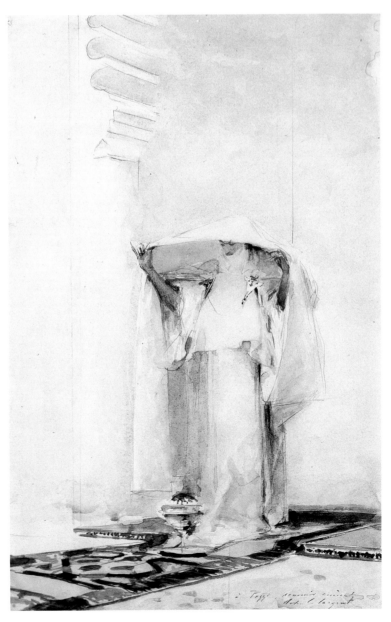

in modern France, the picture's sensualism piqued the desires of fashionable Parisians and echoed the dreamlike, antirationalist yearnings of the emergent Symbolist movement in literature and the visual arts.

Although Paris—the artist's backyard—was not "exotic," Sargent found a few situations to fire his sense of pictorial and emotional intrigue. One notable example came from the rehearsals of the orchestra led by Jules Étienne Pasdeloup (fig. 2.11). A passion for modern music made Sargent a fan of this conductor, whose concerts often included works by Wagner. His unusual view of Pasdeloup's orchestra could be glimpsed only during their rehearsals in the auditorium of the Winter Circus (Cirque d'Hiver), where they occupied the seats normally taken by the circus audience. Effortlessly condensing an exciting architectural space, people, sheet music, and musical instruments, Sargent's design makes one want to hear the grand symphonic noise of Wagner's music. The nearly monochromatic palette of blacks, grays, browns, and whites underscores the graphic inventiveness of the composition: the dark silhouettes of string and woodwind instruments, the silvery outlines of the brasses, and the alert postures of the musicians generate a wonderful visual energy. These various details take turns pulling the eye around the great curve of the steeply banked seats. In another painting of this scene Sargent added a group of costumed clowns in the lower right foreground, underscoring the oddness of the rehearsal venue.[12]

Venice was the environment where Sargent's senses most often found their reward. He first used it as a subject in the early 1880s and returned there on numerous occasions before World War I. Two visits between 1880 and 1882 inspired pictures dominated by local working-class women on the street or in the halls of a rundown palazzo. *A Street in Venice* (fig. 2.12) typifies the generally moody, ambiguous character of that first major series. Sargent was still assimilating his recent visit to the Prado, where he had copied Velásquez's somber-toned paintings of courtiers, dwarves, and weavers. Venice inspired him to blend his love for the painterliness of Velásquez with his Realist desire to explore slightly edgy back-street imagery. He ignored the grandest architectural splendors that attracted genteel tourists and put aside the stylistically narrow prescriptions of the pre-Raphaelite crusader John Ruskin: the young Sargent sought out the sensualism that was the root of Venetian style and imagination.

The sharply receding planes of two walls and a pavement dominate the composition of *A Street in Venice*. It resonates with the exhilarating contrasts that Venice unleashes on the senses: confined alleys and open spaces; strong light and gray shadow; worn old buildings and stylish citizens. Though true to Venice, the boldness of the pictorial space has broader affinities with the Impressionist art that had

2.11 REHEARSAL OF THE PASDELOUP ORCHESTRA AT THE CIRQUE D'HIVER, c. 1879–80
Oil on canvas
22½ × 18⅛ in.
Museum of Fine Arts, Boston, The Hayden Collection

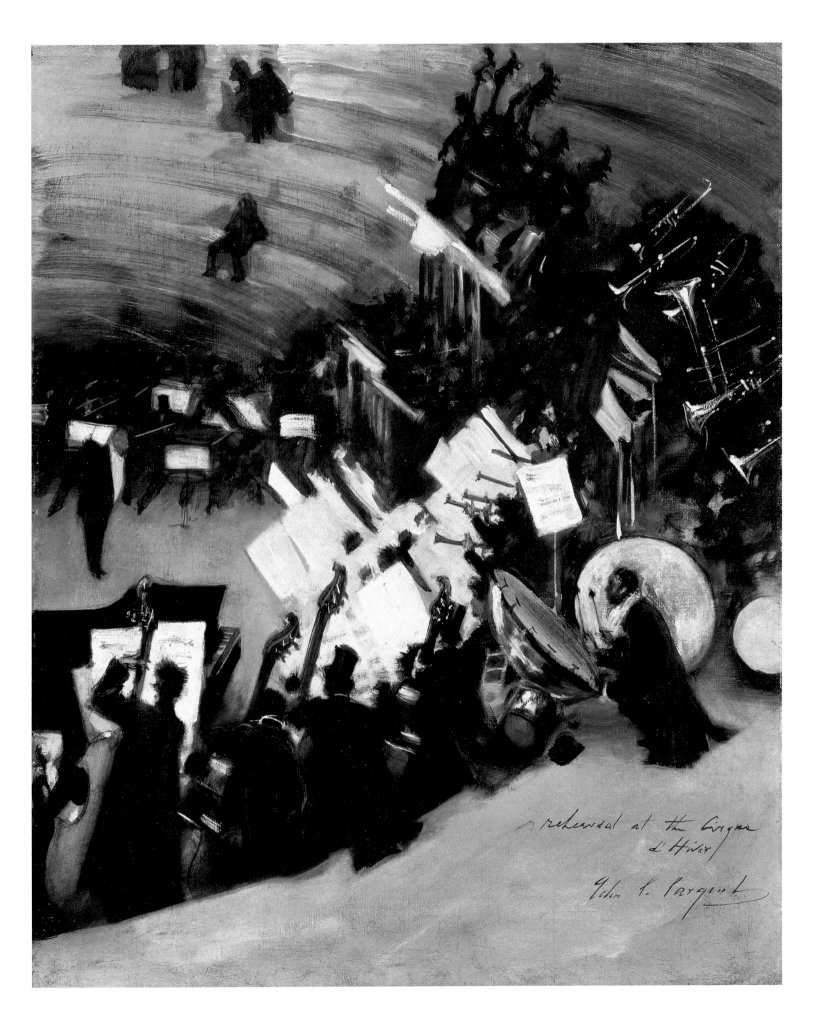

rehearsal at the Cirque
d'Hiver

John S. Sargent

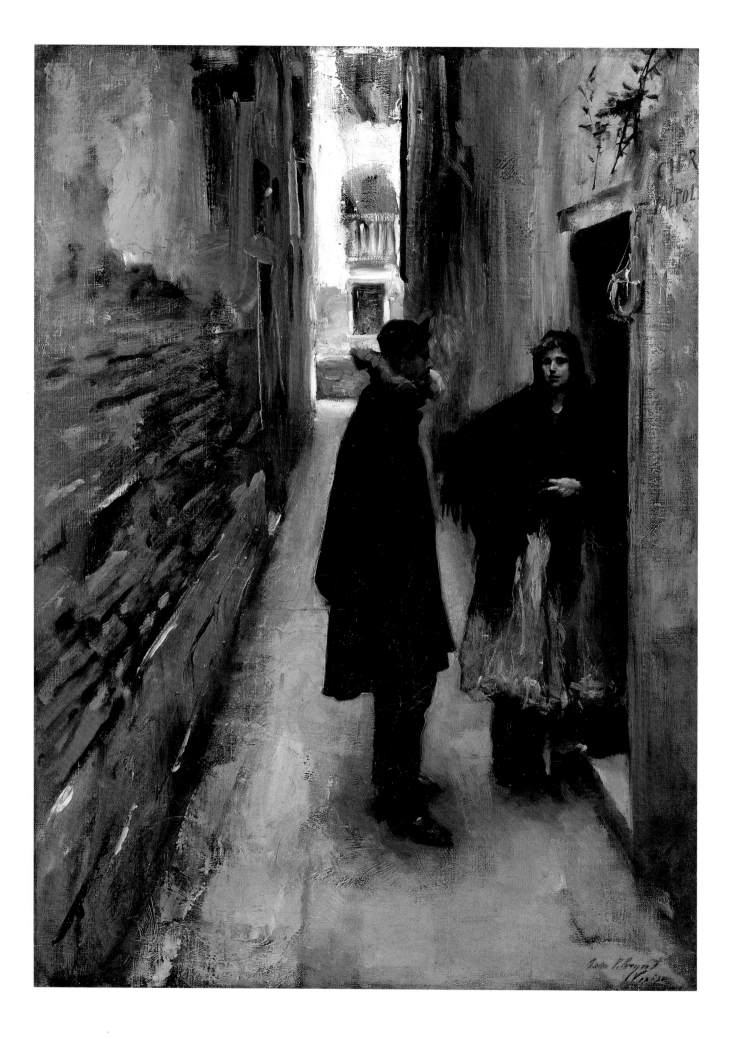

begun to interest Sargent; unconventionally cropped, snapshotlike points of view often characterized the pictures of Caillebotte, Cassatt, Degas, and Renoir. On the left side of his canvas Sargent made quick long strokes of reddish pink to suggest the lines of bricks exposed by the crumbling of its weathered stucco finish. At the top of the picture, where he depicted a blast of sunlight at the end of the shaded alley, he used a palette knife to work the thick bright paint. After rendering this visually active space, Sargent added two figures standing in conversation. They strike strong silhouettes thanks to his black cape and her black shawl. In addition, each person wears an item that Sargent clearly enjoyed painting: the man's fur collar and the woman's glinting, colorful skirt. The woman, from her clothes clearly a local person, turns to the dark interior of a tavern doorway, as if a flirtation is developing. The scenario is cryptically seductive, and the painterly treatment of the details is its own vehicle of sensual expression.

Sargent's ability to translate appealing or curious things into engaging paint surfaces reflected his delight in experiencing the world. He continued to use his painterly technique to enliven his responses to evocative settings throughout his career. Thirty years after painting *A Street in Venice,* he explored the same pictorial issues from a more seasoned perspective. *Women at Work,* a late outdoor picture probably painted during a holiday in Spain, tackles a complicated and subtle set of spatial and lighting effects (fig. 2.13). The sunlit, lushly fruited grapevine at the top of the canvas caps the composition like a proscenium arch. Although we cannot see its extent, it clearly spreads like a roof over much of the space. The vine shades the bower where three generations congregate—a child at play, women doing laundry, and old people husking orange-yellow ears of corn. The eye needs time to grasp these exciting conditions of light. A darkly shadowed doorway glimpsed at the upper right is set off by the bluish outdoor shade; another strong contrast comes from the brilliant light penetrating the vines at the edges of the courtyard. Forceful white diagonals and luminous shadows dance across the walls at the left. Sargent observed and rendered these people and this place in a manner that feeds our imagination as we contemplate the scene. Think, for example, of the different tactile experiences each person in this picture is having; imagine the intensity of the sunlight and the relief of the shade. By appealing so richly to the senses, his best pictures touch the thirst for life.

2.12 A STREET IN VENICE,
c. 1880–82
Oil on canvas
29⁹/₁₆ × 20⅝ in.
Sterling and Francine Clark Art Institute, Williamstown, Massachusetts

EARLY APPRECIATIONS OF SARGENT'S STYLE

Prior to the mid-1890s many mainstream critics in France, Great Britain, and the United States found Sargent's art unconventional and forced. Given an initial predominance of suspicious or pointed assessments of his prodigious talents, it is useful

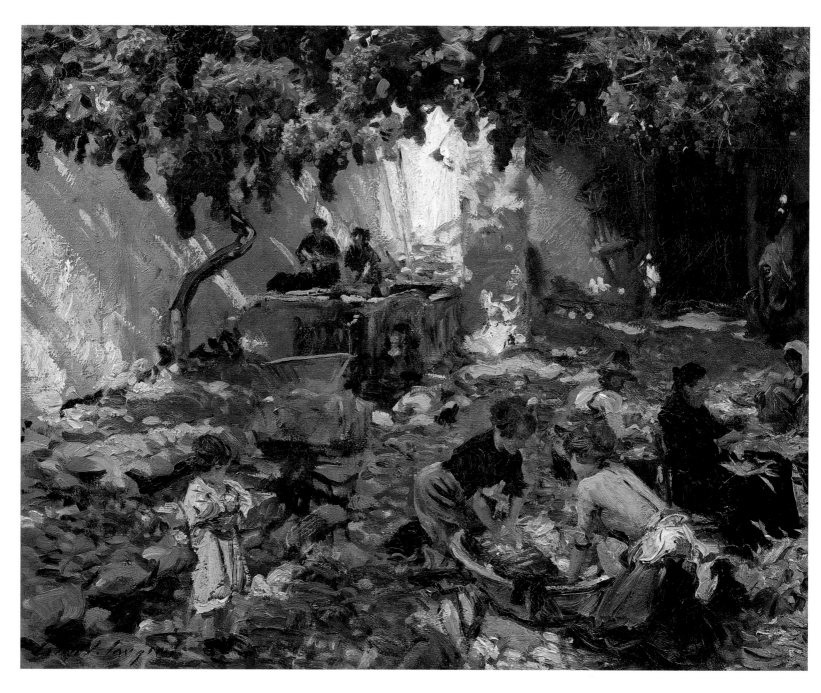

2.13 WOMEN AT WORK, C. 1910
Oil on canvas
22 × 28 in.
Private collection

to see how his close acquaintances viewed his bold painting technique. What follows is a summary of responses from four individuals—a painter, a painter-writer, a writer, and a collector—who knew Sargent's work well during his early rise to success. This spectrum of opinion, from diary entries and published commentaries to a buyer's choices, demonstrates the degree of enthusiasm Sargent inspired in his admirers.

Carroll Beckwith was an American artist who enrolled in Carolus-Duran's atelier in 1873. He shared a studio with Sargent in Paris in the mid-1870s. After returning to New York in 1878 he worked as an art school teacher and commercial illustrator to supplement the modest income he made as a painter. Sargent never experienced that kind of struggle because his talents allowed him to live solely by his brush. Beckwith turned to his diary on several occasions to express amazement at his friend's abilities:

> His work is so stunning it makes me blue. (1890)

> I can imagine no one so brilliantly and justly endowed as Sargent. . . . Nothing can be more glorious than his stupendous talent. . . . I have deeply envied him his splendid powers. . . . I wonder if any painter ever stood so far above his contemporaries. (1895)

> [Sargent's *John D. Rockefeller*] makes my own work look tentative and hesitating. This ease with which he paints. (1917)[13]

R. A. M. Stevenson (a first cousin of the Scottish writer Robert Louis Stevenson) studied painting with Carolus-Duran in the mid-1870s. He could not make a living as an artist and turned to criticism for an income. In an essay published in 1888, he wrote the most thorough early analysis of Sargent's talents, allowing his own experiences as a painter to flavor his appreciation of the technical rigor of Sargent's art:

> Mr. Sargent's painting is strict painting, as Bach's fugues are strict music. . . . The beauty of light playing on the varied surfaces of things, that is his matter. Form must be expressed as light expresses it, or veiled as light veils it, and color must be gradated and harmonized on no other system than the natural method of light. . . . Not merely a machine-like accuracy of eye, and a docile, nimble hand, but also a fine taste in form, color, and ornamentation, are necessary for an artist who would emulate the beautiful craftsmanship of [Mr. Sargent's portraits].[14]

Stevenson explained that Sargent's "eloquent" handling of paint was never merely "humbug" or cleverness:

In this art of brushwork Mr. Sargent is a master both by natural taste and by intelligent study of great models. With his supple lively touch, now forcible, now delicate, now, as it were, *legato,* and now *staccato,* he can so caress the surfaces of changing planes, so swamp and reveal the contours of objects, and so subtly gradate passages of light, that he can give, besides a mere account of shapes, a commentary of his own about their sentiment or character. By the way in which they are touched in, the expression of objects can be emphasized or transformed so as to give them dignity, soft beauty, nervous grace, solid majesty—in fact, so as to give them a character suitable to the *ensemble* of which they are to form a part.

As Stevenson acknowledges, there is magic in Sargent's ability to "touch in" and "caress" a given passage, revealing both the object and the artist's characterization of it. Sargent's tactile and showy manipulation of pigment is a threshold between the pleasures of looking and touching, and this painterliness is one facet of his sensual nature.

Sargent's painterly sensibility informed his drawings as well as his paintings. In a quick pencil sketch of a baby (fig. 2.14) he uses light hatching and shading to suggest the soft pudginess of the face. This treatment differs considerably from the dancing quickness of the lines that summarize the elaborate bonnet and dress. Similarly, the darkness of the infant's large eyes is rendered quite differently from the dark area in the upper right, which is probably the front of his mother's dress. Produced during one of Sargent's English summer holidays devoted to Impressionist experimentation, this drawing demonstrates the way in which his manner of observation engages and directs the viewer to interact imaginatively with the image.

In an essay of 1887 Henry James appraised the broader implications of Sargent's technique in the first major American publication on him.[15] He claimed that his friend's art reached its highest level when he applied a "certain faculty of lingering reflection" to the persons and things he depicted. According to James, "[Sargent] sees deep into his subject, undergoes it, absorbs it, discovers in it new things that were not on the surface, becomes patient with it, and almost reverent, and, in short, elevates and humanizes the technical problem."

The extent of James's admiration for Sargent's method is further shown in his private notebooks. When contemplating, in 1894, a short story for a magazine, James made a notebook entry:

> The formula for the presentation . . . is to make it an *Impression*—as one of Sargent's pictures is an impression. That is, I must do it from my own point of view—that of an imagined observer, participator, chronicler.

I must picture it, summarize it, impressionize it, in a word—compress
and confine it by making it the picture of what I see. . . .
[I] should have found it impossible to content myself with any literal
record—anything merely narrative, with the detail of narrative. . . . The
subject remains the same, but the great hinge must be more salient
perhaps, and the whole thing simplified. A strong subject, a rich sub-
ject *summarized*—that is my indispensable formula and memento.[16]

James's 1887 essay on Sargent had already hinted of this idea: "Mr. Sargent
simplifies, I think, but he simplifies with style, and his impression in most cases
is magnificent."

In 1897 James returned to describing Sargent's unique qualities when review-
ing two group exhibitions in London. He claimed that the painter had at his dis-
posal "a knock-down insolence of talent." In their "truth of characterization," his
best portraits make "a wonderful rendering of life, of manners, of aspects, of types,

2.15 ISABELLA STEWART
GARDNER, 1888
Oil on canvas
74¾ × 32 in.
Isabella Stewart Gardner Museum,
Boston

of textures, of everything." In conclusion, James observed: "It is the old story; he expresses himself as no one else scarce begins to do in the language of the art he practices. . . . Beside him . . . his competitors appear to stammer."[17]

Mrs. John Lowell Gardner of Boston, nicknamed Mrs. Jack and now remembered as Isabella Stewart Gardner, expressed her admiration of Sargent by collecting his work for more than thirty years. In 1887, when others were still daunted by the Parisian fuss over *Madame X,* this lively transplanted New Yorker commissioned her own full-length portrait (fig. 2.15) in hopes of rivaling Sargent's notorious French work. The artist and his forty-seven-year-old sitter conspired to concoct a sensation. The symmetrical composition and decorative background evoke an enshrined deity; the rather severe, tight, décolleté Parisian gown silhouettes her figure and sets off her rubies and pearls; and the unusual pose helps transform a rather plain woman into a complicated, glamorous, and iconic presence. The picture challenges viewers with its ambiguous double characterization of dominating femme fatale and gracious queen of cultural life. It proved to be the most modern and quirky portrait painted in Boston in the nineteenth century. After its local debut in 1888 inspired jokes and disparaging comments, Mr. Gardner kept it from public view.[18]

Mrs. Gardner assembled a collection of about fifty Sargents, intending it to constitute a landmark in his and her legacy when, after her death, her house became a museum. Sargent was fortunate to know that his art would live on in the company of outstanding works by Raphael, Titian, Rembrandt, Vermeer, and Rubens, as well as modern pictures by Manet, Whistler, and Degas. All were displayed in elegant and refined settings featuring early furniture, textiles, and architectural fragments. In 1896 she purchased Sargent's *Astarte,* a beautiful painting of his recently completed vaulted ceiling at the Boston Public Library (fig. 6.3). Mrs. Gardner had long wanted to own his early Salon success *El Jaleo* (fig. 4.3), and, after finally acquiring it in 1914, she built a special room for it, now known as the Spanish Cloister. In 1916, eager to buy a representative work when Sargent returned from the Canadian Rockies, she obtained the oil painting *Yoho Falls,* as well as a watercolor (fig. 5.13). When Sargent's Parisian patron Dr. Samuel Pozzi died in 1919, she purchased a watercolor and a painting from the sale of his collection (figs. 2.10, 3.7).

Sargent showed his gratitude in many ways. Moved by her special installation of *El Jaleo,* he pasted twenty-one Spanish drawings into an album and gave it to her in 1919 (see fig. 4.4). He painted a touching watercolor portrait of her in 1922, depicting a feeble but still exceptional woman of eighty-two swathed in white. In their respective careers both were mavericks with a penchant for unconventional gestures. Hers were played out, sometimes outrageously, in a large social arena, while his passions were publicly expressed on canvas and paper.[19]

Chapter 3

PORTRAITS WITH A FLAIR FOR THEATER

In the double portrait of Ena and Betty Wertheimer, the girls are shown wearing evening dresses whose décolletage has the frank sexuality that puts us in mind of the scandalous gown worn by Sargent's notorious sitter Madame X. Betty opens out her fan in a gesture that could be read as forward, while Ena is shown fingering the knob of a Chinese porcelain vase. With their arms circling each other's waists, their faces animated, laughing, they appear at once sensual and vulgar. They seem not to know the rules of decorum that demure English débutantes would automatically adopt.

— British art critic Richard Dorment (*Daily Telegraph,* January 15, 2000)

Sargent's decision to take up portraiture as a profession gained him independence and eased pressures on his parents' modest private income. What might have been a monotonous vocation was, in his hands, a lucrative, occasionally controversial public career. An odd combination of urges shaped his portrait making: a New England Protestant belief in work, improvement, and accomplishment; an eagerness to be part of exciting modern developments; and a passion for the "curious" and theatrical. Rather than settle for a conventionally prosaic approach, it was Sargent's instinct to be different. In his best portraits he allowed his own sense of ostentation, hyper-refinement, or edginess to direct the staging of the subject. People began to realize in the 1890s that a "ravishing portrait" from his hand had the power to make someone into "a society celebrity."[1]

The French social elite first warmed to Sargent's talent after his portrait of Carolus-Duran (fig. 1.2) won an honorable mention at the Salon of 1879. A few months later, an engraving of that elegant and flattering picture filled the cover of the upmarket periodical *L'Illustration.*[2] His early successes in Paris did little to help Sargent immediately among critics in Great Britain or the United States. In 1886 it was argued in the London *Times* that Sargent's pictures did not deserve the

Detail of ENA AND BETTY,
DAUGHTERS OF ASHER AND
MRS. WERTHEIMER, 1901
(fig. 3.17)

prominent places they occupied at a recent Royal Academy exhibition. An editorial declared: "[He is a] young man who is not even an Englishman, who flies in the face of all the time-honored traditions of the Academy, and who paints portraits which many people think frankly hideous."[3] Two years later, following a solo exhibition in Boston, a local critic summarized: "[Boston propriety] is still undecided, I think, whether it was insulted or delighted. . . . The first impression of many a well-bred Boston lady was that she had fallen into the brilliant but doubtful society one becomes familiar with in Paris or Rome. . . . The spirit and style of the painter were so audacious, reckless, and unconventional! He actually presented people in attitudes and costumes that were never seen in serious, costly portraits before, and the painting was done in an irreverently rapid, off-hand, dashing manner of clever brush-work."[4]

Sargent's basic attraction to portraiture can be examined in two early depictions of individuals whom the artist hired as models. His response to the captivating young people portrayed in *Carmela Bertagna* and *Man Wearing Laurels* (figs. 3.1, 3.2) helps to explain the unconventionality of some of his commissioned portraits. The subject of *Carmela Bertagna* was characterized recently as a sensual creature: "[She] gazes out with an almost predatory intensity. The directness of her look is both explicit and unnerving."[5] This is also true of the unidentified male with laurel wreath, whose naked chest and shadowed face reinforce a gaze that is as "explicit" as Carmela's. Rather than give his models the ingratiating smiles common in conventional depictions of "picturesque" folk, Sargent portrayed the look of detachment they assumed while posing. Although they may have been bored, or perhaps were countering his voyeuristic gaze, Sargent interpreted their expressions as sultry self-confidence. He took his enjoyment from translating his perception of an attractive individual into an expressive, painterly image. He became the conduit between an alluring personality and a pictorial record with its own sensual nature.

Sargent indulged his appreciation of textiles when he created *Carmela Bertagna,* allowing vibrant colors and different surfaces to enliven the picture. He delighted in arranging and depicting his sitter's white, orange-brown, and pink clothes, her deep red hair ribbon, and the bluish-white cloth backdrop. Each fabric was a foil for the subject's splendid golden brown tresses. (Over the years Sargent assembled a large personal collection of textiles; he liked to seek them out on his travels, and used them as souvenirs and decorations in his home and as props in his art.) *Man Wearing Laurels* is comparatively stark but no less dramatic: its sole adornment is a laurel wreath, a classical attribute for a man in perfect physical prime. Other than the name and Paris address that Sargent inscribed on the female portrait, we know nothing further about either model. The early ownership of *Carmela*

3.1 CARMELA BERTAGNA, C. 1880
Oil on canvas
23½ × 19½ in.
Columbus Museum of Art, Ohio, bequest of Frederick W. Schumacher

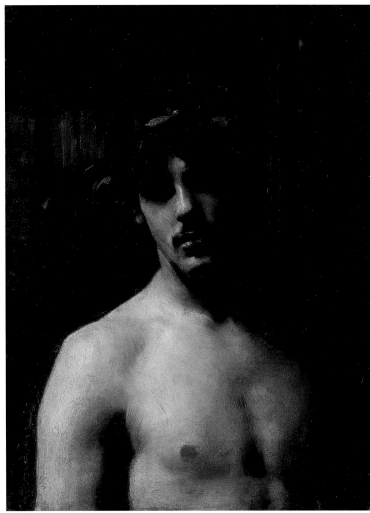

3.2 MAN WEARING LAURELS, C. 1874–80
Oil on canvas
17½ × 13³⁄₁₆ in.
Los Angeles County Museum of Art, Mary D. Keeler Bequest

3.3 MADAME EDOUARD
PAILLERON, 1879

Oil on canvas
82 × 39½ in.
Corcoran Gallery of Art, Washington, D.C., museum purchase and gifts of Katherine McCook Knox, John A. Nevius, and Mr. and Mrs. Lansdell K. Christie

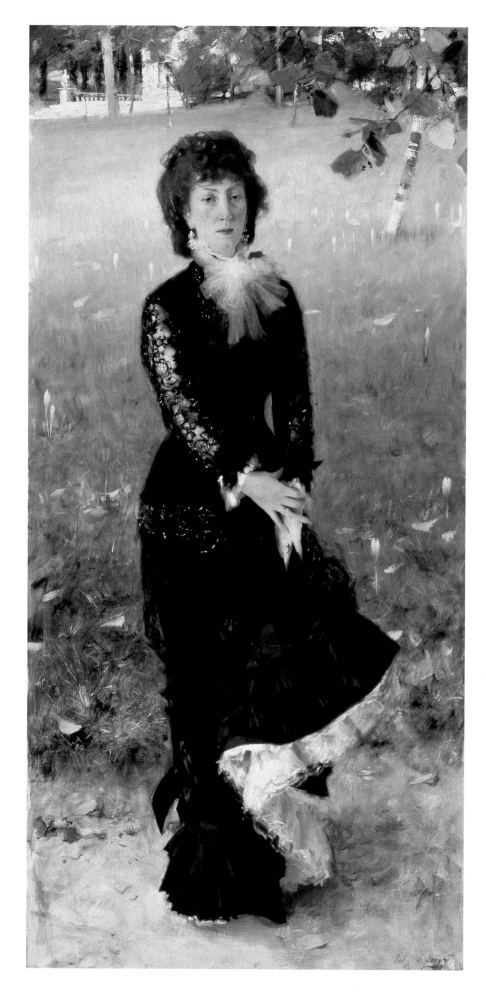

Bertagna is not documented, but *Man Wearing Laurels* remained in Sargent's personal collection all his life. He seems not to have included either canvas in exhibitions, but he retained this kind of informal portrait for himself and displayed some of them at his workplace along with his copies of Old Master paintings. Such pictures were part of his personal landscape and a source of pleasure for the artist to share with his visitors.

Sargent's love of painterly expression sometimes conflicted with the professional need to satisfy a client's desire for a "good" likeness; one unhappy client of 1885 claimed that his portrait made her look like a murderer.[6] A few documents point to the unusual visual effects that stimulated his interest. During a visit to the English countryside in 1885, Sargent eagerly sketched the effect of August noontime sun on Edmund Gosse's light brown hair: "[Sargent] gave a convulsive plunge in the air with his brush, and said 'Oh! what lovely lilac hair, no one ever saw such beautiful lilac hair!'"[7] After he saw Ellen Terry in a highly touted production of *Macbeth,* Sargent was desperate to paint her magnificent stage persona. He wrote a friend in 1889: "From a pictorial point of view there can be no doubt about it— magenta hair!"[8] In 1914 he expressed his fascination with the subtle coloration of the skin of his Jewish friend the countess of Rocksavage (née Sybil Sassoon): "Sybil is *lovely:* some days she is *positively green!*"[9]

Sargent's ambition to paint the Parisian social elite in a modern manner is exemplified by *Madame Edouard Pailleron* and *Dr. Samuel Jean Pozzi at Home* (figs. 3.3, 3.4). The character of his gifts is apparent when these grand pictures are compared to *Carmela Bertagna* and *Man Wearing Laurels.* There are two main differences: the commissioned full-lengths have slightly more finish and more detailing in the background settings, and they entered the homes of society figures who made them available for exhibitions. But all four pictures are equivalent as expressions of Sargent's sensual temperament. Madame Pailleron, the daughter of a prominent literary editor and the wife of a poet and playwright, participated in a clever, cultivated, and very social family. Sargent, just twenty-three at the time, painted her when he was a late-summer guest at the Paillerons' country home in the south of France, in 1879. He depicted his thirty-nine-year-old patron on the grounds of the estate, fitting the landscape into the vertical format of a full-length standing portrait. Sargent allowed the timeless, somewhat wistful qualities of the verdant background to fight with the woman's fashionable persona: the blaze of her red hair and the sparkle of her black and white afternoon dress. If he hoped to puzzle viewers with this willful incongruity, his wish was granted.

In contrast to Madame Pailleron, who projects chic for Sargent with a stoic patience, Samuel Pozzi apparently loved posing. In his portrait of 1881 he looks

away from the viewer, confident that all gazing upon him will admire what they see. The thirty-five-year-old beauty was a favorite physician of privileged Parisians and a specialist in gynecology. Recently married, and newly ensconced in a home on the elegant Place Vendôme, the doctor revealed an exhibitionist streak when posing for Sargent. The literature routinely suggests that he had numerous female lovers, and while the documentary evidence for this is slight, the visual evidence of Sargent's sensual portrayal sustains this belief. The treatment would seem more appropriate for a glamorous celebrity of the performing arts, and it remains a mystery how Sargent got an eminent doctor to be so intimate in a portrait destined for public exhibition.[10] This vision of a gorgeous man dressed to match a sumptuous red interior could not be more theatrical. The palette triggers associations of blood, passion, luxury, and devilishness, while the dressing gown echoes the scarlet robes worn by cardinals. Perhaps Sargent was having fun updating the standing robed figure in Velásquez's *Aesop* (fig. 2.5)—turning grizzled age to flaming youth, and monkish sobriety to worldly passion. The courtliness and nonchalance of the attenuated figure is especially reminiscent of the portraits of Van Dyck (as Henry James was quick to point out in his essay of 1887). Although the idealized refinement of the hands emulates Baroque pictorial conventions, Sargent's pictorial allusions may have been influenced by the man's medical specialization and his allegedly winning bedside manner.

Madame Edouard Pailleron and *Dr. Samuel Jean Pozzi at Home* stirred lively comment when exhibited around Europe in the early 1880s. Sargent had learned how to command attention with such splendid pictures, although people who were blind to the values of his experimentation showed little sympathy. Remarks by two contemporary art critics were as queer as the portraits themselves. Lucy H. Hooper observed in an American magazine: "It is to . . . be regretted that Mr. John Sargent should have exhibited this year a work so unworthy of his growing reputation as . . . [*Madame Pailleron*]—a red-haired, red-faced damsel in black, standing in the midst of a field that shows like a Brobdingnagian dish of green peas."[11] In a Belgian publication Émile Verhaeren wrote: "[Sargent's *Dr. Pozzi*] lacks solidity and foundation; it sets out to surprise and shock; it is theatrical and assumes a pose; in the end it tires one out; it contains, like a champagne glass filled too quickly, more foam than golden wine."[12]

MADAME X: A PROFESSIONAL WATERSHED

Sargent's experimentation with portraiture reached a climax with his portrait of Madame Pierre Gautreau (née Virginie Avegno), now popularly called *Madame X* (fig. 3.5). The picture caused a sensation at the Salon in 1884, the year its subject

3.4 DR. SAMUEL JEAN POZZI AT HOME, 1881
Oil on canvas
80½ × 43⅞ in.
Armand Hammer Museum of Art and Cultural Center, Los Angeles, The Armand Hammer Collection

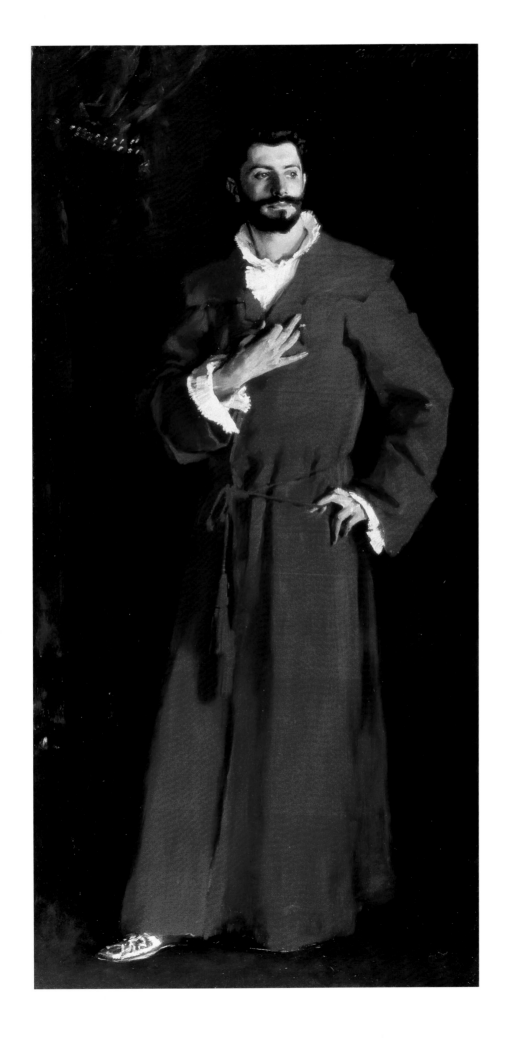

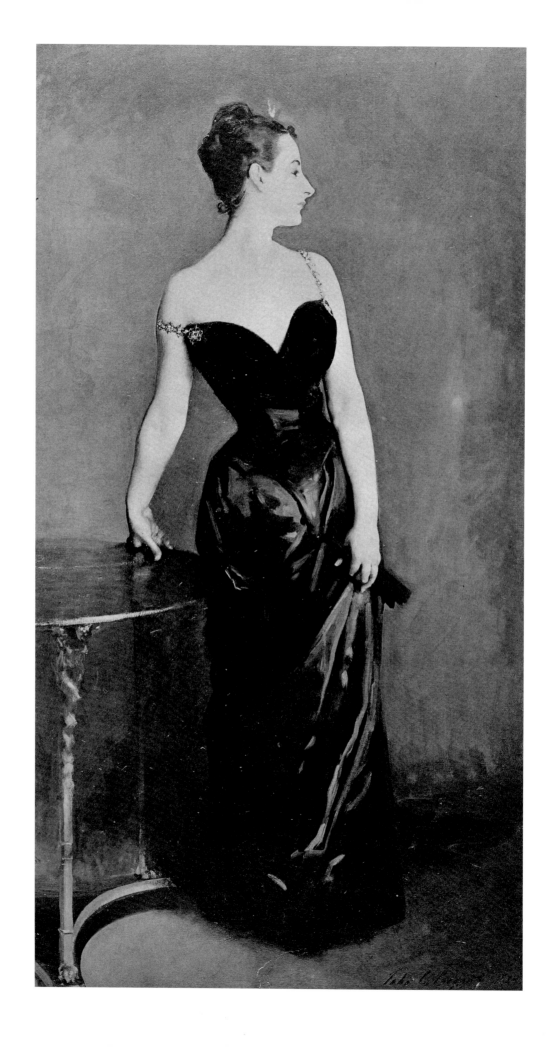

turned twenty-five. Vernon Lee observed "shoals of astonished and jibing women" crowding around it, turning both Sargent and Gautreau into sources of amusement.[13] The Salon included numerous paintings of female nudes that year, and several were lascivious in tone. Yet they caused no scandals because they depicted mythical figures (a bacchante, for example) or were allegories for such subjects as the dawn. Sargent, however, had shone an insinuating light on a member of Parisian society.

Madame Gautreau, the Louisiana-born wife of a Parisian businessman, was justly famous for her exquisite profile and the shapely perfection of her arms, shoulders, and bust. Sargent had observed her at social gatherings wearing a black gown, engineered to reveal much pale-powdered flesh, and crowned with the crescent of Diana, goddess of the hunt. Bewitched by this "curious" social creature, he planned a Realist homage to a celebrity with a unique sense of ostentation. But Sargent failed to consider that other Parisians might not relish such a hard look at the woman and her eccentric theatricality. When the portrait went on view, people laughed at the corpselike effect of Madame Gautreau's makeup and the absurdity of a dress that scarcely covered her breasts. Only the patrician critic Louis de Fourcaud wrote a long, thoughtful, and confidently positive review. He applauded the painting as a finely conceived and executed condemnation of the flashy *parvenus* who were beginning to control French cultural life.[14]

The most damning detail of *Madame X* was the fallen shoulder strap that pressed into her flesh. The extreme torque of her arrogant pose held this diamond-studded band in horizontal tautness. Sargent was too young to appreciate it, but the public's vituperative response echoed the reception of Manet's *Olympia* at the Salon of 1865. When the mockery failed to abate, he tried to remove the painting from the exhibition temporarily so that he could paint the strap in the "proper" upright position. The authorities denied his request, supposedly as a cautionary lesson about the dangers of artistic recklessness.[15] Sargent made the change as soon as the exhibition closed, but he had alienated the sitter, and the picture remained in his possession. The Gautreau family, who had not commissioned the portrait, felt intellectually offended and socially humiliated.

Sargent was probably plotting to paint Madame Gautreau as early as 1881. He found her just as spectacular and outlandish as the subject of his Moroccan picture of 1880, *Fumée d'Ambre Gris* (fig. 2.7). Indeed, the two pictures share several features: bizarrely clad, heavily made-up women; striking, unconventional postures; stark, monochromatic compositions; and theatrically honed scenarios. The range of the preparatory studies and sketches for *Madame X* was not known until after Sargent's death, and the history of the picture has been slowly enriched since

3.5 MADAME X (MADAME PIERRE GAUTREAU), 1883–84
The original version as exhibited at the Salon of 1884, before its repainting
Oil on canvas
82⅛ × 43¼ in.
The Metropolitan Museum of Art, New York, Arthur H. Hearn Fund, 1916

1927, when some early comments by the artist and his friends were first published in Evan Charteris's biography of Sargent. Several drawings record Madame Gautreau's celebrated profile (fig. 3.6) and suggest that Sargent was reminded of Renaissance profile portraits when he scrutinized her fine lines. In letters Sargent admits his fascination with her skin color, which he describes as lavender, blotting paper color, and the color of chlorate-of-potash lozenges. (In his Salon painting all her natural color is subdued by her pale powder, with the exception of the bright pink ear.[16]) Most surprising, in light of the austere full-length composition, are Sargent's sketches that present her in a casual guise. In one painting she reaches languidly across a table to make a toast (fig. 3.7), and in several drawings she lounges on a sofa in the now-infamous black dress (fig. 3.8). These works, probably made in 1883 at the Gautreau summer home in Brittany, evoke a languorous, early-eighteenth-century, Watteau-like ambience that Sargent would eschew in the Salon picture. One of his letters from Brittany talks of the struggle to capture her "unpaintable beauty and hopeless laziness."[17]

Sargent's images of a looser, more whimsical Madame Gautreau have an affinity with his contemporary picture *The Sulphur Match* (fig. 3.9), which evokes the allure of a Venetian working-class woman. The uninhibited Italian balances her

3.6 MADAME GAUTREAU IN PROFILE, 1883–84
Pencil on paper
12¾ × 9⅜ in.
Ms. Elizabeth Feld

3.7 MADAME GAUTREAU DRINKING
A TOAST, C. 1883
Oil on wood panel
12⅝ × 16⅛ in.
Isabella Stewart Gardner Museum,
Boston

3.8 MADAME GAUTREAU, C. 1883
Pencil on paper
9¹¹⁄₁₆ × 10½ in.
Fogg Art Museum, Harvard University Art Museums, Cambridge, Massachusetts, bequest of Grenville L. Winthrop

chair on its back legs, luxuriating in a bohemian aura of cigarettes, alcohol, and flirtation. Although she and Madame Gautreau occupied very different places in the social order, they were equals for Sargent in their free-spirited disregard for decorum in the pursuit of pleasure. Sargent himself found it hard to relax in public. Given that he spent much energy closeting his sexuality, it makes sense that he idolized those who were able to brazenly assert their own social differences. His repression might explain why he responded to these showy women like a starstruck fan. Madame Gautreau, one of the most theatrical people in Paris at that time, won her prominence by stylishly and willfully challenging social norms. The Venetian woman and her attractive male companion win Sargent's attention with their display of lounging, coquettish ease.

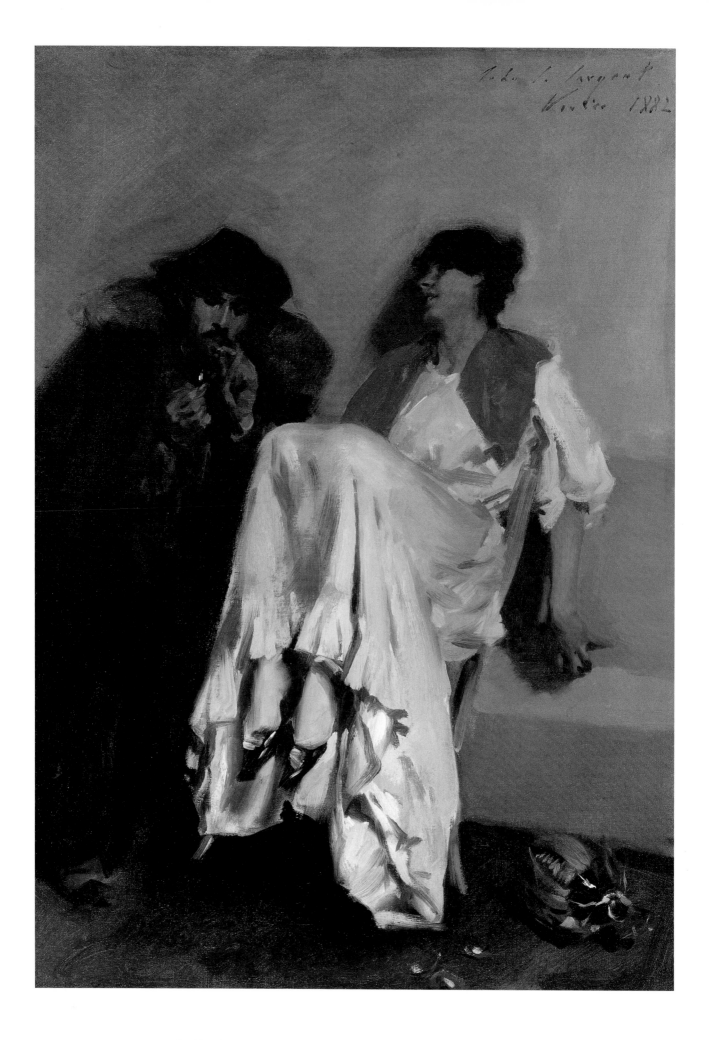

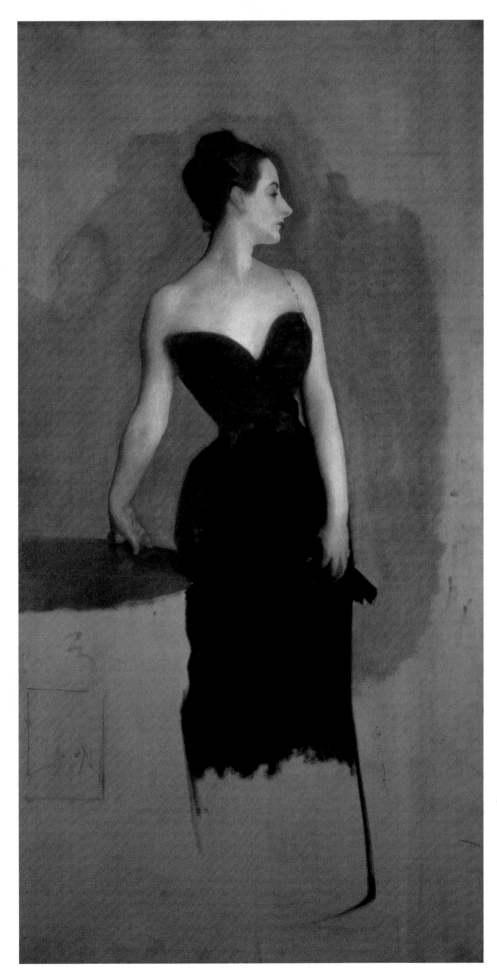

3.9 THE SULPHUR MATCH,
1882
Oil on canvas
23 × 16¼ in.
Marie and Hugh Halff

3.10 MADAME PIERRE
GAUTREAU, c. 1884
Oil on canvas
81¼ × 42½ in.
The Tate Gallery, London,
presented by Lord Duveen through
the National Art-Collection Fund,
1925

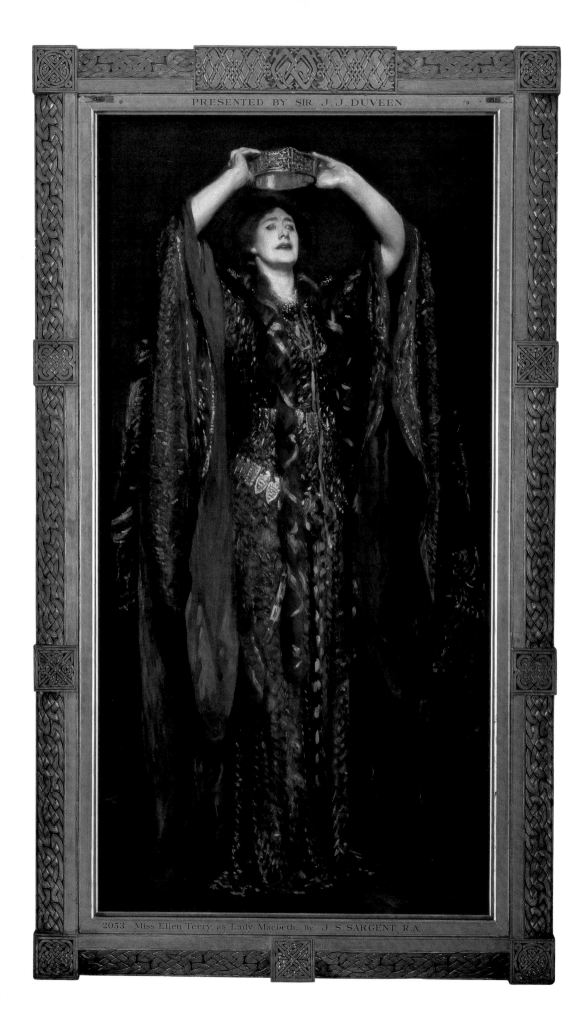

PRESENTED BY SIR J. J. DUVEEN

2053. Miss Ellen Terry, as Lady Macbeth. By J. S. SARGENT, R.A.

More still needs to be known about the *Madame X* story, starting with a better
biographical account of the subject. It is surprising that just seven years after the
Sargent fiasco she allowed another artist, Gustave Courtois, to paint her in profile
with a fallen shoulder strap; moreover, this picture entered the French national
collection while she and Sargent were still alive.[18] Although documentation is
scarce, she is said to have spent her later years in hiding, embarrassed by time's
effects upon her body.[19] Another mystery concerns Sargent's unfinished replica,
Madame Pierre Gautreau (fig. 3.10). It is not known precisely when he began this
canvas, or why he did not complete it. The picture is a replica, for it shows no signs
of the extensive reworking apparent in the Salon picture. Although the background
is incomplete, its subdued earth brown color resembles that of the Salon work,
which has at least two different layers of brighter background colors beneath its
surface.[20] It seems Sargent never exhibited the replica, and he chose to hang the
repainted original in his London home. He was sensitive to the initial objections
of the sitter and her family and kept the Salon picture in confinement for twenty-
one years. Eventually he sent it to exhibitions in London (1905 and 1908), Berlin
(1909), Rome (1911), and San Francisco (1915). In 1916, one year after Madame
Gautreau's death, he sold it to the Metropolitan Museum of Art, New York. The
replica was part of Sargent's estate. His sisters initially planned to sell it at auction,
but they changed their minds at the last minute and allowed the Tate Gallery to
acquire it in 1925. It presents a beautiful enigma, made more cryptic by the com-
plete absence of the problem shoulder strap, and it is arguably more suave and con-
fident in its presentation of the splendid head and shoulders.

STAGING THE PERSONALITY WITH COSTUMES AND PROPS

Sargent, like many late-nineteenth-century artists, saw his studio as a setting that
was a combination of museum, antique shop, den, showroom, and alchemist's labo-
ratory. He outfitted it with an eclectic display of bibelots, souvenirs, and diverse
items that might prove useful as props in a portrait. The staging of a portrait of-
ten may have been more of a creative challenge for Sargent than the execution.
Decisions about costuming, pose, and setting all conditioned the overall impres-
sion of the picture. In some respects the portrait of Vernon Lee (fig. 2.6) represents
the visual minimum for him: a quick précis of the face and an undifferentiated
background with loosely brushed areas of color. The artist painted it in a single
three-hour sitting, sensing that a spare format and an animated treatment were
ideally suited to the sitter. Lee was a talker, a bright, opinionated person whom
Henry James once described as "a tiger cat."[21] She was probably more vulnerable
than her bold, high-minded social manner sometimes suggested. Rather than steer

his portrayal to suggest a conventional feminine type, Sargent was as straightforward as could be: his picture shows a modern intellectual who resembles a male poet of the Romantic period. Lee herself enjoyed sitting for Sargent and was delighted with his portrayal: "John [was] talking the whole time and strumming the piano between whiles. I like him. The sketch is . . . considerably more like me than I expected anything could [be]—rather fierce and cantankerous."[22]

Sargent's painting of London's preeminent actress, Ellen Terry (fig. 3.11), shows the extent to which he was willing to allow costume to direct his work. The canvas celebrates the actress's creative force while purporting to be a record of her at work in full costume. As the title makes clear, it is a two-layered statement about a performer and a role—*Ellen Terry as Lady Macbeth*. Whether Sargent says more about the period's Celtic Revival (a statement firmly underscored by the frame's carved motifs) or Terry's interpretation of the villainous Lady Macbeth remains debatable.[23] The memorable costume designed by Mrs. Comyns Carr featured the most sumptuous surfaces: beetle wings, rubies, and diamonds were sewn onto a shiny blue-green dress, and red tinsel griffins were embroidered on the shot velvet cape. As noted earlier, Sargent also was beguiled by the magenta sheen of the big-braided orange-red wig. By having Terry dramatically lift the crown above her head (something she did not do in the play), Sargent effectively made the costume fill the canvas. His dramatic composition allows the woman's grandly confident body language to declare "I now crown myself queen." Sargent painted the remaining background areas a blue monochrome, which, oddly, feels less empty than the lively sketchiness in *Vernon Lee*. This dense field of blue engulfs Terry and caps the overall sumptuous tone. The combination of costume, pose, and mesmerizing performer stimulated Sargent's painterly instincts, especially in the Monet-inspired flickering brushwork that evokes the shimmering dress. In 1889 the artist Ralph Curtis described the canvas as "a swim of strange and glorious color."[24] A quip by Oscar Wilde confirms that Sargent had fallen for the most flamboyant outfit in the production: "[Lady Macbeth] evidently patronizes local industries for her husband's clothes and the servants' liveries, but she takes care to do all her own shopping in Byzantium."[25]

The pictorial possibilities of late-nineteenth-century male portraiture were hampered by the dark and rather uniform nature of menswear. *Dr. Samuel Jean Pozzi at Home* (fig. 3.4) shows what Sargent could achieve with a rare male peacock, but the clothes in *Asher Wertheimer* (fig. 3.12) represent the conventional suited and vested norm. Wertheimer was an important London dealer who specialized in furniture, ceramics, and Old Master paintings. The inclusion of an ornate Asian screen as a prop hints at his love of luxurious objects. Sargent clearly wanted to

distinguish his painting of this man (who became a close friend) from his typical manner of portraying businessmen. Proof is found at the lower left of the canvas, where he added a sketch of the Wertheimers' black poodle, Noble. The inclusion of a rather comic family pet indicates that this powerful masculine figure had a softer domestic side. But it also allows an ambiguous reading, especially by those given to conventional statements, for whom the dog's lolling pink tongue may corroborate an eager carnality in both the man and his beast. *Asher Wertheimer* is one of Sargent's finest portraits because, like *Madame X,* the artist did not hedge his attraction to the personality. Wertheimer's Jewishness, masculine self-confidence, entrepreneurial power, and sensuousness all radiate from the picture. It is arguable whether Sargent's likeness consciously or unconsciously projects the prevailing stereotypes of Jewish features and behavior. The artist did not hide his fascination with Wertheimer's barreling, rather sexy swagger, which argues for an admiring response rather than a cruel caricature. But this and some of Sargent's other portraits of Jewish sitters had the power to trigger the thinly veiled anti-Semitism of Anglo-American culture, as some contemporary responses affirmed. In a letter, Henry Adams called it "a worse crucifixion than history tells of," and an American journalist responding to *Mrs. Carl Meyer and Her Children* (fig. 1.16) quipped that "$10,000 was not much for a multi-millionaire Israelite to pay to secure social recognition for his family."[26] Sargent surely knew that his likeness would allow such jibes, but if one looks closely at the face in the picture, the tender expression of the eyes and mouth shows the warmth of deep friendship between artist and sitter.

Robert Louis Stevenson (fig. 3.13) occupies a position between the gaudiness of *Dr. Samuel Jean Pozzi at Home* and the businesslike black allure of *Asher Wertheimer.* It is a smaller work, made on commission for Mr. and Mrs. Charles Fairchild, Bostonians who were enthusiastic about the author's work. Sargent had painted Stevenson twice before, and the subject owned one of the pictures.[27] The Fairchilds' portrait of the seated author benefits from the slight familiarity between subject and artist. Stevenson casts an amused and quizzical glance at Sargent, who finds much to occupy his painterly endeavors: long skinny fingers, rings, a cigarette, a brightly colored modern wicker chair, a seventeenth-century oak cupboard, an extravagant fur rug, lanky legs in gray flared trousers, and a shiny black shoe. Sargent made the portrait at Stevenson's house in Bournemouth, where he savored the opportunity to record both the sitter and his habitat. He had improvised the rather perfunctory settings of the Pozzi and Wertheimer portraits, but in *Robert Louis Stevenson* the props are compelling extensions of an idiosyncratic person, and moreover, they were his possessions.

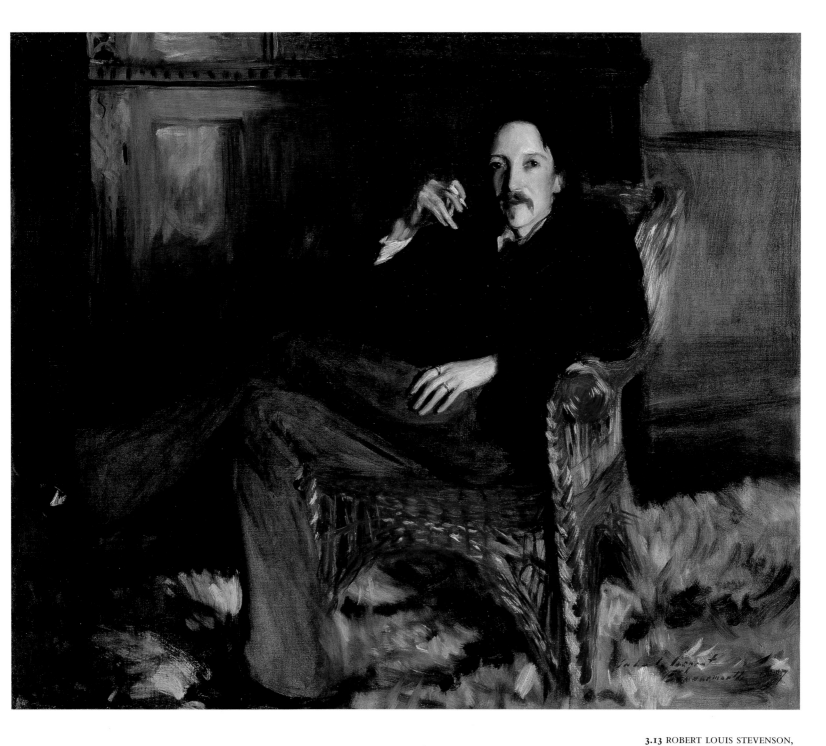

3.13 ROBERT LOUIS STEVENSON,
1887
Oil on canvas
20¹⁄₁₆ × 24¾ in.
Taft Museum of Art, Cincinnati,
bequest of Charles Phelps and
Anna Sinton Taft

3.12 ASHER WERTHEIMER, 1898
Oil on canvas
58 × 38½ in.
The Tate Gallery, London, presented
by the widow and family of Asher
Wertheimer in accordance with his
wishes, 1922

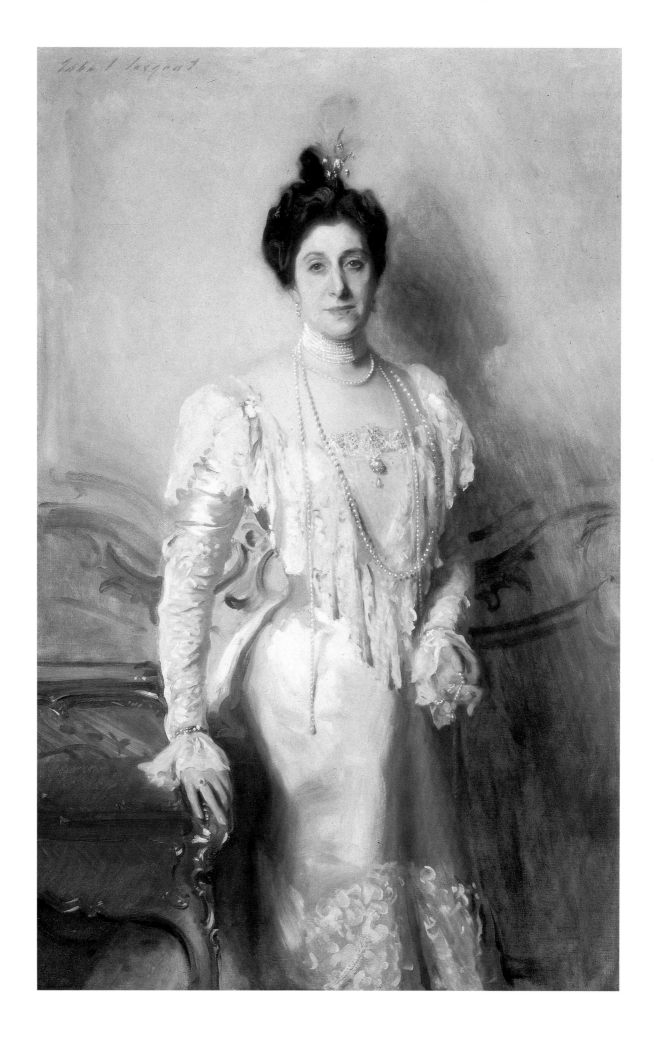

Asher Wertheimer had commissioned his portrait from Sargent in 1898 along
with a pendant portrait of his wife, Flora, to celebrate their silver wedding anni-
versary (fig. 3.14). The pictures have matching frames and share basic compositional
ideas: each is a standing, three-quarter-length image; the subjects wear formal
clothes and look directly at the viewer (the woman in white, the man in black);
each holds something in one hand (pearls for her, a cigar for him). Sargent's pre-
liminary drawings for Mrs. Wertheimer's portrait indicate that he originally thought
of her in a more unassuming stance, set slightly behind a circular neoclassical-style
table (fig. 3.15). In the finished painting she exerts a stronger rapport with the
elegant French rococo accessories: a small desk and a carved panel (the panel was
one of the artist's studio props, and the Wertheimers may have lent him the desk).[28]

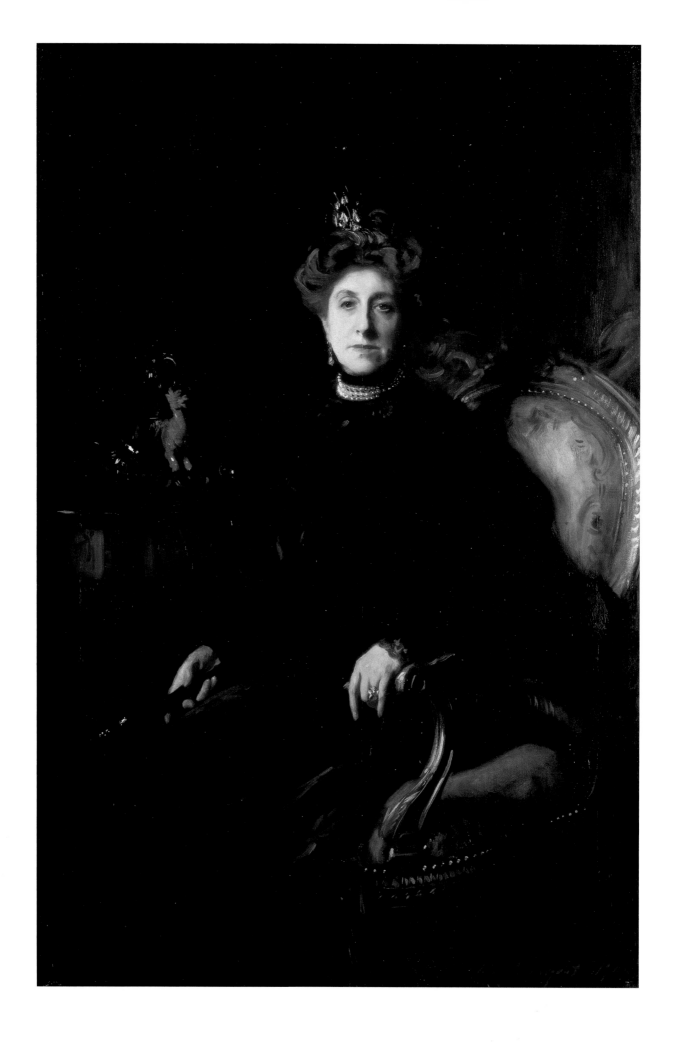

The paneling pushes her slightly diffident figure toward the viewer, and in contrast to the shadowy splendor of her husband's portrait, hers is bright and opulent.

For reasons unknown, the Wertheimer family did not consider *Portrait of Mrs. Asher B. Wertheimer* a great success. Sargent did not publish it in 1903 in his fancy volume of photogravures, even though the pendant of the husband was included. In 1904, six years after the first picture, he portrayed Mrs. Wertheimer again (fig. 3.16). In 1922 the family presented this and not the first portrait to the British national collection, and it now resides in the Tate Gallery. The differences between the portraits of 1898 and 1904 are provocative. One shows a quiet, sensitive person in white, the other a no-nonsense matriarch in black. The gentle entreaty of the earlier face becomes a commanding gaze with no hint of a smile. The grander setting of the second portrait confirms these projections: precious porcelain and crystal objects gleam in the dim light; the subject appears to be enthroned; and she wields rather than holds her fan.[29] Her black clothing and dignified reserve may reflect an extended period of mourning, for the Wertheimers lost their two eldest sons in 1901 and 1902. Which portrait contains more truths? Although the painting of 1904 lacks the pretty dress and kindly face of the first portrait, it presents a more compelling and dramatic personality. Obviously Sargent knew his subject better in 1904, and the fact of being asked to paint a second portrait may have goaded him to do a better, more memorable job. Given the implacable British class system, Sargent also may have wanted to promote the wealthy Jewish outsider who was now a friend. And if he had an inkling that the portraits were destined for the national collection, he would have known the value of giving Mrs. Wertheimer the trappings and bearing of the establishment.

Sargent painted twelve portraits of the Wertheimer family between 1898 and 1908, memorializing each parent, six daughters, four boys, and five dogs. The lively composition of *Ena and Betty, Daughters of Asher and Mrs. Wertheimer* (fig. 3.17) has the ring of documentary truth concerning the confidence of the Edwardian elite. It presents the women in the drawing room of the London house where they and the portrait then resided. *Almina, Daughter of Asher Wertheimer* (fig. 3.18) is more of a pictorial fantasy, an extension of the English tradition that occasionally led such artists as Van Dyck and Lawrence to portray sitters in fanciful exotic costumes. Possibly alluding to their Jewish background, Sargent gave Asian objects strong roles in each of these portraits. In the earlier work, the two eldest Wertheimer daughters glide arm-in-arm, with Ena reaching back to touch the finial on a large ornate Chinese covered jar. Sargent persuaded Almina to dress up as a harem slave for her portrait; he provided the exotic costume and Indian stringed instrument from his personal collection, and he sketched a pool and colonnaded setting

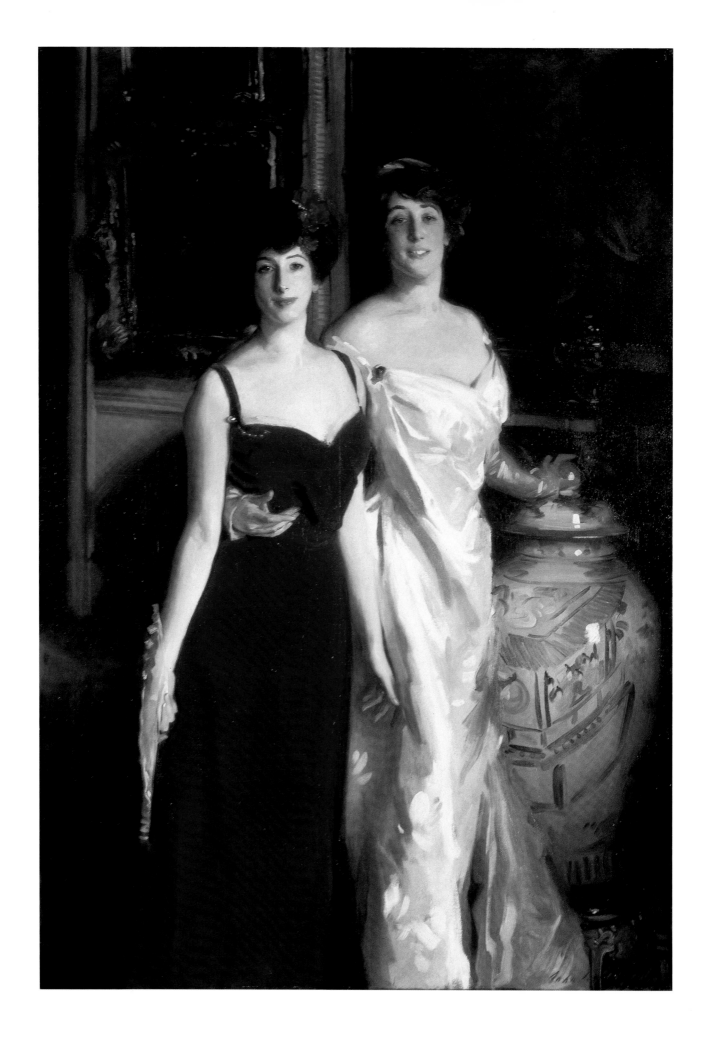

3.17 ENA AND BETTY, DAUGH-
TERS OF ASHER AND MRS.
WERTHEIMER, 1901
Oil on canvas
73 × 51½ in.
The Tate Gallery, London, presented
by the widow and family of Asher
Wertheimer in accordance with his
wishes, 1922

behind her. Recent scholarship confirms that he took liberties in the spirit of fancy dress: the Persian jacket was in fact an item of male clothing, and the *sarod* should be held vertically when it is played.[30] More important, however, is the fact that Sargent's imagination responded so strongly to Jewish sitters. After seeing Sargent's *Lady Sassoon* at the Royal Academy in 1907, a British diplomat wrote in his diary: "[Sargent] paints nothing but Jews and Jewesses now and says he prefers them, as they have more life and movement than our English women."[31]

In both *Ena and Betty* and *Almina* Sargent painted thrilling passages of pictorial ingenuity. Betty's open fan is a miracle of economical brushwork, and her red headpiece is riveting both as image and as paint. Ena's white satin gown is alive with rustle and sheen. Almina's still-life accessory, a shell-shaped silver dish, is filled with pale succulent slices of melon. Since this painterly attention focuses on stereotypically female items, it is worth remembering that Sargent's contemporaries generally characterized his style as virile. In 1901 one London critic eager to acknowledge Sargent's artistic masculinity likened his treatment of paint to a rapelike act of brutality.[32] Although the author claimed to be anguished by the artist's "very unkind" and "impatient" display of painterly might, he admitted his envy of that kind of power. In an essay of 1911 devoted to the twelve Wertheimer portraits, Robert Ross praised Sargent for his "health-giving, manly art."[33] This assertion gains interest given that the art world privately assumed Ross to be homosexual because of his intimacy with Oscar Wilde. Ross also addressed another masculine stereotype that was often applied to Sargent: the machinelike accuracy of his vision. He gave an example in which the camera proved that Sargent did not lie. After noting that people frequently faulted the arm and hand holding the open fan in *Ena and Betty,* Ross recalled a "pedantic and enthusiastic young medical student" who took photographs of twenty different arms in order to prove that Sargent had not resorted to artistic trickery. The medical student and his camera acquitted Sargent, showing his image to have been anatomically correct as well as artistically original.

The remarkable concentration of talent in Sargent's best portraits caused contemporaries to subject them to excessive praise and unwarranted criticism as they struggled to comprehend them. One needed then, as now, an eclectic and open spirit to do justice to the unusual strategies of looking and recording that exist in Sargent's art. Truth is jostled by theatricality, and photographic accuracy is combined with various quirky effects caused by lighting, makeup, and foreshortening. In 1891 an American critic complained about Sargent's habit of detecting the masks worn by his sitters. The most literal instances were portraits of actors and actresses in costume. Painted in studio rather than stage lighting, these pictures seemed to

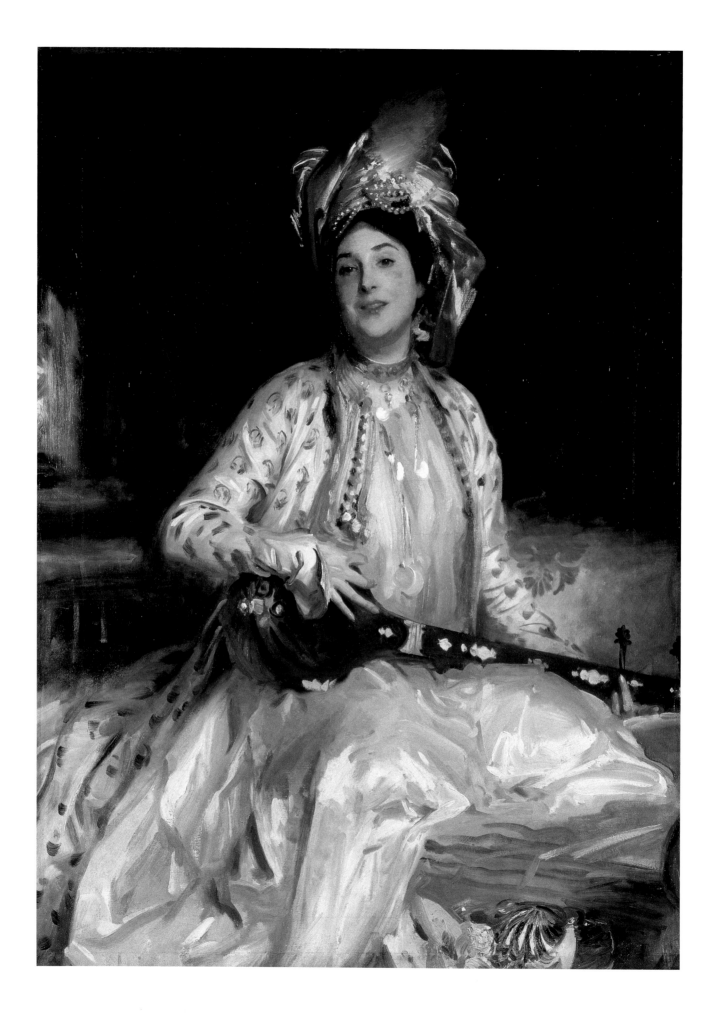

relish the "weird" and "obviously artificial" appearance of their subjects' painted and powdered faces.[34] This kind of visual ambiguity was then ascribed to Sargent's regular portraits, for the writer felt that Sargent's way of painting often hinted that a person's smile or gaze was a facade not quite suited to the wearer. In the same review a somewhat contradictory argument was made when the critic praised Sargent's exceptional ability to record and interpret exteriors: "[He] is cleverest when he aims to represent visible facts. Perhaps no one ever painted clothes better as to [the] rendering of material. Neither has any one made them more expressive of the character of the creature underneath." Sargent did not change his methods to suit this kind of criticism. His Realist urge to record his observations persisted, no matter how "curious" the visual effect. In a portrait of Lord Dalhousie, painted in 1900, the upper section of the young man's forehead is pale because a hat had protected it from the sun; the remainder has the color of a strong suntan. One critic compared this "unlucky" detail to a partially cleaned painting that a restorer might display as a sample, but to Sargent it was a form of evidence.[35] The tan line, marking the ghost of a rakish hat, made a valuable contribution to the ruthless self-confidence that Sargent's characterization evokes.

Hindsight makes it easier to propose that Sargent's delight in an individual's external appearance allows some general insights into his or her life and times, whether or not this was something the artist intended. Sargent painted during a period of tumultuous social change, and it was also possible that some of the heated responses to his pictures were fueled by larger concerns. Reforms had begun to empower the working class, women, and other disadvantaged groups, and the embattled ruling class consequently desired to assert itself anew. The science of psychology had begun to reveal the inner workings of personality just as mass marketing was learning to exploit the way people read exteriors. It was not as easy as it had been to judge people by their appearances. While it is difficult to draw direct connections between these broad historical forces and specific works by Sargent, it is fair to say that his complicated approach to truth and realism in portraiture reflects the innovations and dilemmas that shaped his era.

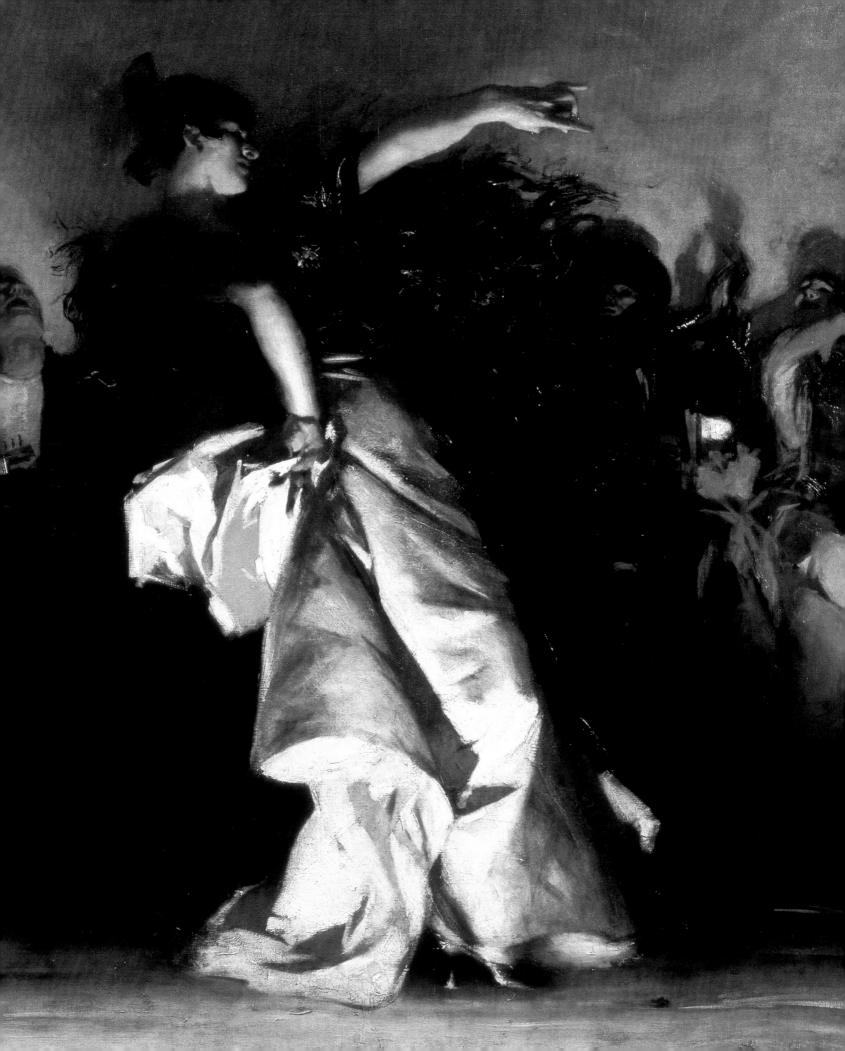

Chapter 4

INTRIGUING BODIES

The love of the body of man or woman balks account, the
* body itself balks account,*
That of the male is perfect, and that of the female is perfect
. . . .
To be surrounded by beautiful, curious, breathing, laughing
* flesh is enough,*
To pass among them or touch any one, or rest my arm ever
* so lightly round his or her neck for a moment, what is*
* this then?*
I do not ask any more delight, I swim in it as in a sea.

There is something in staying close to men and women and
* looking on them, and in the contact and odor of them,*
* that pleases the soul well,*
All things please the soul, but these please the soul well.

<div align="right">—Walt Whitman, I Sing the Body Electric (1855, final version 1881)</div>

The glamour of Sargent's female portraits makes it easy to assume that he was sexually interested in women. Indeed, when Henry James tried to attract new patrons for Sargent in 1887, he argued that the young portraitist revealed a "special feeling" when he painted "delicate feminine elements."[1] But Sargent's interest in male bodies was equally strong, and his artistic responses to masculinity often echoed the frank admiration of the contemporary poet Walt Whitman. The long careers of Sargent, James, and Whitman—bachelors all—prospered because they obscured their private lives to guarantee professional success and social acceptance. Although they all formed numerous close friendships with men, they monitored those personal

Detail of EL JALEO, 1882
(fig. 4.3)

95

relationships so that the public remained suitably unaware. Of the three, Whitman mounted the biggest test of the official pieties of the day by openly professing the mystical and sensual importance of all human contact. In *I Sing the Body Electric,* he praised same-sex attraction by equating it with male-female relationships.

Whitman's humanitarian views on slavery won favor among abolitionists, his invocation of democratic comradeship encouraged socialist reformers, and his attention to men was an inspiration to male readers drawn to other men. He was one of the first modern writers to argue that sexuality is not merely a bodily act but a broad force that shapes the way any individual lives a life and experiences the world. In 1888, in a retrospective assessment of his own work, Whitman stated: "It has become . . . imperative to achieve a shifted attitude . . . towards the thought and fact of sexuality, as an element in character, personality, the emotions, and a theme in literature. I am not going to argue the question by itself; it does not stand by itself. The vitality of it is altogether in its relations, bearings, and significance."[2] Sargent was part of a diverse group of artistic, spiritual, and libertarian types receptive to Whitman's daring work. In Boston in 1887 he contributed to a subscription to purchase a summer cottage for the elderly poet.[3] Three years later, during his next visit to America, Sargent asked if he might paint Whitman, even though he had never made his acquaintance. Whitman agreed to sit in 1890, but then the artist could not find time to go to Camden, New Jersey, to undertake the painting. It seems that commissioned portraits, negotiations over his first mural project, and a full-length portrait of the Spanish dancer Carmencita kept Sargent from meeting the poet.[4]

Whitman's sweeping embrace of "Sex and Amativeness, and even Animality" —expressed in his retrospective essay of 1888—was key to the progressive cultural milieu in which Sargent operated. A study of the late nineteenth century, published while Sargent was still alive, argued:

> It was an era of hope and action. People thought anything might happen; and, for the young, anything sufficiently new was good. . . . Dissatisfied with the long ages of convention and action which arose out of precedent, many set about testing life for themselves. The new man wished to be himself, the new woman threatened to live her own life. . . . People said it was a "period of transition," and they were convinced that they were passing not only from one social system to another, but from one morality to another, from one culture to another, and from one religion to a dozen or none! But as a matter of fact there was no concerted action. Everybody, mentally and emotionally, was running about in a hundred different directions. . . . "A New Spirit of

Pleasure is abroad amongst us," observed Richard Le Gallienne, "and one that blows from no mere coteries of hedonistic philosophers, but comes on the four winds." The old sobriety of mind had left our shores.[5]

By 1892, the year Whitman died, Sargent had already made numerous pictures celebrating outlandish and sensual bodies: urban sophisticates like Dr. Pozzi and Madame Gautreau; Spanish dancers enraptured by passionate Gypsy music; sultry, lower-class Italian women and men; grandiose pre-Christian religious figures; and Arab and Javanese women whose makeup and dress connoted ancient, preindustrial, non-Western cultural systems. All these images lean toward the daring, risky, unconventional, dramatic, erotically off-center, and odd. It is now obvious that they comprise a valuable subset of Sargent's oeuvre. Painting and drawing intriguing bodies was more than a passing fancy to Sargent; it was the activity that brought his personal passions and artistic gifts into a mutually reinforcing rapport.

Mainstream Victorian audiences calmly and automatically expected writers and artists to celebrate heterosexual romance and feminine subjects, and Whitman, James, and Sargent met the standard. But each of these great individualists developed his own impressionistic and suggestive style that left the door open for other audiences to pursue independent conclusions. Regarding the bachelor regime of Henry James, Sargent's British friend Edmund Gosse wrote: "So discreet was he, and so like a fountain sealed, that [close acquaintances] . . . supposed that he was mainly a creature of observation and fancy, and that life stirred his intellect while leaving his senses untouched. But every now and then he . . . admitted such a friend to a flash or glimpse of deeper things."[6] Bound by the Victorian age's atmosphere of self-repression, Gosse (a married man given to strong male friendships) dared not name or explain those "deeper things." But he clearly found it important to hint affirmingly that the "senses" of inscrutable unmarried people like James were not "untouched." Gosse, who visited Whitman in 1885, later wrote: "[Whitman's] real psychology . . . would be enormously interesting. I think the keynote to it would be found to be a staggering ignorance, a perhaps willful non-perception, of the real physical conditions of his nature. But the truth about him (the innermost truth) escapes from almost every page for those who can read."[7]

Thus it was that Whitman, James, and Sargent had permission to express a responsiveness to men in their work as long as they led "proper" public lives. Those who understood same-sex attraction could register the double nature of their lives and the nuances of their work. The humiliation and imprisonment of Oscar Wilde in 1895 underscored the establishment's legal power to destroy those who broke the rules of the hypocritical game.

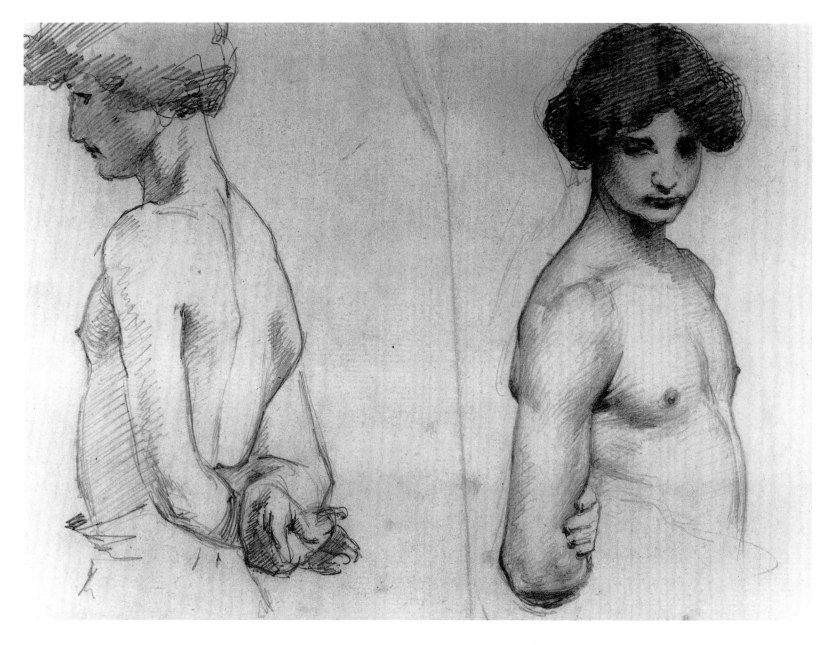

4.1 TWO HALF–LENGTH SKETCHES OF A YOUTH, c. 1878
Pencil on paper
7¹⁄₁₆ × 10⅝ in.
Museum of Art, Rhode Island School of Design, Providence, gift of Miss Emily Sargent
and Mrs. Francis Ormond, through Mr. Thomas Fox

Sargent sketched models from his student days until his death. In his eighteenth year, when a sprained ankle kept him from the Academy in Florence, he hired a model to come to his home. A letter indicates that this was an early instance of his triple delight in physical beauty, music, and dancing: "I have a very handsome Neapolitan model to draw and paint, who plays on the zampogna and tamburino and dances tarantellas for us when he is tired of sitting."[8] During his student years in Paris he and his friend Carroll Beckwith sketched a handsome Italian model named Spinelli.[9] One of Sargent's sheets (fig. 4.1) has two sketches of Spinelli: for each image Sargent chose a view that allowed him to draw a nipple in profile. (For later instances of this kind of silhouette, see folios 5, 22, and 24 in Sargent's *Album of Figure Studies,* reproduced herein on pp. 181–211.) Sargent posed Spinelli in a casual stance with a downward gaze, echoing Donatello's *David,* the celebrated nude statue that Sargent knew well from Florence. His drawing of the Italian youth has an erotic magnetism that recalls *Man Wearing Laurels* (fig. 3.2). Regardless of gender, Sargent had an admiration for olive- or brown-skinned, dark-haired people of Mediterranean origin; he clearly turned to their exotic allure as an escape from his own Caucasian heritage.

Sargent had a long-standing passion for Andalusian music, which combined Spanish and Moorish traditions with the wild and morbid aspects of Gypsy culture. In a letter of 1880 he raved about "dismal, restless [Andalusian] chants" and the "marvelously supple" voices of the Gypsies.[10] Because they supposedly ignored ethical principles and exalted superstition over orthodox religion, nomadic Gypsies were then enduring oppression in numerous countries, but artists and bohemians idealized them as free spirits. Bizet's opera *Carmen,* first performed in Paris in 1875, scandalized the public with its tale of a proud, lusty Andalusian Gypsy torn between an army officer and a toreador; one lover symbolized the progressive modern system, the other, ethnic and regional authenticity. During his travels in Spain in 1879 Sargent was mulling over a major work of art in which he could express his love of Gypsy music, dance, and picturesque costumes. On his return to Paris in 1880 he set to work on a wide horizontal picture whose proportions simulated the shallow stage space of popular musical establishments. He probably hired models to supplement the sketches he had made abroad.

An ink sketch Sargent made on the back of a receipt from a Madrid hat shop (fig. 4.2) presaged the composition of the big canvas that he unveiled at the Salon of 1882 (fig. 4.3). He named it *El Jaleo,* to suggest the name of a dance, the *jaleo de jerez,* while counting on the broader meaning of *jaleo,* which means ruckus or hubbub. The differences between the sketch and his elaborate Salon production

4.2 SPANISH MALE DANCER
BEFORE NINE SEATED FIGURES,
1879
Ink and wash on paper
5¼ × 8⅛ in.
Fogg Art Museum, Harvard University Art Museums, Cambridge,
Massachusetts, gift of Mrs. Francis
Ormond

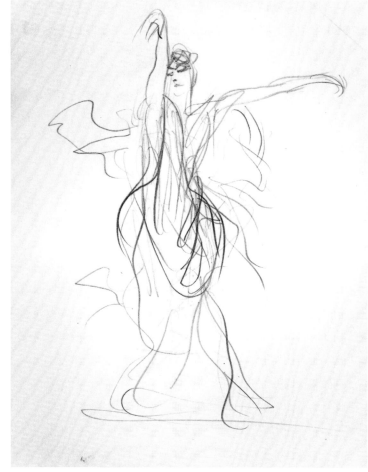

4.4 SKETCH OF A SPANISH
DANCER, C. 1879–1900
Pencil on paper
11⅜ × 9 in.
Isabella Stewart Gardner Museum,
Boston

4.3 EL JALEO, 1882
Oil on canvas
94½ × 137 in.
Isabella Stewart Gardner Museum,
Boston

are telling. The first shows a thin male dancer strutting lightly, his arms raised forward and buttocks pushed back, while the second is devoted to a more imposing female dancer in an astonishing backward-leaning pose. Despite the sculptural precision of her heavy white skirt, the woman still moves fast enough to frenzy the fringe of her shawl. In both images numerous accompanists sit as a line against the back wall; the ink sketch makes a more dramatic contrast between dark male clothes and light female dresses, whereas the painting enlists an empty chair to accent its compositional rhythm of lights and darks. Sargent finessed every detail of *El Jaleo* and crafted his image of high drama in an almost scientific spirit. The best evidence of his own excited reactions to live dance performances can be found in some pencil sketches of a Spanish woman that he included in an album assembled for Isabella Stewart Gardner. They are among his fastest, most

intuitive works. In one drawing (fig. 4.4) a torrent of fast hard lines suggests the twisting shawl from which a majestic neck and outstretched vamping arms emerge.

The reportorial detailing in *El Jaleo* demonstrates Sargent's early affinity with the Realist movement: footlights cast menacing shadows on the shabby wall; pretty female accompanists flash their eyes; a thick-necked man placed at the exact center of the canvas experiences sublime abandon; hands strike strange poses as they strum, clap, dance, and contribute to the "ruckus." It is not known why Sargent decided on a female rather than male dancer; he may simply have chosen to follow the established French Romantic tradition devoted to pictures of exotic female dancers. Delacroix's *Jewish Wedding in Morocco* (which had hung in the Musée du Luxembourg, Paris, since the mid-1840s) shows a woman dancing intently with one arm raised and her skirt swaying. If Sargent was seeking to maximize popular appeal, he failed. His idiosyncratic imagination created a commanding, forceful woman unlikely to amuse and delight the mainstream, and his protagonist was overly realistic ("ugly") and insufficiently idealized for many viewers. While Sargent's pursuit of the bizarre registered all the odd shadows that make the dancer's face ghoulish, his passion for sumptuous textiles gave her a satin skirt that is a little too haute couture for the rest of the picture. *El Jaleo* provoked lively discussion at the Salon, where, according to one American reporter, painters generally praised it as a tour de force but the public called it "the ugliest picture in the whole exhibition."[11] In 1887 Henry James endorsed its "air of reality" and "extraordinary energy and facility," but he found the work disquieting overall: "It looks like life, but it looks also . . . rather like a perversion of life, and has the quality of an enormous 'note' or memorandum, rather than of a representation. . . . *El Jaleo* sins, in my opinion, in the direction of ugliness, and, independently of the fact that the heroine is circling round incommoded by her petticoats, [it] has a want of serenity."[12]

Sargent's love of depicting exotic people—models, dancers, and anyone else he could enlist—persisted throughout his career. Serendipity often allowed creative opportunities of this kind to crop up, as happened during the artist's visit to the Exposition Universelle in Paris in 1889. Sargent had traveled from London to attend the international event, where the new Eiffel Tower was the centerpiece of a 228-acre fairground and six of his recent portraits were hanging in the American section of the Palais des Beaux-Arts. Sargent was one of many artists to visit the fair, including Rodin and Debussy, who responded deeply to the music and dancing of a delegation from the Javanese royal court. During his tour of the Javanese "village"—a display built to showcase Dutch colonial holdings in Indochina—Sargent had a sudden urge to paint. He promptly postponed a visit to Monet in Giverny and sketched four female dancers whose costumes and dance

4.5 A JAVANESE GIRL AT HER TOILET, 1889
Oil on canvas
25½ × 21 in.
Private collection

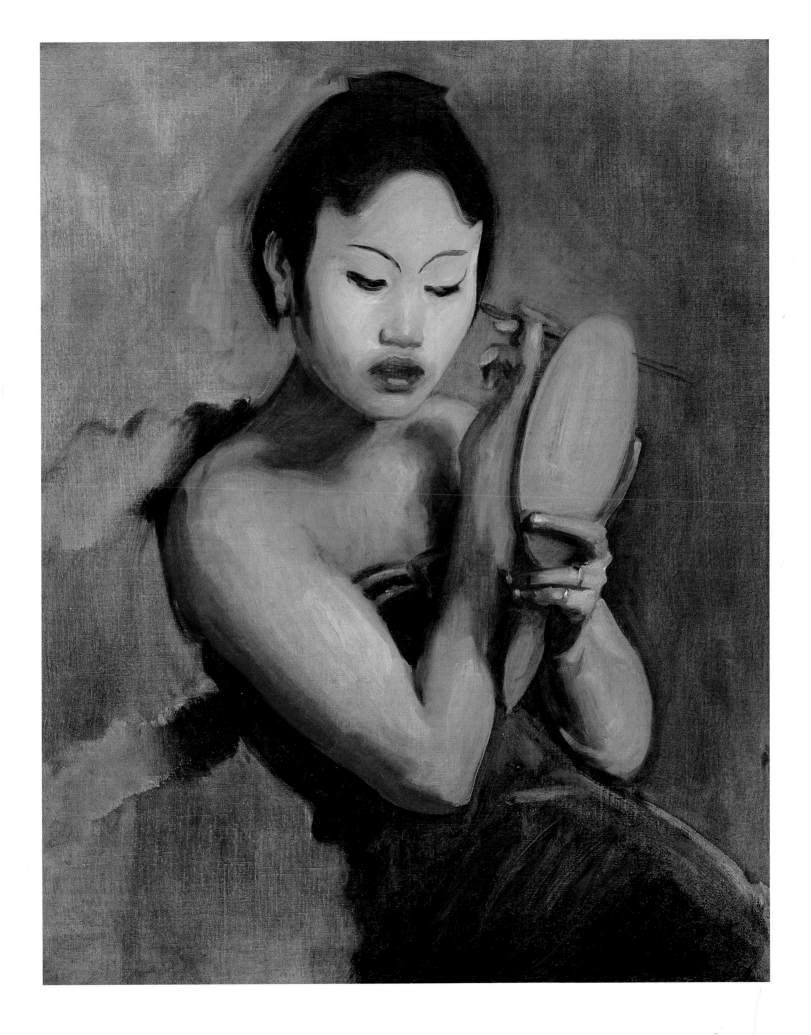

movements were so different from Western traditions. Evidently he gained permission to work behind the scenes to paint one Javanese woman preparing for the performance: she is in the midst of applying makeup to her face and has yet to don her headdress and jewelry (fig. 4.5). While treating large parts of the canvas very sketchily, Sargent made close accounts of her body type, the exquisite black lines painted on her eyes and eyebrows, and the colored shadows playing on her neck and chest. His focus makes the viewer aware of the subject's body and the concentration she needs to complete her task with precision. As in *Madame X* and *Ellen Terry as Lady Macbeth,* Sargent revealed his fascination with makeup and dramatic costumes. Although he did not make a Salon-type picture based on his impressionistic sketches of the Javanese performers, he valued this body of work and exhibited one example next to *Madame X* in London in 1905.[13] In keeping with the independent works he produced in Spain and Morocco, Sargent's paintings of the Javanese performers did not identify the dancers; he was not painting members of his social milieu but capturing the images of nameless workers and performers who embodied Javanese allure.

AN ALBUM DEVOTED TO MEN

Sargent's best excuse to work with models was his mural work. In 1890, when he agreed to make a decoration for the Boston Public Library's new building, he planned to decorate opposite ends of a large hall with imagery symbolic of the Old and New Testaments. His friend Edwin Austin Abbey noted in a letter of 1890 that Sargent had already made "stacks of sketches of nude people" during his American sojourn: "[They are] saints, I dare say, most of them, although from my cursory observations of them they seemed a bit earthy."[14] Abbey did not indicate whether Sargent used male or female models, and it is not known if these particular sketches survive. When his entire production of drawings is taken into account, however, it is evident that Sargent was most absorbed and inspired when working with male models. Not only did he draw men much more frequently than women, his drawings of female models can be unexceptional in execution and lacking in erotic response (fig. 4.6). He often used men as models for female characters.[15] Sargent's fundamental predilection for the male body is concisely demonstrated by his drawing *Rape of a Sabine* (fig. 4.7). When sketching Giambologna's marble statue in Florence, he chose a vantage point that allowed him to dwell on the two masculine bodies and downplay the sexuality of the woman.[16]

One of the finer items in Sargent's oeuvre is an album with thirty-one images of the male figure. It comprises thirty original charcoal drawings and a collotype reproduction of a drawing that the artist had donated to the Museum

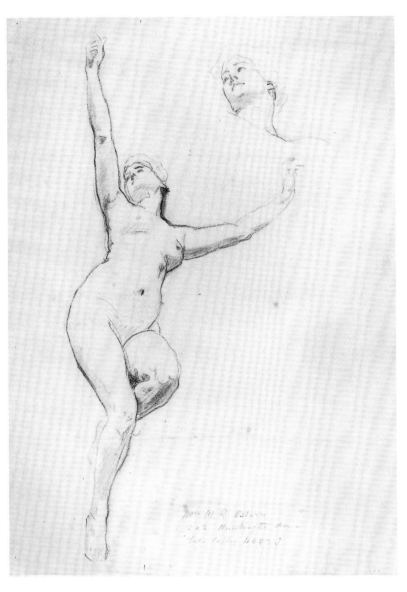

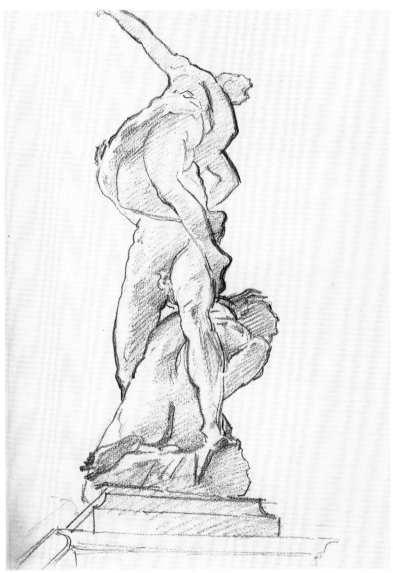

4.6 FEMALE NUDE, STUDY FOR VICTORY IN "DEATH AND VICTORY," C. 1920–22
Charcoal on paper
25 × 18½ in.
Addison Gallery of American Art, Phillips Academy, Andover, Massachusetts,
gift of Miss Emily Sargent and her sister, Mrs. Francis Ormond

4.7 "RAPE OF A SABINE" AFTER GIAMBOLOGNA, LOGGIA DEI LANZI, FLORENCE,
C. 1909–10
Pencil on paper
14⅛ × 10 in.
Fogg Art Museum, Harvard University Art Museums, Cambridge, Massachusetts,
gift of Mrs. Francis Ormond

of Fine Arts, Boston in 1921. Twenty-nine of the works are glued to the pages of the album, and two loose sheets bear no evidence of ever having been attached in this way.[17] Presumably part of the artist's estate, *Album of Figure Studies* entered the collection of the Fogg Art Museum, Harvard University, in 1937. It was part of a gift from Sargent's youngest sister, Violet, that included two other large-format albums with drawings related to the mural projects.[18] The album remained an obscure and uncelebrated item for decades until 1981, when it became the subject of an essay.[19] Six years later, five of the drawings appeared in a Sargent retrospective.[20] All the works are illustrated together for the first time in this publication (see pp. 181–211).

(see pp. 181–211).

While there are no known documents to shed light on the origins and purpose of *Album of Figure Studies,* it seems likely that the artist selected the large loose-leaf binder and glued the drawings to its pages. Some of the drawings show wear and edge damage, and they may have been collated in the artist's later years.[21] An album would have given Sargent a convenient way to protect the works while making them easily accessible. Stylistic evidence suggests that most of the drawings date from the 1890s or early 1900s. All but two sheets measure approximately 24 by 19 inches; the two exceptions are roughly half that size and are glued to the same album page. Four drawings are clearly connected to a small group of Bible illustrations that Sargent worked on in the late 1890s. The collotype reproduction shows a study for a sculpted figure in the rotunda decorations at the Museum of Fine Arts, installed in 1921.[22]

The majority of the works in the album were probably made for the pleasure of drawing dramatically posed models, although the artist may have relied on them subsequently to generate ideas. Their quality generally exceeds that of the numerous drawings of models that Sargent made expressly as studies for the poses and detailing of his murals. They possess something of the lingering, leisurely spirit of Sargent's holiday watercolors, their pictorial wholeness and degree of finish making them informal portraits of the naked or draped models. These drawings of undressed males may be considered the counterparts of his great pictures of costumed females. In *Fumée d'Ambre Gris, Madame X, El Jaleo, Ellen Terry as Lady Macbeth, Ena and Betty Wertheimer,* and other key works, unusual, splendidly clad women control space and exert a powerful allure with stretching, twisting, leaning, or vamping gestures. In *Album of Figure Studies,* strapping men assume showy or exultant postures and create a comparable sense of dramatic display. A memorandum by Anton Kamp, who modeled for Sargent in Boston in the early 1920s, confirms that the artist made informal drawings of the nude as a pleasurable, diverting indulgence:

4.8 STANDING MALE NUDE, VIEWED FROM BELOW, c. 1890–1915

Folio 23 from *Album of Figure Studies*
Charcoal and white chalk on paper
24⅞ × 19 in.
Fogg Art Museum,
Harvard University Art Museums,
Cambridge, Massachusetts, gift of
Mrs. Francis Ormond

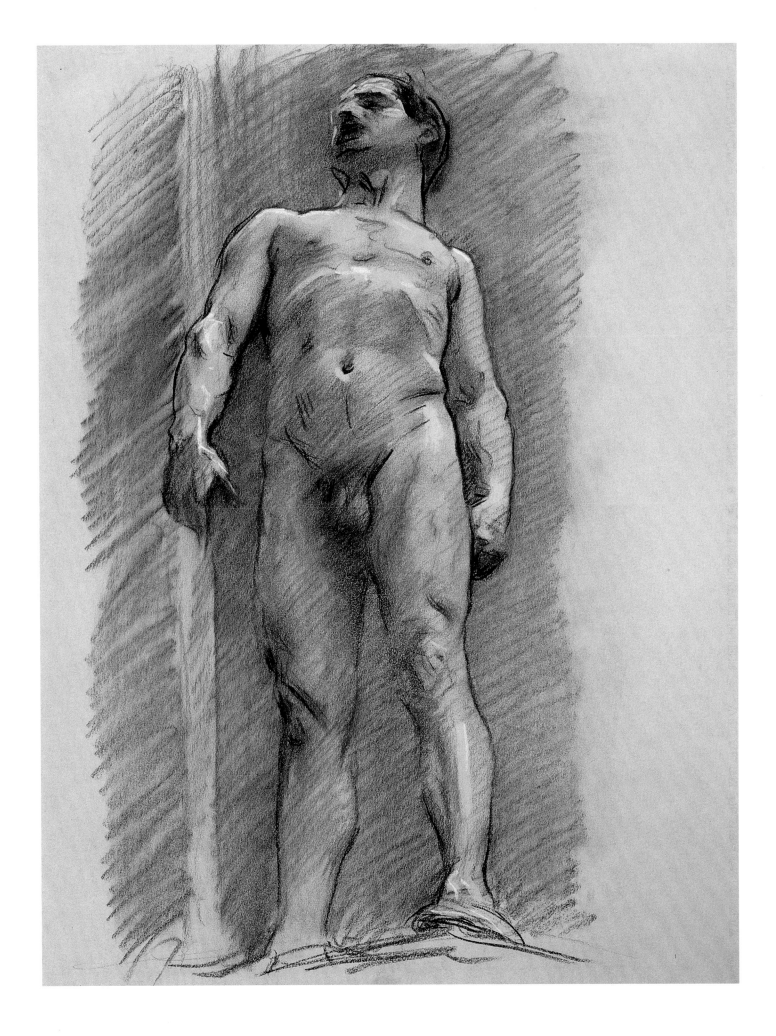

On this morning . . . no special posing assignment was underway. About forty-five minutes after arriving at the studio I was on top of the elevated platform, relaxed, awaiting his [Sargent's] orders. Whatever I did at the moment brought forth a request to hold a minute. Then, drawing a chair toward me, he sat down gazing at me intently. "Please remain as you are while I get some paper" was his only remark. [He then drew] two figure studies [on a single sheet, making them], I suspected, in the same spirit which some months before brought forth the muscular study of Tom McKeller [fig. 6.18]. . . . The drawing had no special purpose in mind concerning the [mural] decorations. [It was] simply the outcome of a moment when the routine imposed upon Mr. Sargent by the murals could be sidestepped, indulging in what might be assessed as an inspirational diversion.[23]

In formal characteristics, *Standing Male Nude, Viewed from Below* (fig. 4.8) is typical of the works in *Album of Figure Studies.* All these drawings rely on Sargent's painterly aesthetic to maximize the broad tonal range of the charcoal medium. He used hatching and shading to produce a variety of grays, often rubbing a given area to create a more even tone. When he needed to introduce a highlight in a gray area, he erased the charcoal. (Fresh bread was Sargent's favorite eraser when drawing with charcoal.) The firmest, most conspicuous strokes established the thick, dark outlines of the bodies. *Standing Male Nude, Viewed from Below* is unique among these sheets in using white chalk to add definition to the highlights. As with his painting style, Sargent's artistic shorthand is conspicuous. His broad and economical bravura technique makes viewers think associatively about the gesturing, expressing, and marking that brings forth the images, inducing a subliminal sensuality that subtly reinforces Sargent's salute to the nude.

A knowing delight in robust masculinity underlies these drawings. The artist's sincere and inquiring admiration parallels that of Boucher and Rodin, for example, when they drew the female body. Sargent evokes the ephemeral beauty of his men with rare feeling, enjoying the play of light and making their bodies radiant and palpable. Occasional glimpses of the nondescript settings where he staged the sittings contrast with the models' voluptuousness. The detailing of strategically placed cushions, sinuous draperies, and striking black shadows adds more drama. The collective impact of the drawings echoes the feeling of warm physicality that Whitman achieved in his poetry. *Reclining Male Nude with Hands behind Head* (fig. 4.9)— probably an image of Sargent's manservant, Nicola D'Inverno—brings to mind two declarative and symbolic phrases from the beginning of Whitman's *Song of Myself:* "I lean and loaf at my ease" and "[I will] become undisguised and naked."

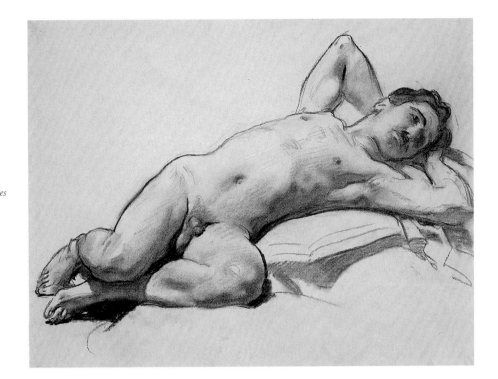

4.9 RECLINING MALE NUDE
WITH HANDS BEHIND HEAD,
c. 1890–1915
Folio 28 from *Album of Figure Studies*
Charcoal on paper
18¾ × 24⁷⁄₁₆ in.
Fogg Art Museum, Harvard University Art Museums, Cambridge, Massachusetts, gift of Mrs. Francis Ormond

Prized by Sargent, this group of drawings foregrounds his interest in manly figures who can strike splendid, self-confident poses. The body types of the models recall those of such contemporary strongmen as Sandow the Magnificent (fig. 4.10), who was an international sensation in the 1890s. But Sargent's imagery is not as affected as the promotional photographs generated for the emerging bodybuilding business. The intimate and quiet sense of bodily display that Sargent achieved was closer to the male nudes produced by Wilhelm von Gloeden and other photographers for a private market around 1900 (fig. 4.11). Thus the images in *Album of Figure Studies* have affinities with both bodybuilding and erotic photography of the day, without being pretentious or salacious.[24]

Sargent's pictorial sensibility in these drawings was as refined and intelligent as his artistic technique. It should not be surprising, given the nature of his education in Europe, that an awareness of the history of art is a strong undercurrent in the album. The vivid posture of *Standing Male Nude, Viewed from Below* (fig. 4.8) echoes Mannerist and Baroque art, and Sargent's decision to elevate the model enhances the sense that this figure would work well as a sculpture adorning an Italian building, piazza, or garden. On several occasions Sargent sketched works by Michelangelo, Cellini, and Giambologna, and the grandeur of their statues in particular echoes throughout the album.[25] It is easy, in fact, to find loose visual parallels between the models' poses and numerous historic works of art. And it is equally easy to compare the drawings in the album to figures in Sargent's murals.

4.10 Unidentified photographer,
STRONG MAN EUGENE SANDOW,
c. 1893
Hulton-Deutsch Collection/
CORBIS

4.11 Guglielmo Plüschow
German, active Italy, 1852–1930
NUDE YOUTH, C. 1900

The visual similarities are usually too imprecise, however, to confirm that Sargent was closely copying historical precedents or that the album's images were made solely and specifically for his murals.[26] It is more plausible that *Album of Figure Studies* served Sargent as a repository of favorite poses—general points of departure that he modified and adjusted according to need. It remains unclear what the album meant to the artist, and, as a result, the fact that so little is known about such a remarkable group of drawings augments their fascination.

"ABORIGINAL TYPES"

The breadth of Sargent's interest in the body was evident in his image collecting as well as his art making. According to Martin Birnbaum, he possessed "an enormous scrap album, filled for the greater part with photographs and reproductions of aboriginal types the world over."[27] In 1922 Birnbaum had a chance to peruse the album in the artist's rooms at the Copley-Plaza, Boston, while waiting to sit for a portrait drawing. (The artist was now sixty-six and Birnbaum, forty-four.) Thomas Fox, Sargent's chief Bostonian aide on the murals, noted: "Books of travel were numerous and the file of a geographic magazine, primarily for the pictures, was kept intact so far as possible."[28]

Birnbaum further reported that Sargent greatly admired *Dalziel's Illustrated Arabian Nights' Entertainments,* published in London in 1864 with more than two hundred images by eight artists: "[Sargent] searched his rooms, determined that I should see it at once. Finally, with surprising agility for a man of his size, he got down on hands and knees, to crawl under a bed and recover the well-thumbed volume from an old valise."[29] Although the artist loved the entire publication, he was especially fond of the illustrations by Arthur Boyd Houghton. It is easy to find echoes of Sargent's sensual and imaginative sensibility in this book, which he may have known since his youth. Two of Houghton's images (figs. 4.12, 4.13) present exotic female beauties in billowing dresses. They combine splendor and indolence in ways that would be echoed in Sargent's *Almina, Daughter of Asher Wertheimer* and *The Chess Game* (figs. 3.18, 5.3). Thomas Dalziel's illustration of a masked female dancer with hair flying (fig. 4.14) makes an amusing comparison with *El Jaleo* (fig. 4.3), to say nothing of its more general rapport with Sargent's theatrical enthusiasms. And John Tenniel's picture of a sleeping genie (fig. 4.15) depicts the kind of masculine physicality that Sargent made the focus of his *Album of Figure Studies.*

Sargent constantly monitored the tensions in his professional life. A comment he made in 1919 indicated that his high artistic goals included "beauty of composition," and yet a recurrent source of inspiration was the sensuality of all kinds of people.[30] His pictures of unusual and alluring non-Causasian people, including

4.12 PRINCESS OF
BENGAL

Illustration by A. B.
Houghton from *Dalziel's
Illustrated Arabian Nights'
Entertainments*, 1864

THE PRINCESS OF BENGAL.

which she had hitherto pursued, as the most likely to preserve her affections unmolested,
for a prince to whom she had pledged her heart and faith; and she added that, had this
scheme failed, she had resolved to die rather than resign herself to the sultan, whom she
neither did nor ever could love.

34
B 5

4.13 THE BEAUTIFUL
SLAVE

Illustration by A. B.
Houghton from *Dalziel's
Illustrated Arabian Nights'
Entertainments*, 1864

THE BEAUTIFUL SLAVE.

again. Though very unwilling to be so long deprived of the pleasure of her society, the
king granted their request. 'I agree,' said he, 'on condition that you punctually keep
your promise.'

"The capital of the King of Persia was situated in an island, and his palace, which
was extremely grand, was built on its shore. The apartment of the king, and also that

MORGIANA DANCING BEFORE COGIA HOUSSAIN.

was time to serve the fruit. She carried it in; and when Abdalla had taken away the
supper, she placed it on the table. Then she put a small table near Ali Baba, with the
wine and three cups, and left the room with Abdalla, as if to leave Ali Baba, according
to custom, at liberty to converse and enjoy himself with his guest while they drank their
wine.

4.14 MORGIANA DANCING

Illustration by Thomas Dalziel from
*Dalziel's Illustrated Arabian Nights'
Entertainments*, 1864

4.15 THE SLEEPING GENIE

Illustration by John Tenniel from *Dalziel's Illustrated Arabian Nights' Entertainments,* 1864

THE SLEEPING GENIE AND THE LADY.

The report of this unexampled cruelty spread consternation through the city. And at length, the people who had once loaded their monarch with praise and blessings, raised one universal outcry against him.

The grand vizier, who was the unwilling agent of this horrid injustice, had two daughters, the eldest called Sheherazade, and the youngest Dinarzade. The latter was a

his male nudes, straddle these sacred and profane instincts. The public did not always enjoy Sargent's attempts to depict a given body's intrigue, and he himself conducted a personal battle with repression and self-expression, a struggle that in many instances fostered outstanding art.[31]

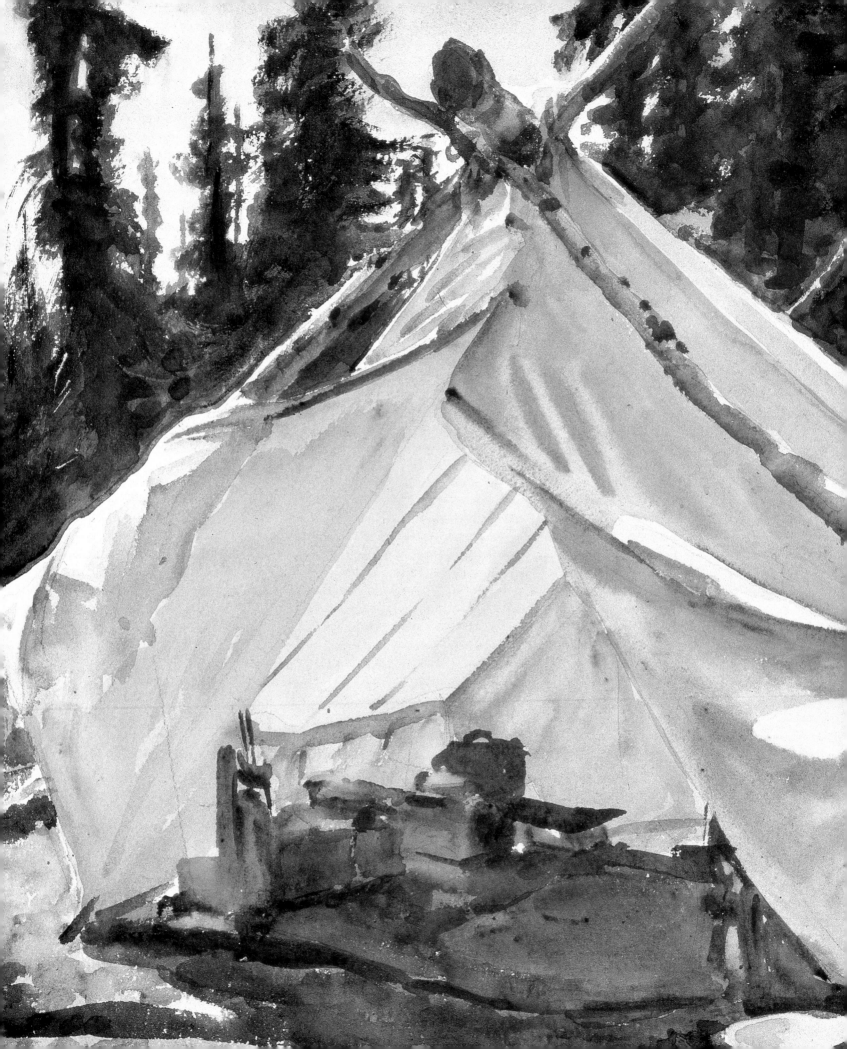

Chapter 5

PLACES OF DISTRACTION, RESPITE, AND DELIGHT

On a ride from Ceuta to Tetuán [Morocco] we essayed a most tremendous storm of hail and rain that made us shiver and set our half naked Arabs shaking in the most alarming way, but now the weather is beautiful [in Tangier]. . . . We have rented a little Moorish house (which we don't yet know from any other house in the town, the little white tortuous streets are so exactly alike). . . . All that has been written and painted about these African towns does not exaggerate the interest. . . . The aspect of the place is striking, the costume grand and the Arabs often magnificent.

—Sargent, 1880, describing his travels with French artists Ferdinand Bac and Charles Daux

Sargent relied on travel to disrupt the routine of professional life. Although he continued to paint during trips and holidays (see photo, p. 1), he worked more casually and experimentally when detached from the demands of sitters and public commissions. Prior to World War I it was not unusual for him to combine a holiday with research for his religious murals at the Boston Public Library. In 1897, for example, he wrote a young friend in Massachusetts: "My work for the library is sticking fast . . . and I am off to Sicily to find out more about angels and the Holy Trinity. They say there is plenty to see there besides."[1] By 1905 an additional benefit of travel was the opportunity to meet the growing market for his landscapes and informal figurative pictures.

Trips, tours, and journeys were embedded in Sargent's personal history: just before he was born, his parents embarked on an expatriate existence predicated on roaming and highbrow tourism. Mrs. Sargent steered their course, and she deserves most of the credit for her son's dedication to travel. In 1908 Vernon Lee eulogized "this most genially imperious, this most wittily courteous, this most wisely fantastic of Wandering Ladies" in *The Sentimental Traveller: Notes on Places*. She felt that a "sacred fury" impelled the "enchanting, indomitable, incomparable" Mrs. Sargent to

Detail of A TENT IN THE ROCKIES, 1916 (fig. 5.13)

travel; she was a "priestess of the Genius Loci" and an "inspired votary of the Spirit of Localities." Lee fondly remembered the lady's witty declaration that "the happiest moment in life was in a hotel 'bus."[2]

It was Vernon Lee's belief that anyone's pleasure in places—"the lie of the land, shape of buildings, history, and even quality of air and soil"—is entwined with his or her dreams and wishes. She argued that the places we favor in the "world of reality" always reflect "our hearts' desire." Lee later confirmed that Sargent disapproved of modern psychological interpretations of this sort: "[He] did not know that *seeing* is a business of the mind, the memory and the heart, quite as much as of the eye; and that the *valeurs* [tone values] which the most stiff-necked impressionist could strive after were also *values* of association and preference."[3]

Lee perceived Sargent as a person with two pairs of inner conflicts, each involving a battle between indulgence and repression. The first conflict he inherited from his parents: the vivacious mother opposed to the stern, self-denying father. The second derived from Sargent's own personality: he used his art to engage bizarre and outlandish subjects while guardedly denying that it had personal and symbolic meanings. This flamboyant streak troubled Sargent. Taking the *Madame X* episode as an example, it can be argued that he understood his own artistic appetite for eccentricities; yet, by repainting that portrait, he admitted that such enthusiasms might be a weakness. Since Sargent insisted that his art was devoted to external appearances, his holiday paintings ought to offer glimpses of the "real" artist with his guard somewhat down. Certainly these pictures give the fullest view of the diverse things that held his gaze. The places of his heart's desire were the sunny sequestered corners of houses, gardens, riverbanks, side streets, and harbors. And he was especially happy when he could watch and paint people or animals relaxing and napping in these quiet havens.

ESCAPE FROM LONDON

The premodern, non-Christian cultures in North Africa and the Middle East were a great lure to Sargent. His Moroccan tour of 1880 produced an important Salon picture (*Fumée d'Ambre Gris,* fig. 2.7), and his memories of those travels were probably useful when he decided to address the historic precursors of Christianity in a mural scheme. In 1890–91 and 1905–6 he made two extensive scouting and research trips for those decorations. He undertook the first with his mother and two sisters the year after his father died. After a stay in Alexandria, they toured extensively in Egypt before visiting Greece and Turkey. Sargent's Impressionist-influenced *Door of a Mosque* (fig. 5.1) shows his fascination with the clothing in these regions, particularly the stately qualities of its concealing but loose folds of

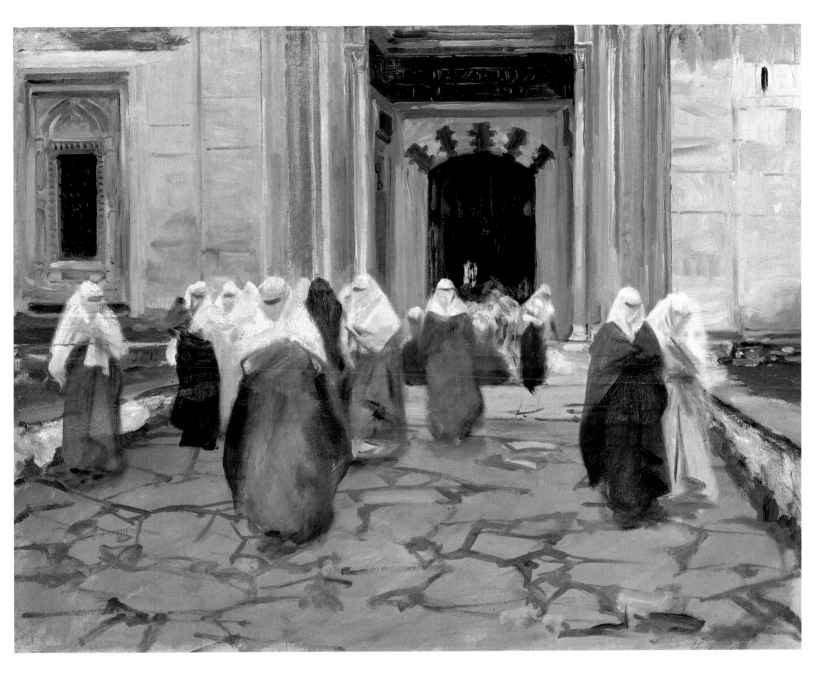

5.1 DOOR OF A MOSQUE, 1891
Oil on canvas
24⅛ × 31½ in.
Museum of Fine Arts, Boston, gift of Mrs. Francis Ormond

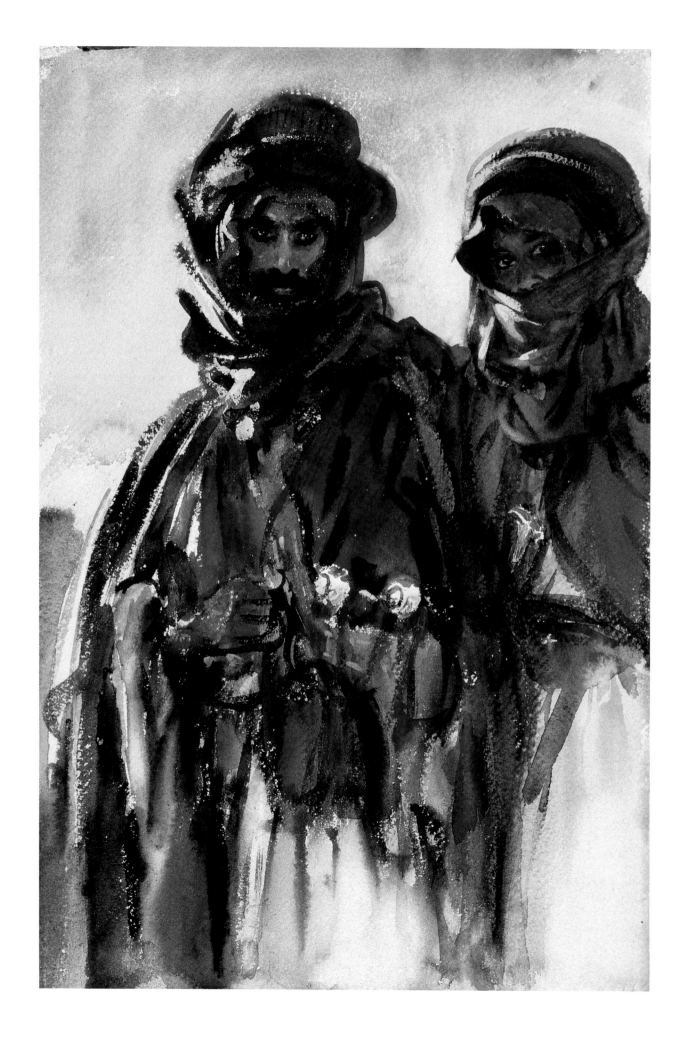

fabric. To paint *Door of a Mosque* in 1891, he positioned himself directly in front of the sacred edifice and evoked a sense of being engulfed in an exodus of heavily veiled worshipers.

Sargent painted the watercolor *Bedouins* (fig. 5.2) on a taxing journey to Syria and Palestine late in 1905. He had failed to find a male artist friend whom he could pay to travel with him (both Wilfrid von Glehn and Albert de Belleroche declined), and so he was accompanied only by his manservant, Nicola d'Inverno.[4] While he was abroad in 1906, his seventy-nine-year-old mother died in London following a series of minor ailments. Sargent made his sisters delay her funeral for the ten days it took him to get to Bournemouth. Von Glehn's wife, Jane, wrote in a letter to her mother: "It was awfully hard for them [Sargent's sisters]. I can't imagine why he did it. Except that he is probably reproaching himself so much for not coming back [to his sick mother], and wanted to make it harder for himself in some way, not realizing that it was harder for them."[5]

For *Bedouins,* Sargent had his young subjects stand immediately in front of him, their eyes engaging his. He captured the mixture of curiosity, shyness, soulfulness, and silence in their glances, then made an exuberant, sketchy record of the striking colors and shapes of their clothing. Despite this haunting record of their turbaned heads and swathed faces, his picture confirms rather than dissolves the barrier of cultural differences separating him from them. The vague longing of *Bedouins* is more touching in light of Sargent's personal life at that moment. He had felt obliged, for the sake of his murals, to visit the birthplace of Christianity, but local travel, on horseback, was arduous; his sole companion was his manservant; he turned fifty on the trip; and he was fighting off anxieties about his mother's health. The flash of adoration at the heart of *Bedouins* was indeed a respite, for Sargent was beginning to be openly negative about professional portraiture. His mother's death strengthened his resolve to focus his energy on producing, exhibiting, and selling his nonportrait watercolors and oils. In a letter written a few years later, Sargent explained his need for regular escape from his Anglo-American professional circle: "My hatred of my fellow creatures extends to the entire race, or to the entire white race, and when I escape from London to a foreign country my principle is to fly from the species. To call on a Caucasian when abroad is a thing I never do."[6] To be a foreigner in a foreign land was, among other things, a temporary antidote to celebrity and overwork.

The pleasurable themes and sentiments of Sargent's late holiday paintings had developed by 1907, and they are fully evident in *The Chess Game* (fig. 5.3). Dramatically cropped and intensely colored, it combines the artist's dual interest in figures and landscape while showcasing his mature adaptation of Impressionist style

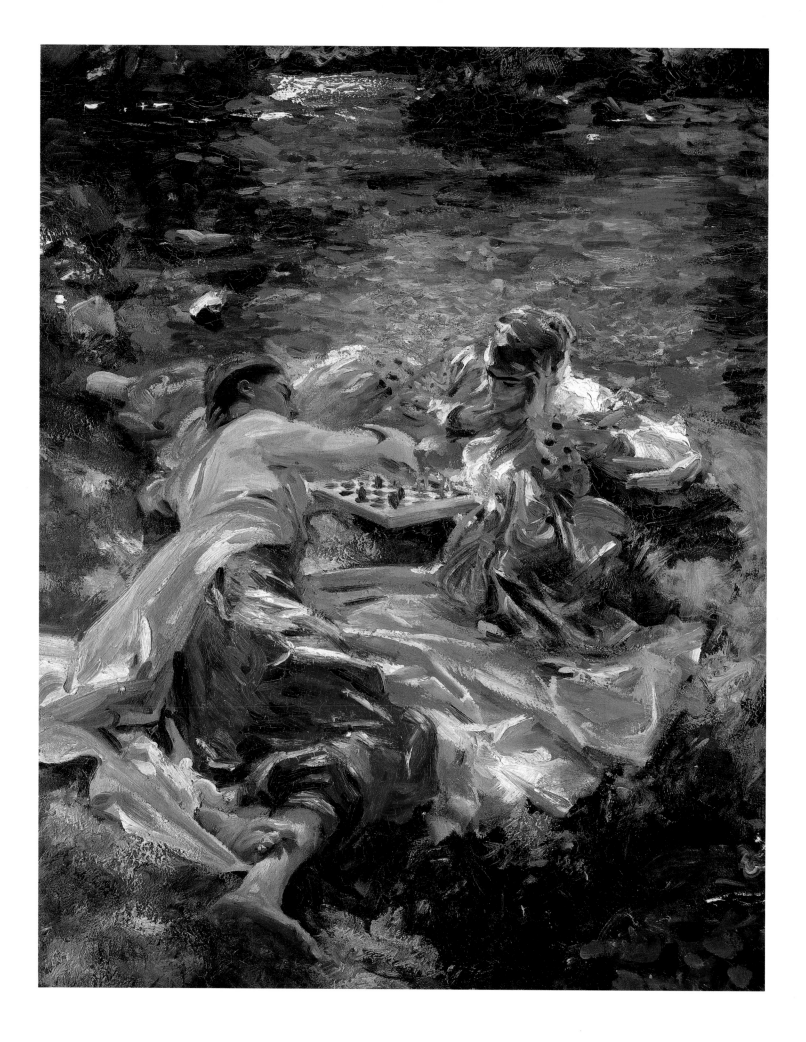

and technique. The top of the picture, where a horizonless watery landscape reflects a sunny sky, echoes Monet's recent paintings of his gardens and pools at Giverny. The foreground is pure Sargent whimsy: lying at water's edge, two people in vivid harem pants and yards of drapery are playing chess. Although the swarthy man and veiled woman might pass as members of a harem enjoying a picnic outing—despite that improbability—the motivation for this picture is not so much "reality" as the delectable pictorial pleasures of paint application, color interactions, compositional rhythms, and decorative patterns. Pleasurable diversion was the subject of the picture and the means by which it came into being. For another painting in this exotic costume series Sargent used the title *Dolce Far Niente,* an Italian expression that declares "It is sweet to do nothing." These were resonant words for him given that he was trying to curb his professional commitments. The notion of *dolce far niente* contradicted the work ethic of his New England heritage, and, ironically enough, the phrase itself may have reminded him of his puritanical father. (In 1867 Dr. Sargent commented on Roman idleness in a letter to an American friend: "*Dolce far niente* is not understood in Boston as it is practiced here."[7])

The Chess Game depicts individuals from Sargent's holiday entourage in northern Italy. For four summers (1904–7) the artist visited the remote village of Purtud, close to the Swiss border. He liked to invite his sisters Violet and Emily, Violet's family, and his own friends.[8] Soon after traveling in the Middle East, Sargent introduced fancy-dress occasions into one of these holidays so that he could make decorative paintings with playfully "Oriental" subjects. Having brought quantities of costumes to Purtud, Sargent encouraged his companions to dress up and pose for him. His outdoor masquerades featured voluptuous textiles and languorous bodies at the edge of a sunlit Alpine stream. The male character in *The Chess Game* is his manservant; the veiled female figure is impossible to identify.

Even though these outfits had some authentic components, Sargent was not pretending to make an accurate depiction of Eastern culture, which had been the case in his earlier studies for Bible illustrations of draped, reclining figures (see *Album of Figure Studies,* pp. 178–209, folios 16 and 17A). *The Chess Game* is a latter-day expression of the long-standing European tradition of fantasizing about harems and courtly customs in a mythical Asia. In the eighteenth century this kind of decorative exoticism played a major role in the Rococo style. The first translation of the *Arabian Nights* into English was published in 1708, and these fantastic stories eventually inspired William Beckford's *Vathek* (1786), a British classic in the same genre. As noted earlier, Sargent prized his copy of *Dalziel's Illustrated Arabian Nights' Entertainments* (see, for example, the princess and slave images, figs. 4.12, 4.13). He

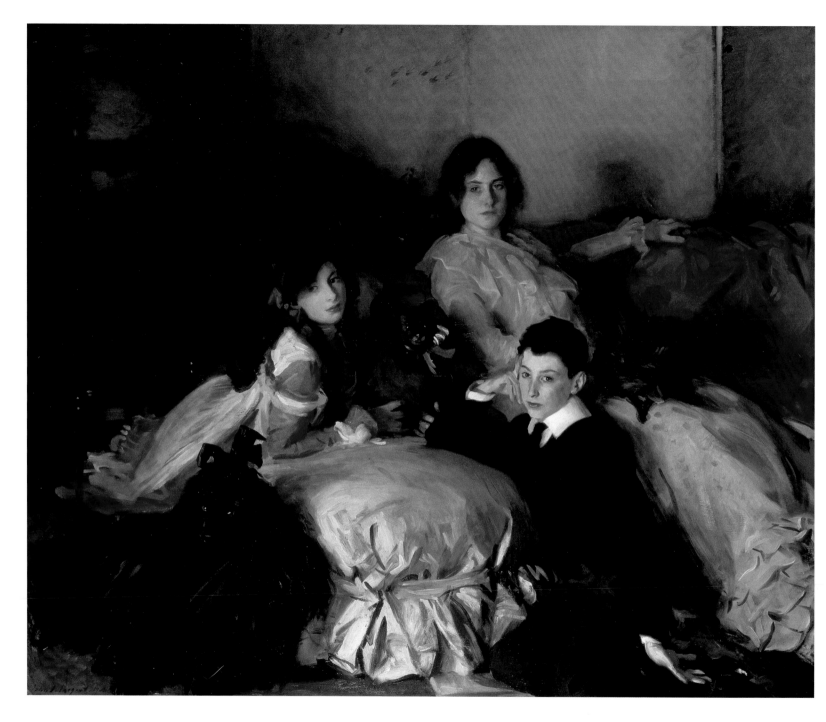

5.4 ESSIE, RUBY, AND FERDINAND, CHILDREN OF ASHER WERTHEIMER,
1902
Oil on canvas
63½ × 76¼ in.
The Tate Gallery, London, presented by the widow and family of Asher Wertheimer
in accordance with his wishes, 1922

was also a great enthusiast of *Vathek,* which he and his companions are said to have enjoyed reading on their Alpine holidays.[9] Sargent even named a painting after a character in Beckford's tale; *Princess Nouronihar,* probably produced in the Simplon Pass, depicts three women, wrapped in identical cashmere shawls, asleep on a flower-dotted, mountain-ringed plateau.[10]

Just a few years before Sargent produced *The Chess Game,* one of his commissioned London portraits (fig. 5.4) had reminded a British critic of a harem: "Here the painter has adopted a more decorative scheme, a more luscious chord of color than usual. The three children are variously and gaudily dressed; they lie about among cushions like odalisques in a harem, and are sprinkled over with dogs. The dogs are mere maps of dogs, but the children's heads are sympathetically treated, and the painting [technique] as a whole is fat and Flemish."[11] It may be that the references to gaudiness and haremlike languor were obliquely anti-Semitic, but regardless of that possibility, these remarks indicate that Sargent's Edwardian portraits already had a reputation for heightened decorative splendor and a spirit of *dolce far niente.* This British critic may have inadvertently inspired Sargent to paint Almina Wertheimer as a harem slave in 1908 (fig. 3.18).

Glimpses of others relaxing—reading, bathing, or napping—abound in Sargent's twentieth-century pictures. While *The Chess Game* showed him costuming the characters and inventing a narrative, Sargent also depicted many other languid figures in works that are more conventionally reportorial. He produced a group of watercolors of African-American bathers when he was a guest in 1917 at Villa Vizcaya, the nearly completed estate of the bachelor plutocrat Charles Deering, just south of Miami. *Figure on the Beach, Florida* (fig. 5.5) shows a man who may have been employed at the estate. Although the watercolor records what was probably an ordinary scene in that setting at that time, exoticism influenced Sargent's pictorial response; it played a role in the allure of the figure, the intimate bowerlike setting, and the sense of a voyeuristic peek into a more carefree world.

Corfu: A Rainy Day (fig. 5.6) depicts an entirely different form of relaxation. Here Sargent's painter friends the von Glehns are stuck indoors, whiling away a wet day during a holiday in Greece. Sargent's observant eye gathers telling details in a vignette. An elegant sofa serves as a crammed double berth. Jane wears a heavy overcoat to keep warm during her nap. Her feet pen her husband, while her abandoned shoes wait jauntily on the floor. Wilfrid is patient about having to read and pose. The umbrella glimpsed at the right underscores the weather problem. Sargent once joked that watercolors were his way to "make the best of an emergency," and this picture confirms that he usually found a way to work no matter what else was going on.[12]

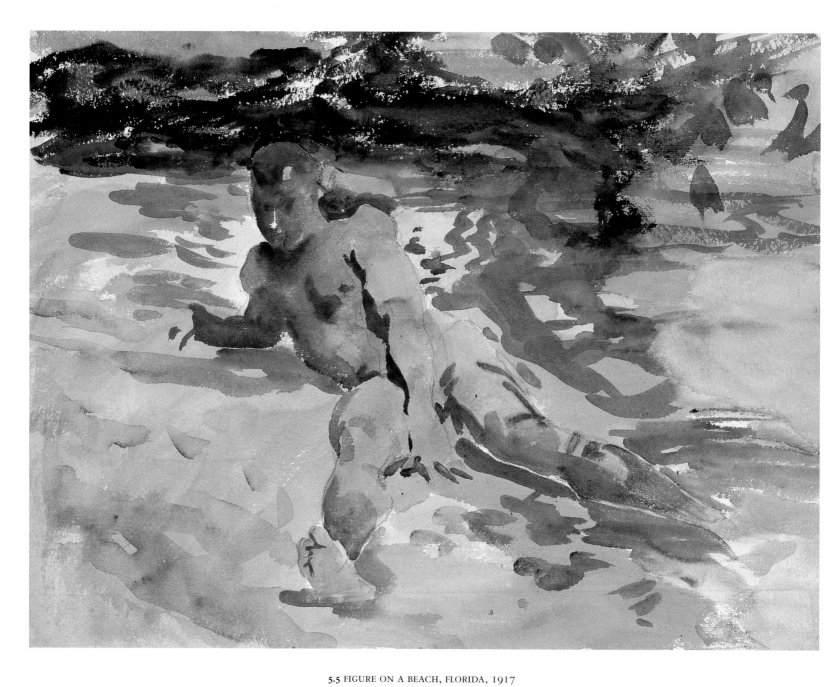

5.5 FIGURE ON A BEACH, FLORIDA, 1917
Watercolor and pencil on paper
15¾ × 20⅞ in.
The Metropolitan Museum of Art, New York, gift of Mrs. Francis Ormond, 1950

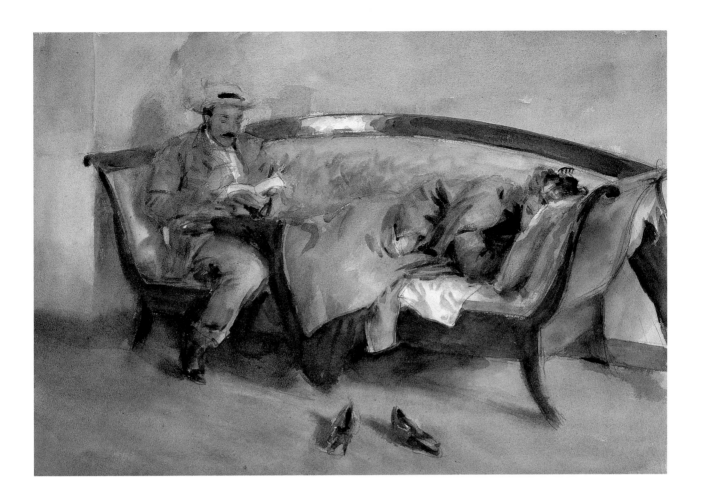

5.6 CORFU: A RAINY DAY, 1909
Watercolor and pencil on paper
14½ × 21¼ in.
Museum of Fine Arts, Boston,
The Hayden Collection, Charles
Henry Hayden Fund

LIGHT, SHADOW, AND SHADES OF WHITE

Although Sargent grew up sketching in watercolor, he did not give it steady professional attention until his late forties. In 1903 he allowed the Carfax Gallery in London to exhibit thirty of his informal figurative pictures and foreign scenes, five of which were watercolors. (Since this new gallery was primarily committed to emerging artists, it was appropriate that a celebrity like Sargent should present non-portrait works that were unfamiliar to the public.) A year later, at his debut at the Royal Watercolour Society, Sargent showed another five holiday sketches. A definitive change in his reputation—by which he was seen as much as a watercolorist as a portraitist—came in 1905, when Sargent included forty-four watercolors and only three oils in a solo exhibition at the Carfax Gallery. He won broad acclaim with this professional gambit, and his bravura watercolors were loved by the public and mainstream critics for the rest of his life.

Sargent's early-twentieth-century watercolors were his most original adaptation of Impressionism. They embody a seasoned, personal response to a style he first embraced in the 1880s. After leaving Paris, where he had attended Impressionist exhibitions and befriended Monet, Sargent had actively defended Impressionism

against the suspicions of English and American audiences. For example, his painting *A Morning Walk* (fig. 5.7) served as a banner for the Impressionist cause when it appeared in group exhibitions in London, Boston, New York, and Chicago in 1889–90. It embodied a sincere desire to emulate Monet's most recent figurative works, but it was not a slavish imitation. Sargent exercised his interest in the human figure and personality, and, as was recently argued, he may have alluded to Gainsborough's famous outdoor portrait, *The Morning Walk*.[13]

Sargent's *A Morning Walk* is an informal portrait of his teenage sister Violet, made during a holiday in the English countryside. It has several of the features that would eventually bring Impressionism enduring popularity: a rapturous response to nature; a charming, momentary image of a woman, dressed in white; and a close study of the coloristic effects of both direct and reflected sunlight. The "white" of the dress and parasol is brushed with many subtle colors, and the shadow cast up inside the parasol is a luminous tinted echo of the subject's hat and shoulders. Two American comments about *A Morning Walk,* both made in 1890, show why Impressionist art was a provocation and a threat. The critic for the *New York Times* disapproved of its "hardness of touch and shrillness of color" and claimed the picture would not have been exhibited had it been painted by an artist less prominent than Sargent; the critic for the *New York Tribune* admired its "luminous, brilliantly painted, and audacious" qualities, but felt that the reflection of the sky in the water was "palpably exaggerated."[14]

Impressionism exerted its greatest impact on Sargent's use of color. He experimented with brighter, less black-inflected palettes and sought to capture the colors of highlights, shadows, and reflections in all their variety. An element of paradox often came into play, for the artist's emphasis on the natural effects of light—blue and lavender shadows on a sunlit white dress—could produce a pictorial effect that struck some viewers as forced or unnatural. The contradictory aspects of Sargent's Impressionist credo are evident in a memorandum written by Frederick Pratt after he watched Sargent paint some Impressionist sketches in Worcester, Massachusetts, in 1890:

> The Impressionist's view of nature is introspective. He paints objects as they appear to the inner eye, expressing the extremes of light and shade . . . and emphasizing richness of colors. . . . The deliberate process of laying out and completing a picture through slow stages and laborious execution is repugnant [to him]. His work bears the marks of impulsive fervor guided by the trained instincts of the artist. . . . "Brilliancy is everything." "The expression of the transient mood of nature . . . gives to art its chief pleasure." . . . Usually the Impressionist

is one of a delicately sensitive nature, impatient and highly susceptible to influences about him. Sargent says that cultivating this highly sensational condition is probably not good for the race.[15]

The Cashmere Shawl (fig. 5.8) gives an indication of how richly Sargent translated these Impressionist preoccupations into his late watercolors. His rendering of the lights and shadows playing on the costume relied heavily on the whiteness of the underlying paper. He used a variety of techniques for different whites. Depending upon the desired effect and the particular watercolor he was creating, Sargent might do any of the following to the paper: leave it unpainted; tint it with translucent washes; mask or block out small areas with a clear waxy substance that resisted the water-based colors; apply color, then scrape or scratch out parts of it to reveal the underlying white; brush on highlights of opaque white paint called gouache.

The figure in *The Cashmere Shawl* is more airy and ephemeral than the one in the oil *A Morning Walk,* which is sculptural and solid. This stems in part from the fact that the transparency of watercolor disallows virtually any reworking, while the opaqueness of oil permits any amount of change. But the differences between *A Morning Walk* and *The Cashmere Shawl* are more than technical. The oil painting belongs to the international heyday of Impressionism, while the watercolor demonstrates Sargent's loyal and increasingly lyrical effort to sustain an Impressionist "legacy" at a time when younger figures had turned to Post-Impressionism and other vanguard departures. Sargent was twenty-two when he made the oil painting and fifty-four when he produced the watercolor. The subject of the oil painting was the mother (age eighteen) of the young woman depicted in the watercolor (Rose-Marie Ormond, age seventeen). *The Cashmere Shawl* is an inspired staging of grace and beauty. It is like a prayer to all previous works of art that celebrated the ephemeral charm of a refined young woman. Its tall, gliding draped figure is vaguely reminiscent of English neoclassical portraits, but it also has affinities with antique statues and figurines. The silhouette Sargent created with the skirt, shawl, and bonnetlike headdress harks back to the 1840s, the early Victorian period when his mother was a teenager. Through these diverse historical allusions *The Cashmere Shawl* signals a new level of interest in classicism, which would eventually lead to Sargent's blithely refined murals for the Museum of Fine Arts, Boston.

There is a fitting correspondence between Sargent's pictures of stylish women in white and his watercolors of pale marble statues. *Boboli* (fig. 5.9) is part of a group of watercolors produced in Florence at the Boboli Gardens. This particular statue is an allegory of Prudence by the sixteenth-century sculptor Giovanni Caccini, and one of four decorative accents placed at an intersection on the main avenue that

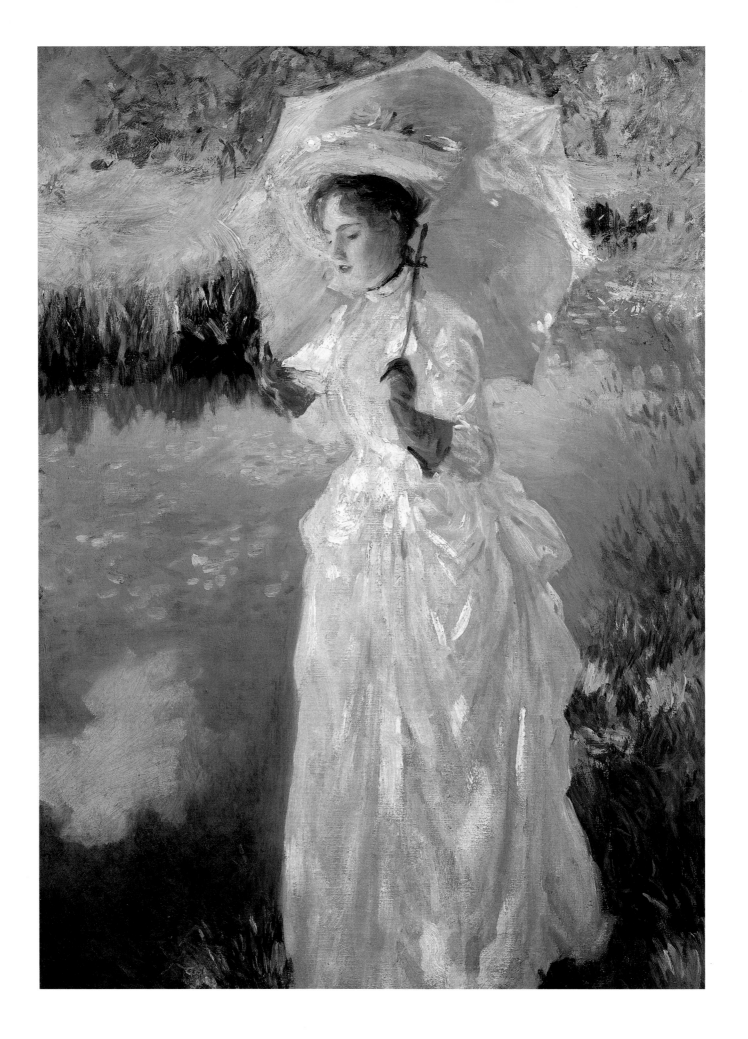

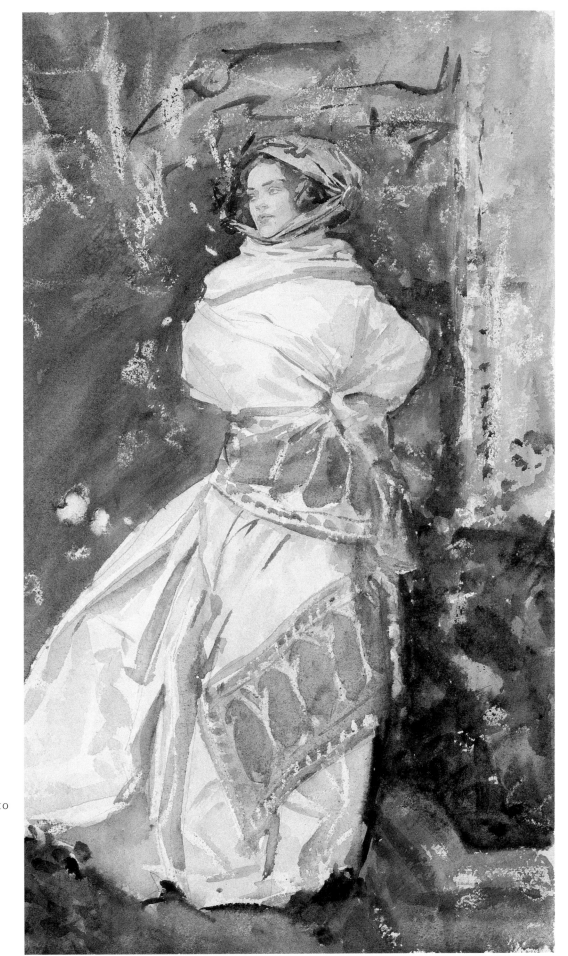

5.7 A MORNING WALK, 1888
Oil on canvas
26½ × 19¾ in.
Private collection

5.8 THE CASHMERE SHAWL, 1910
Watercolor and pencil on paper
20 × 14 in.
Museum of Fine Arts, Boston,
The Hayden Collection, Charles
Henry Hayden Fund

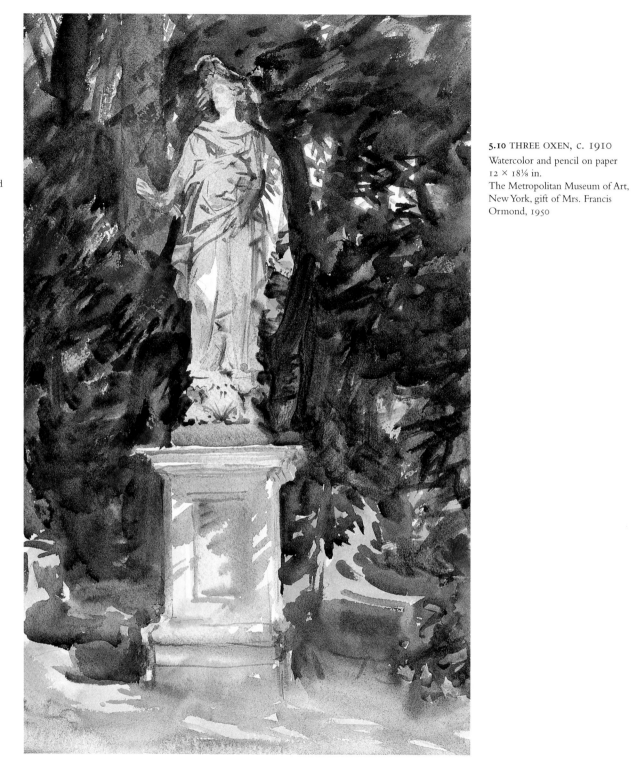

5.9 BOBOLI, 1907
Watercolor and pencil on paper
18⅛ × 11⁷⁄₁₆ in.
Brooklyn Museum of Art, purchased
by special subscription

5.10 THREE OXEN, C. 1910
Watercolor and pencil on paper
12 × 18⅛ in.
The Metropolitan Museum of Art,
New York, gift of Mrs. Francis
Ormond, 1950

5.11 TOMMIES BATHING, 1918
Watercolor and pencil on paper
15⁵⁄₁₆ × 20¾ in.
The Metropolitan Museum of Art,
New York, gift of Mrs. Francis
Ormond, 1950

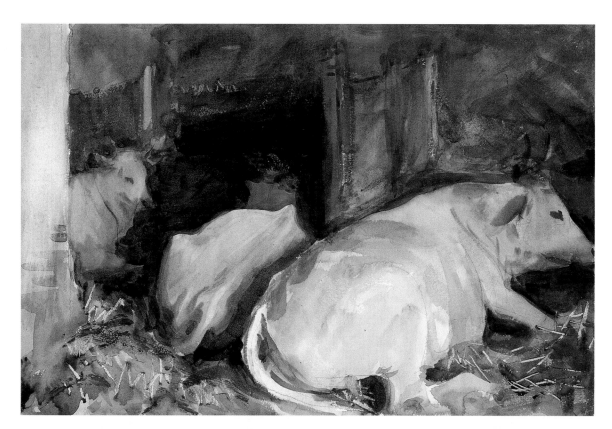

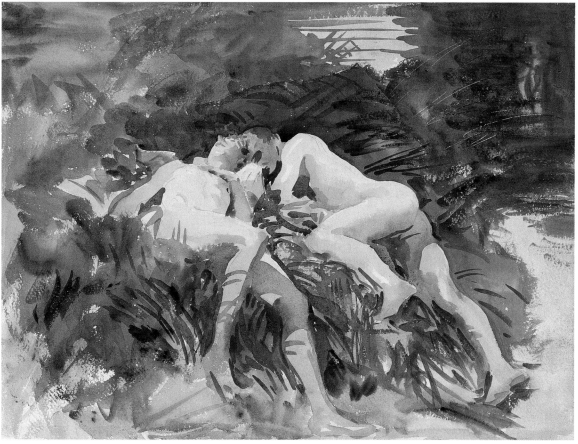

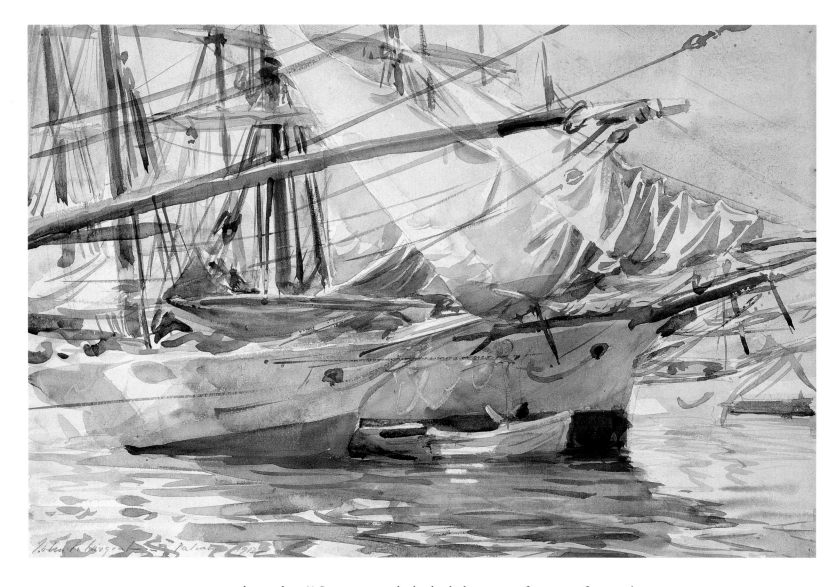

5.12 YACHTS AT ANCHOR, PALMA
DE MAJORCA, 1912
Watercolor and pencil on paper
16 × 20 in.
Private collection

crosses the gardens.[16] Sargent records the body language of a serene figure who personifies thoughtfulness and planning, but *Boboli* is mostly devoted to capturing the atmosphere of tinted shadows and lush foliage that shrouds and encircles the tall marble creature. All but bringing the serene statue to life, Sargent evokes a spirit that seems to haunt the air, the plants, and the venerable pathways where it stands. This is the essence of the *genius loci* described by Vernon Lee. Sargent's appreciation of these tangible but ephemeral things gives his watercolor its poetic force. His response also reflects the new interest in early formal gardens, a taste that was promoted in 1904 in Edith Wharton's *Italian Villas and Their Gardens.*[17]

Although complicated white forms had been subjects for Sargent's watercolors as early as 1880 (see the Moroccan example, fig. 2.10), he did not embrace them as a combined formal challenge and playful holiday quest until the twentieth century. Women in white were a pictorial convention, but Sargent chose many other

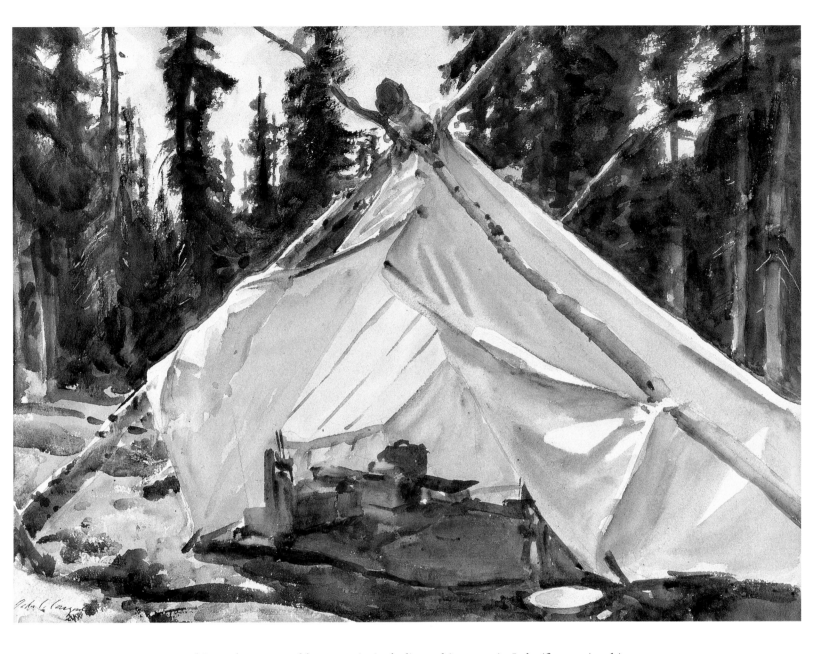

subjects that were odd or prosaic, including white oxen in Italy (fig. 5.10), white horses in Palestine, pale muddy alligators in Florida, and pallid soldiers sunbathing beside a French river during World War I (fig. 5.11). From Monet, in the 1880s, Sargent learned to use a small boat as a floating studio, enabling him to work where sunlight and water interact to generate a radiant shimmer. When in a harbor—in the Mediterranean (fig. 5.12), Maine, or Florida—Sargent would float among the white hulls and sketch the movement of water and the bouncing reflections of light. Sails, furled or unfurled, were another white attraction. When landlocked, he responded to similar forms—a line of laundry in an Italian yard or the flaps of a tent in the Canadian Rockies (fig. 5.13). Sargent's energetic curiosity amplified the

5.13 A TENT IN THE ROCKIES, 1916
Watercolor and pencil on paper
15 × 20½ in.
Isabella Stewart Gardner Museum, Boston

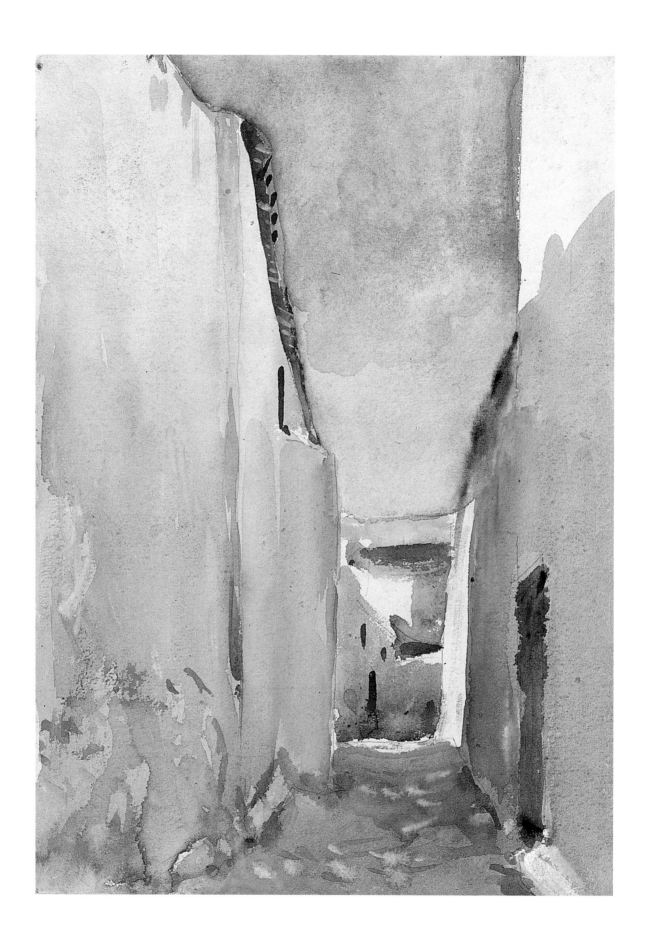

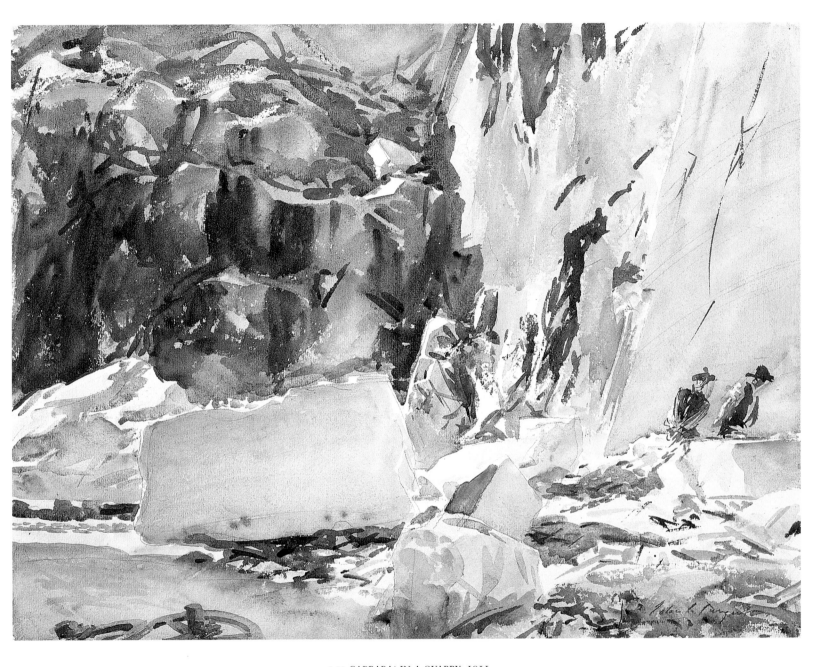

5.15 CARRARA: IN A QUARRY, 1911
Watercolor and pencil on paper
16 × 20¾ in.
Museum of Fine Arts, Boston,
The Hayden Collection, Charles Henry Hayden Fund

5.14 TANGIER, 1895
Watercolor and pencil on paper
13¹⁵⁄₁₆ × 9¹⁵⁄₁₆ in.
The Metropolitan Museum of Art,
New York, gift of Mrs. Francis
Ormond, 1950

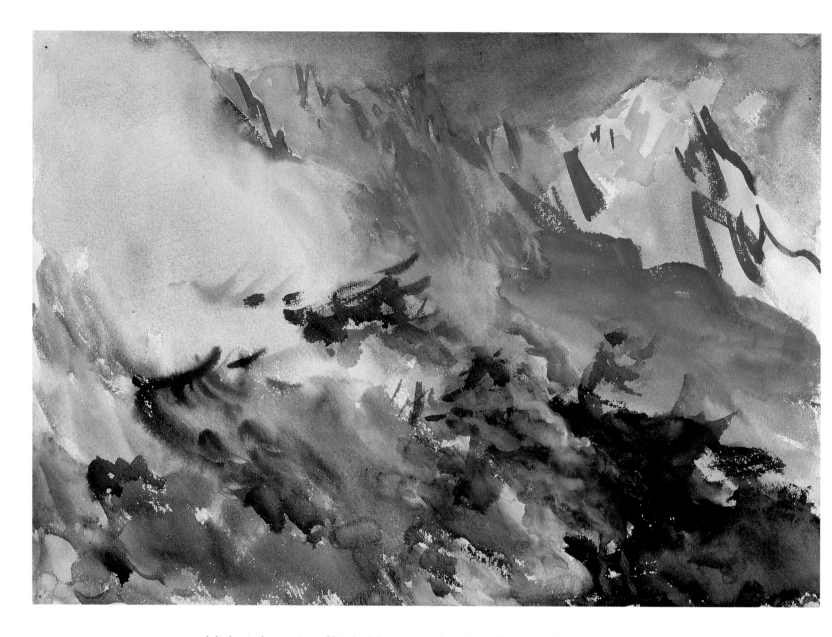

5.16 MOUNTAIN FIRE, C. 1903
Watercolor and pencil on paper
14 1/16 × 20 in.
Brooklyn Museum of Art, purchased
by special subscription

delight and surprise of his holiday watercolors. It makes sense that some people now consider Sargent's watercolors his most rewarding works—they embody an enthusiasm and spontaneity noted by his friend Evan Charteris: "[Sargent] had the supreme gift of being able to look forward, with the certainty of discovering excitement in new scenes and places."[18]

Sargent was happy to paint the forms of *things*—people, animals, objects, and buildings—and less drawn to the atmospheric volumes inherent to landscape. "Enormous views and huge skies do not tempt me," he remarked in 1920.[19] When Italian friends encouraged him to paint a scenic view *(una veduta)* he remarked: "I can paint objects; I can't paint *vedute*."[20] Although abstraction and spatial ambiguity exist in some of his watercolors—one of an empty street in Tangier (fig. 5.14),

another devoted to boulders in a marble quarry (fig. 5.15)—their compositions are built around the specifics of sunlight defining a space, as opposed to evocations of general atmosphere. *Mountain Fire* (fig. 5.16) is one of the few "enormous views" that Sargent painted. Lacking a foreground, he used a nearby cloud of smoke and the most distant sunlit peak to balance the composition of this technical tour de force. It takes a while to realize that the opaque red markings in the lower right are the flames of the fire, and even then the scale of things remains uncertain.

It can be hard to keep Sargent's broad range of interests in focus. The man who communed with the majestic goddesses of the Boboli Gardens (fig. 5.9) was also happy to spend time in the stable with oxen (fig. 5.10). For all his urbanity and familiarity with the staterooms of ocean liners, Sargent was happy to rough it when his traveler's curiosity was piqued. A trip to Yoho National Park, British Columbia, in 1916 was one of the toughest. Sargent's quest to paint the remote and spectacular Twin Falls seems to have been inspired by a postcard given to him by Denman Ross, a Bostonian aesthete. Living in tents for several weeks became an endurance test after rain and snow set in near Lake O'Hara. Sargent, usually uncomplaining, wrote: "There was a good deal of hardship about it."[21] Despite everything, the Canadian sojourn produced a handful of grand landscapes and some wistful pictures of the bracing accommodations. The oil painting *Tents at Lake O'Hara* (fig. 5.17) is a souvenir of the damp and chilly days at the camp: a muddy terrain, the dark grandeur of the encircling trees, the trappings of hearth and table, and the young guide who accompanied Sargent and his manservant. After enduring freezing nights, the sixty-year-old artist was no doubt happy to resume work on the pictorial options at hand. Even the wan autumn sunlight of the Canadian Rockies could inspire a good picture when there was something white for it to play against—draped tent fabric and pale smoke lingering in the moist air.

HARKING BACK TO ITALY

Despite an American passport and a British home base, Sargent's enjoyment of the world had strong roots in Italy, his country of birth. Prior to World War I he returned regularly to experience the culture he loved. Italians practice a special sensory appreciation of the beauty in life, and Sargent knew this instinctively. His Italian pictures comprise an almost encyclopedic grasp of the country's cultural heritage: views of Venice, Florence, Rome; landscapes of legendary lake and mountain regions; informal portraits of historic buildings, sculptures, fountains, and gardens; and sketches of the Italians themselves, possessors of a vital civilizing legacy.

Sargent never had a problem finding something to paint in Italy. The improbable subject of one haunting early picture is a winepress in a dimly lit basement

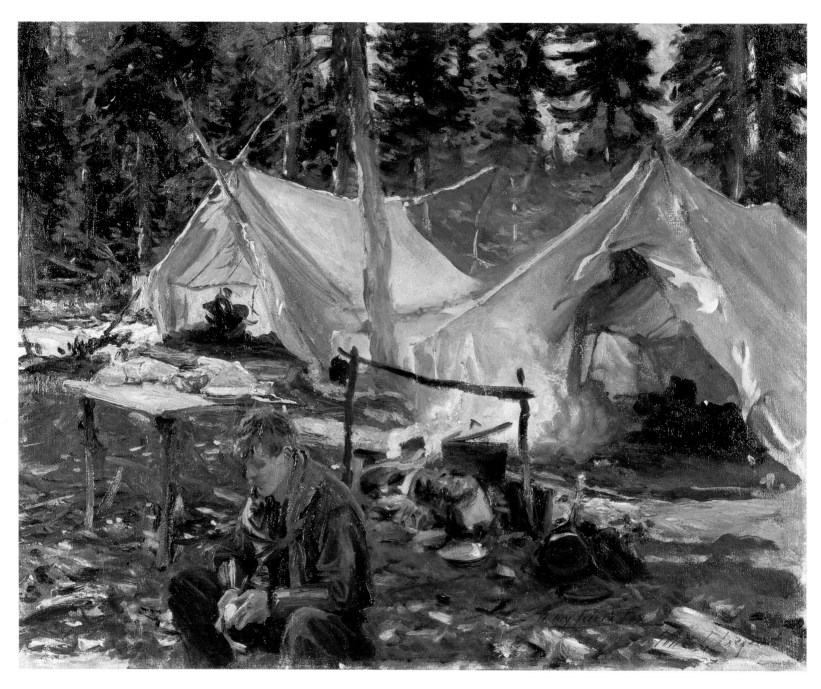

5.17 TENTS AT LAKE O'HARA, 1916
Oil on canvas
22 × 28⅛ in.
Wadsworth Atheneum, Hartford,
The Ella Gallup Sumner and Mary Catlin
Sumner Collection Fund

5.18 PRESSING THE GRAPES: FLORENTINE
WINE CELLAR, C. 1882
Oil on canvas
24⅛ × 19⅝ in.
The Beaverbrook Foundation, The Beaverbrook
Art Gallery, Fredericton, New Brunswick

(fig. 5.18). The drama of this rapid impression conveys Sargent's rapport with a most Italian subject and setting: the moody atmosphere of the room; the nostalgic aura of the worn, stained baskets and old equipment; and the wholehearted exertions of the people who worked there. Although the picture has never been well known, it inspired a remarkable passage in R. A. M. Stevenson's early essay on Sargent:

> [This] sketch . . . exactly demonstrates Mr. Sargent's wonderful power of suggesting a mysterious sentiment by light. The vicious tones of the wine stains on the floor and wall, the glimmer of light on bare flesh standing out sharply from the dim swimming atmosphere, and the threatening bulk of the wine-press reaching its arms into the darkness, all combined to produce the aspect of some hideous underground torture-chamber. It is in such scenes that Mr. Sargent should seek the poetical expression of his way of seeing. No one could compete with him in treating the mystery of real light and shadow, wrapping figures in a half gloom.[22]

A late watercolor with its own distinct sense of mystery is also connected to wine production (fig. 5.19). Sargent painted numerous stained leather wine bags hanging in a roofed and colonnaded space. Their bizarre shapes and reddish-purplish colors struck a chord with Sargent's eye. This image would be hard to understand without the title's explanatory reference to "wine bags"—containers made from animal hides according to ancient winemaking practice. The bags seem to speak of the visceral, messy, and transitory nature of life, especially when presented in contrast to the enduring and orderly classicism of the architecture. It might even be argued that they symbolize the Italian sensuality that Sargent's more proper Anglo-American contemporaries frowned upon. Sargent also depicted the "home" of these weird, raunchy wine bags in a square and unusually large watercolor, *Florence: Torre Galli* (fig. 5.20). In combining an architectural portrait and a genre scene, this orderly composition is reminiscent of a stage set. The hanging bags are visible in the open gallery near the top of a crenellated medieval wall. The main doors of the courtyard are open, revealing a long tree-lined road. Workers occupy the foreground: six Italian men and two pairs of yoked white oxen. Sargent was staying with a party of friends at the Villa Torre Galli in 1910 when he produced this workaday autumn scene.[23]

In the autumn of 1911 Sargent lived in very modest circumstances in order to make watercolors and oil paintings in the marble quarries outside Carrara. As in the early painting of the Florentine winepress, he chose to depict a craft-based activity rather than modern industrial labor. He was drawn to processes with deep

5.19 FLORENCE: TORRE GALLI
WINE BAGS, 1910
Watercolor over pencil on paper
19¾ × 12½ in.
Museum of Fine Arts, Boston, The
Hayden Collection, Charles Henry
Hayden Fund

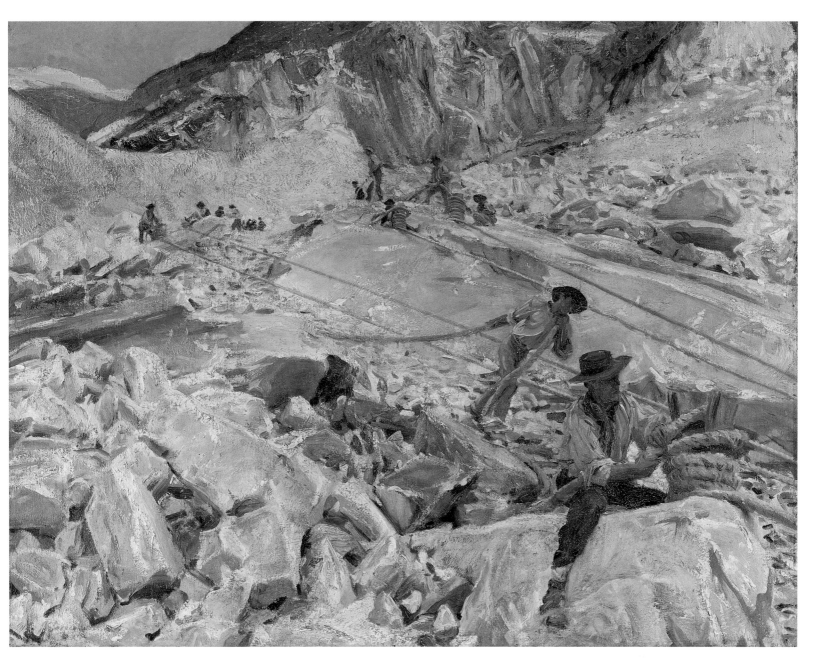

5.21 BRINGING DOWN MARBLE
FROM THE QUARRIES TO CARRARA,
1911
Oil on canvas
28⅛ × 36⅛ in.
The Metropolitan Museum of Art, New
York, Harris Brisbane Dick Fund, 1917

5.20 FLORENCE: TORRE GALLI,
1910
Watercolor and pencil on paper
26½ × 26¼ in.
Museum of Fine Arts, Boston, The
Hayden Collection, Charles Henry
Hayden Fund

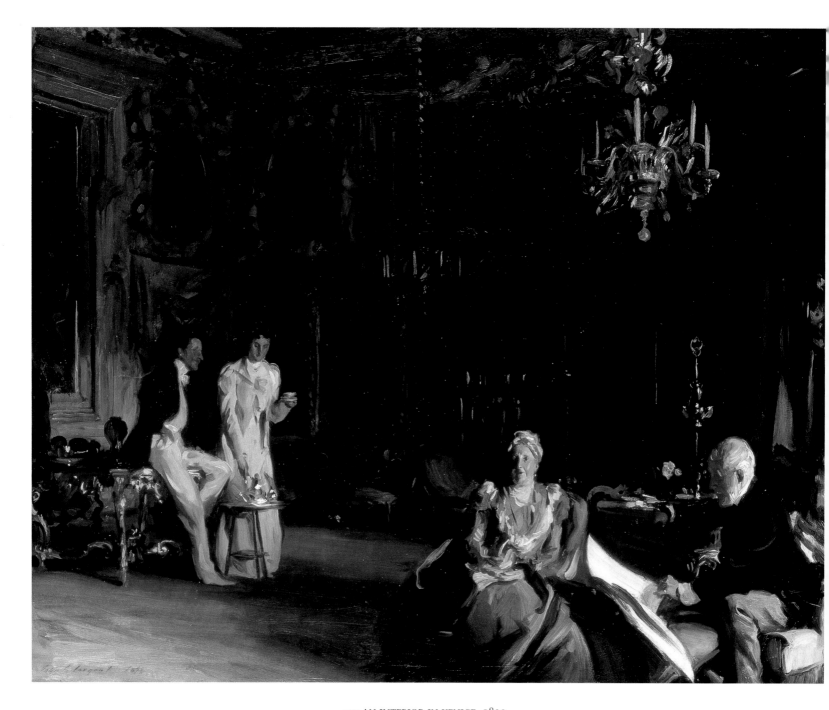

5.22 AN INTERIOR IN VENICE, 1899
Oil on canvas
25½ × 31¾ in.
Royal Academy of Arts, London

historic roots, and Carrara, after all, provided the finely textured white marble used by Roman and Renaissance sculptors, including Michelangelo. The largest of the Carrara paintings (fig. 5.21) is a stirring tribute to the physical effort and engineering skill required to harvest marble from the earth's crust. From a pictorial point of view, the teams of workers deploying massive ropes provide a sense of scale in this disorienting and inhospitable terrain.

Sargent interacted with many different types of people in Italy. An important and regular stop during his travels was the luxurious Venetian establishment maintained by the Curtis family. They lived in the Palazzo Barbaro, a Gothic building with splendid early-eighteenth-century interior decorations. *An Interior in Venice* (fig. 5.22) shows two generations of Curtises in the airy, magical ballroom that overlooks the Grand Canal. These Americans easily inhabit their extravagant milieu of fanciful furniture, sparkling chandeliers, and ornate plasterwork. Sargent's dapper artist friend Ralph Curtis is seen taking tea with his wife of two years; Ralph's slightly uptight parents, two expatriated Boston Brahmins, occupy the foreground. The senior Mrs. Curtis faulted the picture for revealing her age and for making her son look too slouchy. Another favored guest of the Curtises was Henry James, who used some of his impressions of the palazzo in his novel of 1902, *The Wings of the Dove.*

Venice, an idiosyncratic center for medieval, Renaissance, and Baroque art, inspired Sargent's largest and richest group of Italian pictures. Nowhere else does the meeting of water and sky, palace and gutter, beauty and decay, and fantasy and fact spark the imagination with such romantic force. In the nineteenth century Venice enraptured romantic types, for she was a magical and melancholy survivor, stripped of her former might, floating in isolation at the edge of the sea. A most touching regal presence, she offered abundant echoes of her former importance as a style center for art, architecture, music, lace, and glass. Sargent's watercolor of the Custom House, La Dogana (fig. 5.23), expresses the ecstatic pleasure he could feel during a sunny day in Venice. Working close to the tower of this famous landmark, he looks up to its remarkable sculptural ornament comprising two giants holding a golden ball on which the nimble figure of Fortune has alighted. This whimsical early-seventeenth-century work by Bernardo Falcone marks the entrance to the Grand Canal and functions as a weathervane (the shield that Fortune holds aloft catches the wind and causes her figure to rotate). The expressive brushwork and vibrant color of *Venice: La Dogana*—the swiveling figure atop her golden ball, the wispy clouds sweeping energetically across the blue sky, the radiant whiteness of the architecture—confirm Sargent's joy.

5.24 BRIDGE OF SIGHS, C. 1905–8
Watercolor and pencil on paper
10 × 14 in.
Brooklyn Museum of Art, purchased
by special subscription (09.819)

5.23 VENICE: LA DOGANA,
C. 1906–11
Watercolor and pencil on paper
19¾ × 14 in.
Museum of Fine Arts, Boston, The
Hayden Collection, Charles Henry
Hayden Fund

A similar exuberance is conveyed in the watercolor *Bridge of Sighs* (fig. 5.24). Sargent sketched the familiar landmark that separates a palace (at the left) and a prison. The bridge is blanched by bright sun, and Sargent gives a good deal more attention to a gondola that has just passed beneath it. The aerial bridge becomes a serene, crownlike foil for the bustle in the foreground, where a pair of gondoliers whisk their parasol-bearing passengers out of the shady side canal and toward the lagoon. Sargent underscores the dynamic divisions of his composition by using bravura strokes of thick opaque white paint to depict the gondola's occupants. The viewer's eye jumps back and forth between the pale wet washes that capture the quiet repose of the massive buildings and the forceful marks devoted to the propulsive movement of the boat.

Gondoliers were an important part of the human attractions in Venice. One need only turn to the writings of Henry James for confirmation of the fact that these picturesque specimens of masculinity delighted male and female observers. In an essay of 1872 the twenty-eight-year-old American opined: "The mere use of one's eyes in Venice is happiness enough. . . . Everything the attention touches holds it, keeps playing with it—thanks to some inscrutable flattery of the atmosphere. Your brown-skinned, white-shirted gondolier, twisting himself in the light, seems to you, as you lie at contemplation beneath your awning, a perfect symbol of Venetian 'effect.'"[24] In *Roderick Hudson* (a novel serialized in *Atlantic Monthly* in 1875), James wrote: "One morning the two young men had themselves rowed out to Torcello, and Roderick lay back for a couple of hours watching a brown-breasted gondolier make, in high relief against the sky of the Adriatic, muscular movements of a breadth and grace that he had never seen equalled."[25] A second essay on Venice, published in 1882, included the following impression: "Nothing can be finer than the large, firm way in which, from their point of vantage, . . . [graceful gondoliers] throw themselves over their tremendous oar. It has the boldness of a plunging bird and the regularity of a pendulum. . . . Lifted up against the sky [the man's arching body] has a kind of nobleness which suggests an image on a Greek frieze."[26]

Sargent's pencil drawing of a gondolier (fig. 5.25) shows that he too savored the bold grace of these limber men. Like the pair in *Bridge of Sighs,* this one wears a white costume and colored sash; his hair is closely cropped. Despite an impressive economy of lines, Sargent's drawing captures the poise of the figure—his weight resting on his right leg, the body slightly swiveled, and each arm directing the oar with a different force. A particular attention to the folds of the clothing confirms that the artist was looking for outward signs of the body's exertions. Sargent, a connoisseur of *bella figura,* enjoys the quaintness of the traditional costume. The presence of the big sash on this gondolier's well-developed form

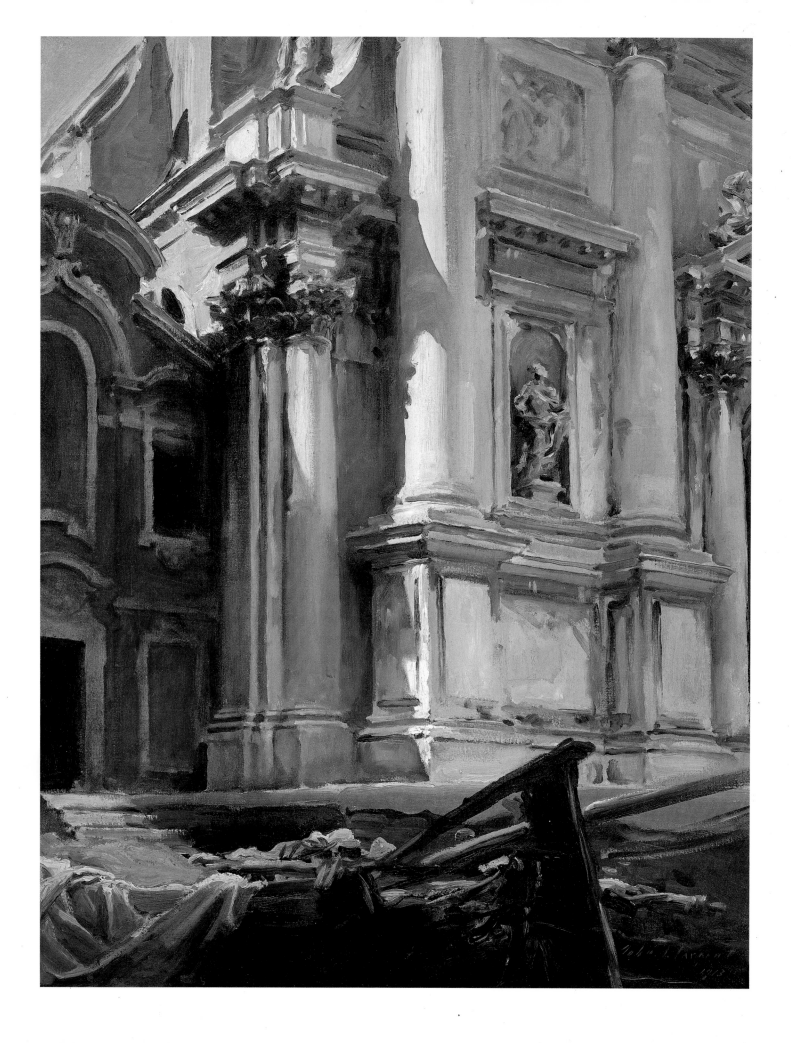

has a certain rapport with the tasseled red headdresses that Sargent depicted on the oxen in *Florence: Torre Galli* (fig. 5.20). In both pictures these details show him savoring a cultural fusion of decorative sweetness and muscular brawn.

Sargent's *Corner of the Church of San Stae, Venice* (fig. 5.26) distills the city's enduring power as a font of sensual pleasure. It confirms, moreover, Venice's memorable ability to serve up her charms with delightful eccentricity. It is impossible to find a true visual center in this remarkable composition. Sargent has stumbled on a wonderful set of juxtapositions and memorialized their lively asymmetry. Although the diminutive red-painted Scuola dei Battiori and the grandly exuberant stone San Stae continue to stand in neighborly disjunction, everything else Sargent painted that day was ephemeral: the quality of light; the tinted shadows sliding round San Stae's columns; the sailing boat that separates Sargent (in his gondola) from the buildings. In ways that are unique to Venice and central to Sargent's appreciation of that city, the picture unites grandeur and modesty. The expressive figure in the niche of the great Baroque church seems as thrilled as Sargent to be part of this spectacular place.

5.26 CORNER OF THE CHURCH OF SAN STAE, VENICE, 1913
Oil on canvas
28½ × 22 in.
Private collection

Chapter 6

UNRAVELING THE PARADOXES

*His burly full-blooded aspect was deceptive: it gave no warrant of the diffidence and gentle-
ness that lay beneath. A stranger would never have suspected that behind such alacrity and
power was an almost morbid shrinking from notoriety and an invincible repulsion from public
appearances. In this respect he presented a continual paradox. . . . He was shy of emotion,
inclined to shirk it when it came his way; this made him difficult to know: he seemed to protect
himself in a network of repressions.*

—Sargent's British biographer, Evan Charteris, 1927

Sargent performed one of art history's great balancing acts. At the height of his
cosmopolitan career he sought fame and fortune through portraiture, modernity
through experimentation, immortality through public mural decorations, diversion
through watercolors, and a private sense of community through tender male im-
agery. Passions for historic and contemporary art, music, literature, collecting, and
travel filled his life, cross-fertilized each other, and fed the teeming sensibility from
which his art flowed. The kinds of things that excited him—Venice, Wagner's op-
eras, Mannerist and Baroque sculpture, Fauré's chamber music, alluring Mediter-
ranean people, and the dancing of Nijinsky and Karsavina—befit a person with a
vivid imagination and a need for rapturous emotional escape. After contemplat-
ing the luscious aspects of *The Chess Game* (fig. 5.3) it is myopic to picture Sargent
as a stranger to closeness and affection. Nonetheless, scholars too often have cred-
ited him with a cold-fish detachment, even as they avowed the voluptuous lean-
ings of his art. As discussed earlier in this book, he engineered this paradox through
a willful caginess. On becoming famous, he disassociated himself from his subject
matter by refusing to discuss possible interpretations of his work, then developed
a few lines for protection: "I do not judge, I only chronicle"; "I chronicle, others

Detail of ASTARTE, 1895
(fig. 6.3)

153

may judge"; and "I chronicle, I do not judge."[1] The cold-fish legend presided over the catalogue of the last major Sargent retrospective (1998):

> Sargent continues to guard his privacy. That he was a physical and sensual kind of person is clear from the whole tenor of his work. But he did not relish intimacy, and he avoided emotional entanglements likely to complicate his life and compromise his independence. If he had sexual relationships, they must have been of a brief and transient nature, and they have left no trace.[2]

Given that Sargent was "a physical and sensual kind of person," it is logical to explore the connections between his temperament and his artistic activities. While his pictures do not illustrate his personal life, they are sources of visual evidence about his character as well as physical information about his artistic technique. Creative productions—especially art and literature—bear traces of biography, as Sargent's psychologically perceptive contemporaries Vernon Lee (see p. 116) and Oscar Wilde well understood. One of Wilde's characters observed in a short story of 1889: "All Art . . . [is] to a certain degree a mode of acting, an attempt to realize one's own personality on some imaginative plane out of reach of the trammeling accidents and limitations of real life."[3]

Sargent's *Album of Figure Studies* is a prime work to engage when considering the relationships between the artist's sensuality, his approach to his subjects, his self-image, and his public image. These charcoal drawings are just as vivid and individual as his better-known society portraits, Impressionist studies, Venetian vignettes, cashmere shawl caprices, and allegorical designs for murals. The album's male images are variously immediate, lush, intimate, heroic, and tender, and the artist's technical control of the charcoal medium is superb. The presumed dishonor of same-sex affections has abetted the historical obscurity of these drawings, and the artist must take part of the blame: he seems to have valued them as personal studio items while quietly keeping them out of his public professional record. Sargent's need to screen his sexual nature and his "almost morbid shrinking from notoriety" fostered the skewed and sharply contested perceptions of his art that prevailed in the twentieth century.[4] Not surprisingly, scholars remain defensive about a revisionist approach to Sargent's sexuality. They do not want to make conclusions solely on the basis of the visual evidence of his art, and they are likewise content to believe that Sargent preserved his privacy so well that no documentary proof is likely to exist.

Now that art historical practice is becoming more open about the impact of personal identity and desire upon creative sensibility and process, a dialogue is starting to develop around Sargent. In fact there has long been a curiosity about his

seemingly inscrutable personal life, not least because his own best work is so often entwined with the allure of others. It is now documented that Sargent's personal life was debated in London's artistic circles soon after his death, and one of his early sitters, Jacques-Émile Blanche, reported in conversation that Sargent had active associations with men.[5] Moreover, some members of the Wertheimer family were equally assured of his sexual orientation.[6] In the 1970s the veteran Sargent scholar David McKibbin indicated the same opinion in conversation, while cautioning that it was a topic that few liked to mention.[7] In light of this new evidence, Bernard Berenson's comments about Sargent—"He was completely frigid as regards women" and "Was he a lover of women?"—now seem like informed hints.[8] To know that the male nude symbolized something of great consequence in Sargent's life is important and necessary for building an honest and respectful understanding of his public stance. A fuller account of the complexities that affected the person and his art enriches our perceptions of both.

THE 1890s

While it means revisiting some of the issues and objects discussed earlier, a close look at the key decade of Sargent's career will help elucidate the genesis of his paradoxical public persona. As the decade opened, he was well known on both sides of the Atlantic as a talented, innovative, and unpredictable young portraitist. The invitation of 1890 to decorate a room in the new Boston Public Library expanded Sargent's repertoire and signaled that mainstream reservations about his unconventionality were beginning to subside. But a remark made in 1890 by fellow muralist Edwin Austin Abbey confirms that Sargent *was* a risky choice, for Abbey was making reassurances to the building's main architect, Charles McKim: "You will surely get a great thing from him. He can do *anything,* and don't know himself what he can do. He is latent with all manner of possibilities, and the Boston people need not be afraid that he will be eccentric or impressionistic, or anything that is not perfectly serious or non-experimental when it comes to work of this kind."[9] Sargent, however, was privately determined to turn the mural project into the biggest splash he could get away with. In 1890 he crowed to his friend Ralph Curtis: "This Boston thing will be (entre nous) Medieval, Spanish, and religious and in my most belly achy mood—with gold, gems, and phosphorescent Hellenes [ancient Greeks]. What a surprise to the community!"[10] It was his desire to subvert convention with a glittering display of sensual, religion-based imagery.

Sargent was riding high in 1890. Thanks to a rush of portrait commissions from Americans, he was feeling the first flush of financial success. And some of his artistic peers were beginning to acknowledge his clever way of combining Old

Master traditions and Impressionist innovations.[11] People talked about him as well as his art, and he fed them fodder. In Boston, for example, he voiced an interest in brothels. The Impressionist painter Theodore Robinson learned from a mutual acquaintance that Sargent "asked, very audibly, directly on his arrival . . . at some club, where were the swell houses of assignation."[12] His reasons for this obvious maneuver are not known. He may have been seeking modeling or sexual services; the individuals may have been male or female; he may have been striking a pose to throw people off his scent.

Edwin Austin Abbey's correspondence confirms that Sargent was planning to paint a nude in 1890, although whether it was to be male or female is not known.[13] The nude he created in Africa the following year, a full-length painting of a supple young woman titled *Egyptian Girl* (fig. 6.1), emerged during research for his mural projects. Despite its subtle eroticism, it had sufficient modesty and formality to be exhibited and illustrated in Great Britain and the United States without complaints. The artist chose a contorted pose that challenged his virtuosity, and the extensive reworking of the paint surface, especially the silhouette, confirms that he had to labor to get the form right. Judged in relation to contemporary Parisian paintings of the female nude, Sargent's *Egyptian Girl* is prim, and when compared to the male nudes in his *Album of Figure Studies,* it seems strained and unsure. Indeed, in 1905 a critic pointed to the unresponsiveness behind *Egyptian Girl:* "The thing is done as well as it may be done, but it is passionless and coldly disinterested."[14] Exhibiting a female nude was no doubt a risk for a portraitist dependent upon polite Anglo-American society, but it may also have been a calculated gambit to allay questions about his bachelor status.

The various enthusiasms that Sargent projected in the early 1890s are broadly reflected in the mural he installed at the Boston Public Library in 1895—a ceiling, lunette, and frieze devoted to pagan and pre-Christian religions. The sumptuous tenor of the whole is conveyed by a detail from a large study for his *Frieze of the Prophets* (fig. 6.2), which shows Moses, shrouded in the wings of divine presence, standing next to Joshua, a military leader of the Israelites. Moses, an awe-inspiring pillar of bearded masculinity, holds two tablets inscribed in Hebrew with the Ten Commandments. The younger, more vulnerably human Joshua reaches for the sword hidden in his bright hooded cloak. In this study Sargent employed bravura brushwork and bold colors to heighten the drama. The finished mural at the public library extends this almost musical interplay of emotive bodies to a line of nineteen life-sized prophets.

The most astonishing female in the 1895 mural is Astarte, the Phoenician fertility idol (fig. 6.3), who occupies half of the curved ceiling that arches over

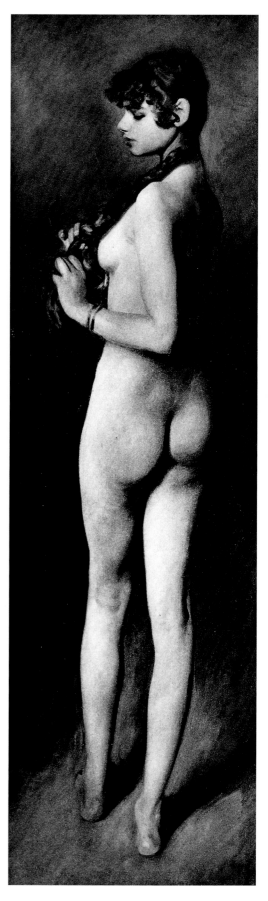

6.1 EGYPTIAN GIRL, 1891
Oil on canvas
From *The Work of John S. Sargent,* 1903
(Private collection)

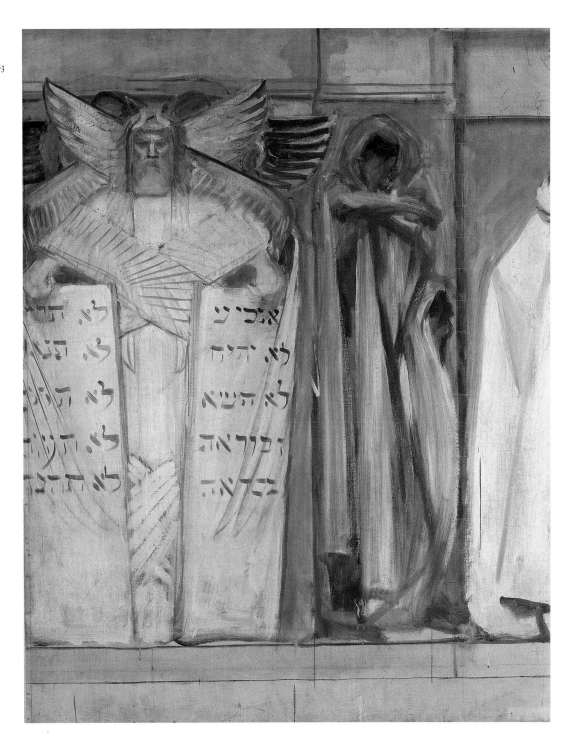

6.2 Detail of STUDY FOR "FRIEZE
OF THE PROPHETS," BOSTON
PUBLIC LIBRARY, C. 1893
Oil on canvas
47¼ × 74¼ in.
Fogg Art Museum, Harvard University Art Museums, Cambridge,
Massachusetts, gift of Mrs. Francis
Ormond

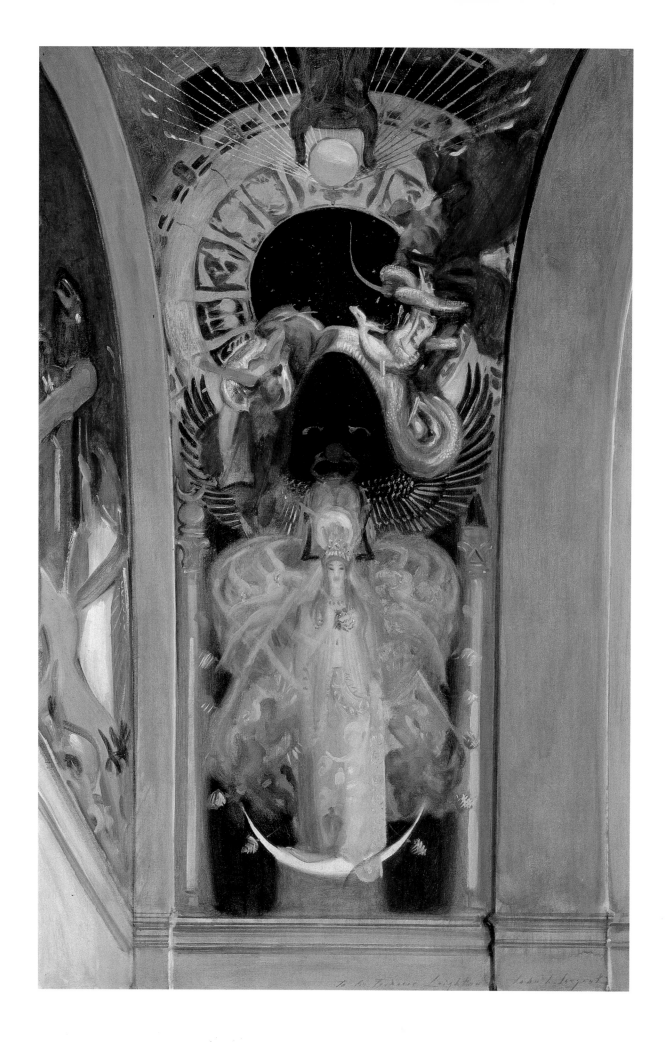

6.4 YOUNG MAN IN A CLOAK,
c. 1895
Lithograph with touches of pencil
16⅛ × 9⅝ in.
The Metropolitan Museum of Art,
New York

the *Frieze of the Prophets.* Depicting her enveloped in a billowing, diaphanous veil, Sargent embellished his mural with gilded sculptural ornaments and sparkling glass "gems." The library's handbook described Astarte as "the goddess of sensuality— beautiful, alluring, and heartless," and Vernon Lee wrote in an essay: "[She is a] long erect goddess, swathed chrysalis-like in her blue veil, . . . a moon wraith swaying over the sea, a mystic opium vision; the night, muffled, expectant, so lucid and yet so vague, [is] full of possible dangers."[15] *Egyptian Girl* and *Astarte* proclaimed Sargent's fascination with exotic women, but the fact still remains that he produced far more male than female nudes in the 1890s. Most of the male pictures are works on paper, and few are known today. Although the artist exhibited and illustrated a small selection, he held most of them out of the spotlight.

A look at some of his male nudes and portraits of men from this decade shows that Sargent kept a veiled but sophisticated homoeroticism in play. He produced three lithographs of male models in the 1890s and exhibited one of them in Paris in 1895.[16] *Young Man in a Cloak* (fig. 6.4) features strongly lit, sculpturally bold draperies that connect it to both the *Frieze of the Prophets* and *Album of Figure*

6.3 ASTARTE, 1895
Oil on canvas
33¹³⁄₁₆ × 23⅝ in.
Isabella Stewart Gardner Museum,
Boston

6.5 COVER OF "FIVE SONGS," 1898
Music by Francis Korbay
Published by Boosey and Company, London and New York

6.6 DAVID AND JONATHAN, C. 1898
Charcoal on paper
23⅝ × 17¹³⁄₁₆ in.
Fogg Art Museum, Harvard University Art Museums, Cambridge, Massachusetts,
gift of Mrs. Francis Ormond

Studies. A related project was Sargent's design for a sheet music cover published in 1898 (fig. 6.5). Its heroic image of two strapping laborers has a rapport with Walt Whitman's idealizing admiration for comrades and workmen. The hammering men, framed in a linked ring design, seem to be generating the light that casts strong shadows across their bodies. Although the lyrics of the five songs make no references to male workers, Sargent's illustration evokes subjects that were dear to their author, W. E. Henley: plucky Victorian manliness and a fearless confrontation of life's difficulties.[17]

Late in 1895 a London-based business invited an international group of artists to submit works for possible reproduction in an illustrated Bible, and Sargent was an obvious participant, given the theme of his mural decorations. He decided to illustrate the Old Testament's most widely known narrative involving passionate relationships between men—the story of Saul (king of Israel), Jonathan (the king's son), and David (a young warrior), as told in the first book of Samuel. Sargent made several monochrome oil paintings and drawings of these characters, but none appeared in the three-volume Bible published in 1899.[18] Sargent's exclusion remains unexplained, but it is possible that either he or the publishers concluded that the subject was too sensitive in the aftermath of Oscar Wilde's prosecution.[19]

It is certain that Sargent valued these images because he exhibited some of them in London and Boston, and allowed a few to be published.[20] *David and Jonathan* (fig. 6.6) is probably the drawing he sent to his large solo exhibition in Boston in 1899 with the caption "David and Jonathan swear a Covenant between them and their seed forever." The picture shows the moment after Jonathan has taken off his robe, armor, and girdle and presented them symbolically to David. Although the drawing lacks the personal engagement of the individual drawings in Sargent's *Album of Figure Studies,* and the composition is inert, it is a valuable demonstration that Sargent could romanticize physical closeness between men. The ardent exchange between prince and soldier, accentuated by a soaring bank of clouds, echoes the biblical description of their friendship: Jonathan loved David "as his own soul," and David lamented Jonathan with the words "Your love to me was wonderful, passing the love of women."[21]

In keeping with the prevailing Victorian stereotype of masculinity, Sargent's formal male portraits tended to be unemotional. Nonetheless, he painted three affectionate and intriguing pictures of handsome bachelors at the beginning of the decade: George W. Vanderbilt, a bookish American millionaire; Léon Delafosse, a French pianist (fig. 6.7), and W. Graham Robertson, a British artist (fig. 6.8). Delafosse was a virtuoso known for his interpretations of Chopin's music. His musical abilities and personal attractions endeared him to Marcel Proust and Robert

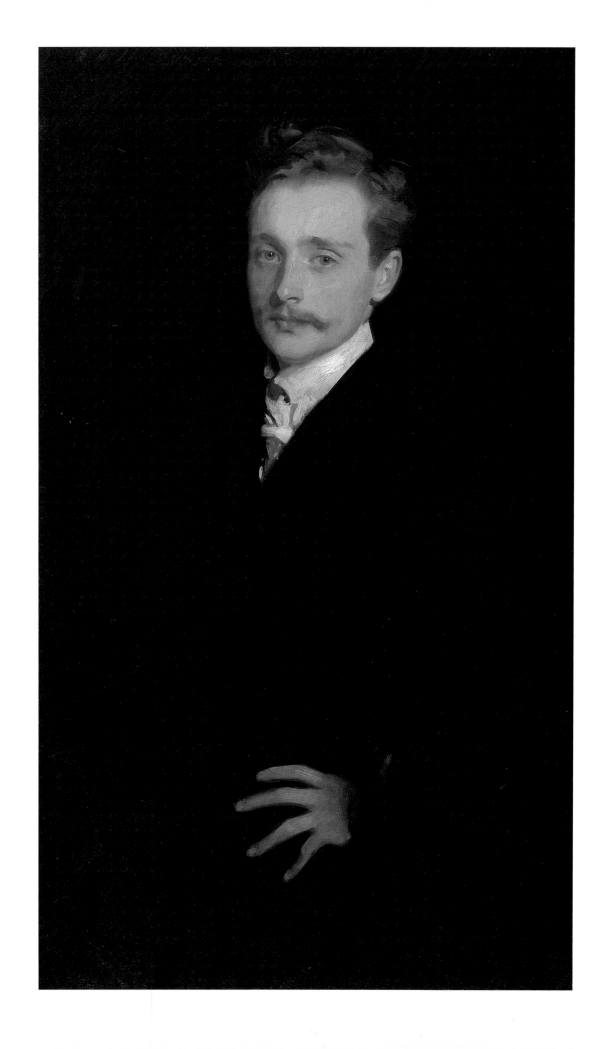

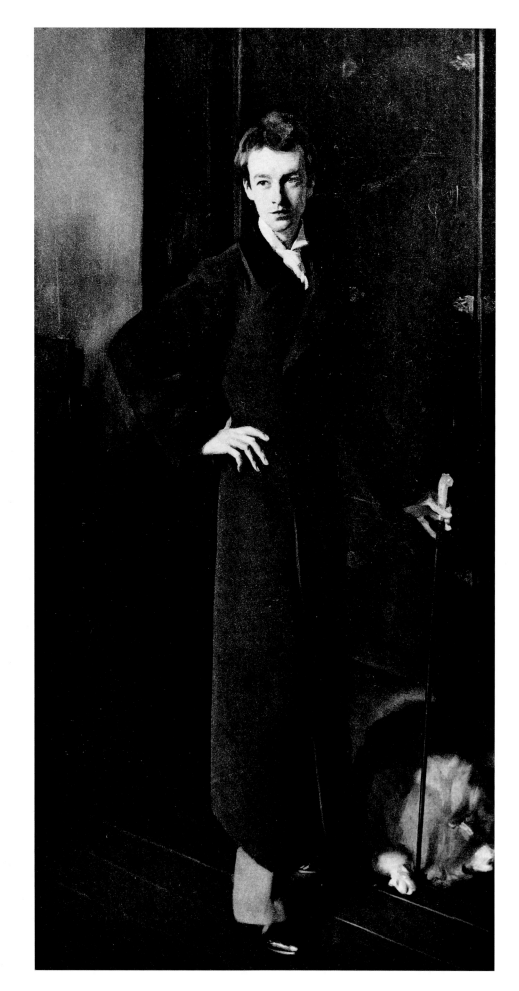

6.7 LÉON DELAFOSSE, 1893
Oil on canvas
39¾ × 23⅜ in.
Courtesy Galerie Schmit, Paris

6.8 W. GRAHAM ROBERTSON, 1894
Oil on canvas
From *The Work of John S. Sargent,* 1903
(The Tate Gallery, London)

de Montesquiou in Paris, and to Sargent in London.[22] Sargent made a teasing, insinuating recommendation of Delafosse's "playing and his French finesse" to one of Boston's preeminent music lovers, Isabella Stewart Gardner: "Of course Delafosse is a decadent—especially in the matter of neckties—but he is a very intelligent little Frenchman, and a composer and excellent pianist, who is probably going over to America in a year's time, so I sent his portrait over as a forerunner."[23] The artist was probably referring to the inclusion of *Léon Delafosse* in a large solo exhibition held in Boston in 1899. One American critic wrote on that occasion: "In wonderful contrast to the virility of . . . [Sargent's portrait of Francis Cramner Penrose] is that of M. Léon Delafosse, a young man of sensitively artistic temperament. The fragile tenderness, the subtle blend of depth and almost evanescent feeling, and the wistful earnestness of the face are wonderfully expressed."[24]

Although *W. Graham Robertson* is very much an individual's portrait, it also captures a social type—the London dandy of the short-lived Aesthetic movement and the Decadent period. Robertson, a man who looked younger than his twenty-eight years, was a member of Oscar Wilde's entourage. Drawn to the stylish manner in which he proclaimed his difference, Sargent asked Robertson if he would sit for a portrait. (It can be argued that *W. Graham Robertson* shares with *Madame X* an ambiguous mixture of giddy attraction and morbid repulsion.) By the time Sargent exhibited Robertson's portrait at the Royal Academy, in the spring of 1895, Wilde was on trial for "gross indecency." The picture was too subtle in its admiration to get Sargent into hot water—indeed, it allowed establishment types to read it as an exposé of dandies and "sensitively artistic" men. In 1895 one critic said that Sargent had painted a "living" likeness for the viewer "to admire, to wonder, or to laugh at."[25] Four years later, an essay profiling Sargent praised *W. Graham Robertson* for mirroring a "weakness" typical of "our present civilization."[26]

After Sargent distilled Robertson as a social type, the image defined a visual stereotype and was eventually mirrored in the first illustrated edition of *The Picture of Dorian Gray.* Wilde's novel of 1891 had created a sensation because the Adonis-like young Dorian had a covert homoerotic appeal. When Paul Thiriat came to illustrate it about fifteen years later, he envisioned the mesmerizing portrait of Dorian Gray along the lines of Sargent's *Robertson.* Thiriat's frontispiece (fig. 6.9) shows an artist and his aristocratic patron admiring the portrait of a man in formal clothes, standing in a darkened room, striking an elegant pose with one arm akimbo.

It is clear that Sargent maintained a fascination with male imagery to the end of the 1890s. He may have curbed his instincts after Wilde's prosecution in 1895, but he did not bury them. In contrast to Wilde's noble professional suicide, he chose reticence and restraint, and his success continued into the twentieth century.

6.9 THE ARTIST, BASIL HALL‑
WARD, SHOWING LORD HENRY
WOTTON HIS PORTRAIT OF
DORIAN GRAY

Illustration by Paul Thiriat from *The
Picture of Dorian Gray* (Paris, 1908)
Courtesy Portland State University
Libraries, Oregon

The primary goal of the foregoing discussion has been to demonstrate that
Sargent on occasion allowed his eye for male beauty to be reflected in his art. It
remains for future research to illuminate how this played out as a social reality. Who
were the sexually tolerant individuals in Sargent's circle of friends? How did his
upper-class status connect with his evident interest in working-class models?

DOMESTIC ENVIRONMENT

While asserting a decidedly public presence with his vast production and tireless
exhibiting, Sargent made his home a retreat. Although we know little of his life
there, its spaces are documented in various texts, photographs, and paintings. In
1886 he rented a unit at 33 Tite Street, Chelsea, a studio building erected in 1880.
In 1900 he leased the adjacent house (31 Tite Street, built in 1879 for the portrait
painter Frank Dicey). After the party walls had been opened, the combined spaces
gave him a generous establishment with two studios. He employed a manservant
in the early 1890s and in later years added two women to his staff: a housekeeper-
cook and a housemaid. While more modest in scale, Sargent's living and working
spaces possessed an aesthetic tenor that recalls the residences of his Bostonian friend
Isabella Stewart Gardner: first the pair of Back Bay townhouses she turned into one
residence in 1880, and then Fenway Court, her remarkable house-museum in the

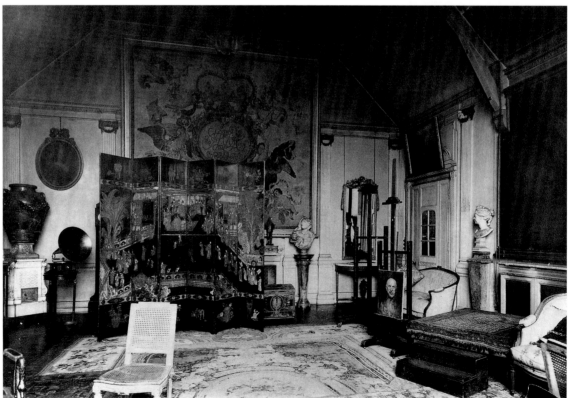

6.10 Sargent's studio at 31 Tite Street, London, c. 1920
The easel is set up for a charcoal drawing. At the lower right, a stereoscopic viewer stands on the same table visible in the drawing of Mrs. Wertheimer (fig. 3.15).

6.12 Susie Zileri
British, act. c. 1890–c. 1950
SARGENT'S DINING ROOM AT 31 TITE STREET, CHELSEA, 1922
Oil on canvas
16 × 10¾ in.
Private collection
The artist dined at home amid continental rococo chairs, a Venetian mirror, and a neoclassical sideboard, side table, and chandelier. Items from his ceramic collection are displayed on the top shelves of the recessed bookcases.

6.11 Sargent's studio at 31 Tite Street, London, c. 1920
A carpeted model stand is seen at the lower right. The ceramic jar behind the phonograph appears as a prop in Sargent's *The Acheson Sisters* (1902), commissioned by Duchess Louisa of Devonshire for Chatsworth House. The largest of the framed items is a 12-foot-square panel of tapestry, probably made in Brussels.

form of a Venetian palazzo, completed in 1903.[27] Mrs. Gardner and Sargent both created stylish rooms by staging eclectic mixtures of historic and modern elements. Sargent used modern Renaissance-style pilasters, cornices, and paneling to formalize the Tite Street interiors. His rooms (figs. 6.10–6.12) harbored a profusion of fine old textiles, Aubusson carpets, Persian rugs, various tapestries, silk curtains, Italian brocades and velvets, embroidered copes and chasubles, Chinese porcelains, antique and modern European furniture, and a great variety of sculptures and paintings. Sargent's collection of large decorative objects included a splendid early globe on a gilt stand, a massive Italian ceramic jar dated 1656 (see fig. 6.11), and "a pair of Adam wood pedestals, carved with rams' heads, trophies, festoons and

key-pattern, and painted white."[28] Numerous items in the Tite Street establishment were enlisted in portraits as props, including tables, chairs, a tall Chinese lacquer screen, textiles, and two carved rococo panels mounted on wheeled stands for easy access. There were pianos, a gramophone, and a viewing box for the stereoscopic photographs he enjoyed taking in later years. Sargent's collection of paintings ranged from modern landscapes by Monet to a religious painting by El Greco (now attributed to that artist's son), *Saint Martin Dividing His Cloak with the Beggar* (fig. 6.13); his sculptures included a bronze of a female nude by Giambologna, a Spanish carved wood figure of the Virgin, and modern works by Rodin and Alfred Gilbert.[29] His own notorious Salon picture *Madame X* was usually on view there before 1915, when it went to the United States for exhibition and subsequently was sold. The back rooms of the upper floors provided splendid easterly views of

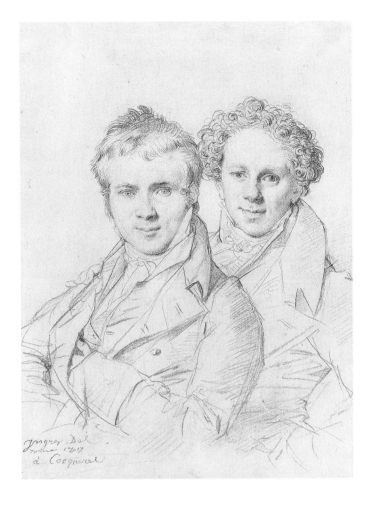

6.15 Jean-Auguste Dominique Ingres
French, 1780–1867
OTTO MAGNUS VON
STACKELBERG [right]
AND A FRIEND [possibly
Jacob Linckh], 1817
Pencil on paper
7¹¹⁄₁₆ × 5¹¹⁄₁₆ in.
Musée Jenisch, Vevey

the wooded grounds of Wren's Royal Chelsea Hospital, which added to the sense of stately retreat that Sargent desired.

The artist Jacques-Émile Blanche described Sargent's domestic setting in his memoirs:

To reach the studio one went up a staircase and crossed a gallery . . . [passing pictures by] Morelli and Mancini, [and] Sargent's studies of his gondolier. . . . In the studio there were pieces of Renaissance furniture, Florentine candelabra; if this London interior called up anything it was the . . . Curtises' [Venetian] palazzo. . . . I think that [Sargent's *Interior in Venice,* fig. 5.22] . . . grips one more than any other he ever painted because . . . he has shown a milieu in which he felt himself at home. He always went there to refresh his spirit. . . . Music and books were his only solace in London.[30]

Martin Birnbaum, an American dealer and bachelor, left a detailed picture based on several visits to Sargent's house after World War I:

Visitors . . . were at once surrounded by Sargent's pictures, which covered almost the entire available space in the entrance hall, and made all

the stairways and landings seem narrow. Every period in his career was represented, and one felt that his life ran by, swiftly and pleasantly, but only in an endless maze of artistic activities. Prominent among the oil paintings was the head of a handsome laughing Italian [fig. 6.14] . . . and some pictures presented to Sargent by his friends Mancini and Helleu. In the main, however, the walls were given over to Sargent's own watercolors. . . . [They were] souvenirs by an artist too busy for independent adventure and executed in happy unguarded moments with dashing brilliance, and, one might say, a divine facility which may never be excelled. . . . One of his most highly prized treasures was an original Ingres pencil drawing of two men made in Rome in 1817 [fig. 6.15] . . . It was presented to Sargent by Sir Philip Sassoon. . . . I never saw a deliberate touch of artiness there. The windows looked down into a quiet green little garden from rooms which breathed an eclectic artistic quality, expressive of his artistic personality. There was an atmosphere of brightness and light everywhere, although [his quarters] were filled to overflowing with a vast accumulation of artistic possessions—pictures, antique frames, rich old textiles, objets d'art and bronzes,—conspicuous among which was a fine bronze cast of Rodin's headless *L'Homme qui marche*. . . . I caught sight of a large oil study for Manet's *Balcony*. . . . Even in those days, however, I thought his outlook a trifle old-fashioned and certainly not "modernistic." He expressed doubt about the influence Cézanne's work was exerting on the younger generation, and he was disturbed by the undue attention which dealers and writers were focusing on the Fauves, Expressionists and Constructivists.[31]

Harold Acton, a wealthy aesthete and bachelor, echoed Birnbaum in a more succinct manner: "Sargent's big studio . . . [recalled] the cosmopolitan Italy of damask and old gold, where everything is in a major key, for huge balls and colonnades. . . . It was like visiting one of the lesser old masters, what our Florentine critics would call a *retardataire*."[32]

THE BATTLE FOR IMMORTALITY

No sooner had Sargent reached the apex of his career than a faction attacked him as a vigorous performer who was not a true artist. Once faulted by the establishment for being modern and slapdash, he now endured taunts from progressives and independents for being too mainstream. Starting in 1900, the artist and critic Roger Fry took several opportunities to criticize Sargent's portraits and informal sketches as not worthy of the name art, despite being outstanding records of appearances.

Fry claimed that Sargent's pictures lacked the "more important emotions" that allow art to move imaginatively beyond "the mood of ordinary life."[33] Discussing *An Interior in Venice* (fig. 5.22), Fry opined: "Sargent is too fond of the sparkle and glitter of life to give us any sense of the dreamy gloom of a seventeenth-century palace. He appears to harbor no imaginations that he could not easily avow at the afternoon tea he so brilliantly depicts."[34] By 1911 Fry had effectively framed Sargent as a traditionalist intolerant of new art.

One wonders if Sargent's willful inscrutability did not encourage the suspicions and critiques of this faction. It must have upset him to be goaded by people eager to parade their fresh irreconcilable artistic differences, even as others continued to write numerous highly laudatory articles. In 1905, for example, D. S. MacColl seems to rebut Fry's complaint about *An Interior in Venice* when he insists that Sargent was not "a brooder or a dreamer." For MacColl the best Sargent was "like an exercise with shape and space and light."[35] It was Sargent's abiding goal to capture conventional appearances and optical realities in paint, while Fry and the new British apostles of French Post-Impressionism sought ways to see and think beyond worldly surfaces—qualities they admired in works by Gauguin and van Gogh. Sargent generally found Post-Impressionist works vulgar, graceless, and distorted.[36] As this cultural battle warmed up early in the twentieth century, Sargent effectively distanced himself from it by turning toward his mural work and informal figurative pictures. After the start of World War I, he never saw Italy again. He spent the war years and their aftermath preoccupied with his public projects.

Sargent benefited in later life from Boston's imperviousness to radical modernism. His New England ancestry predisposed him to the city, and by the 1910s he was probably glad that the "Athens of America" was a relatively quiet, polite echo of Victorian London. The fact that all his murals were destined for Isabella Stewart Gardner's Boston rather than Roger Fry's London was no doubt a comfort. In 1913 the Armory Show, that hot blast of novel art, traveled to Boston after appearing in New York and Chicago, but it strengthened rather than changed the city's genteel traditionalism. Three years later the American magazine *Arts and Decoration* published a strong modernist critique of Sargent's latest murals at the Boston Public Library. The author's great lament was that the decorations lacked the "real thrill" that *Madame X* generated with its "design, nerve, [and] heart."[37] But negative rhetoric was powerless against the local love for Sargent. Until his death in 1925, he remained the darling of the Boston Brahmins and held sway in their cultural institutions.

Although Sargent made a sincere effort to create uplifting, attractive public works in his late murals, they were stilted. The 1895 and 1903 segments at the

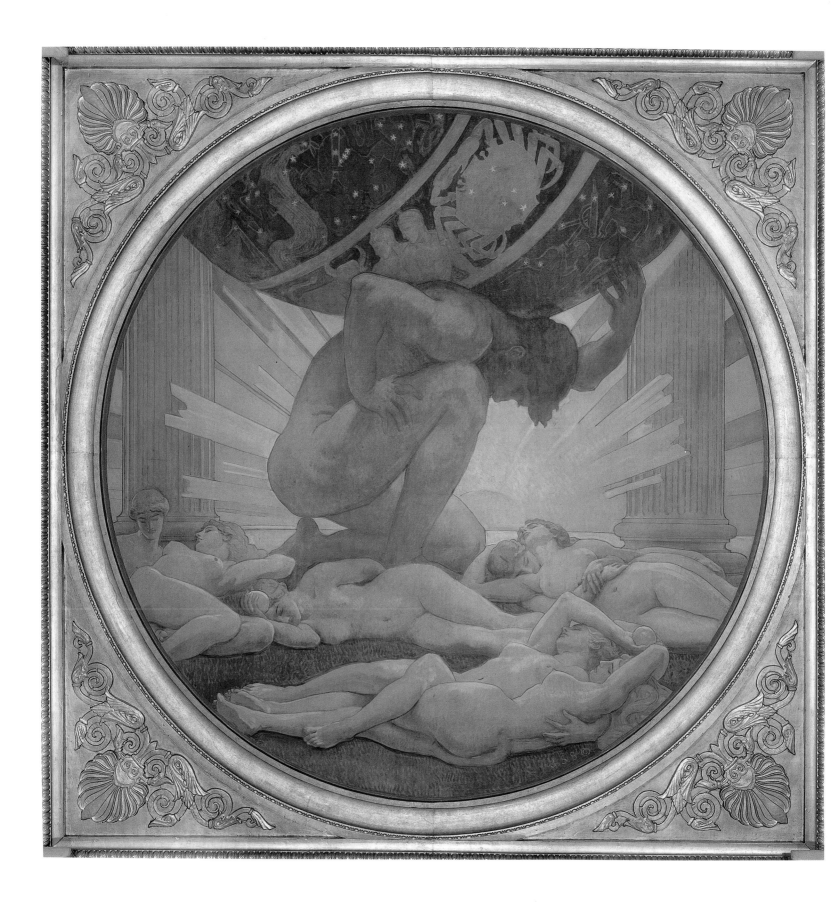

Boston Public Library had been ambitious artistic statements, for they made significant contributions to the international Symbolist and Aesthetic movements of the day. Those artistic sparks of originality, excitement, and mystery waned in all subsequent murals, and the refinement of the decorator guided Sargent's late efforts at the library, the Museum of Fine Arts, and Harvard University. He was certainly eager to develop his scope, power, and fame as a muralist: at the Museum of Fine Arts he exercised architectural ambitions by remaking the rotunda, regrouping massive columns, and designing elegant architectural settings for all his paintings and low relief sculptures. As a change from the rich stew of stories and messages in his religious murals at the public library, Sargent invented a smart, buoyantly classical point of embarkation into the museum's main galleries. Stating that he wanted to suggest "those vistas in Genoese palaces," he shared with Boston his highly informed and deep affection for Italian culture.[38]

Many of the figures in the museum's murals strike bold silhouettes against flat backgrounds of rich blue or gold, and the gracious whole succeeds in disguising the limitations of the individual parts. *Atlas and the Hesperides* (fig. 6.16) typifies the strengths and weaknesses. The composition is pleasingly balanced, and the iconography is suitably studious, yet despite this, the imagery is docile and awkwardly drawn in some passages. Since it is part of the ceiling of a side aisle, it might be argued that the static, storybook composition functions well in the greater decorative scheme. Sargent did labor mightily to finesse the scale of the painted and sculpted elements, the balance of the empty spaces, the lighting, and the overall impression. But he clearly had an inkling of the limitations of these decorations, for he told Mrs. Gardner that he expected critics to make "the accusation of being frivolous, platitudinous, and academic."[39] Sargent took comfort from having changed a difficult, slightly oppressive space into a pleasing and serene environment. These murals have never been seen as first-rate Sargents or major landmarks in twentieth-century decoration, but it is worth remembering their value for some Americans in the 1920s. A writer for *Scribner's Magazine* gave thanks that the "horror of the great war" was over as he stressed the peacetime joy that Sargent's museum murals evoked for him: "It is good to live in a world where such [artistic] beauty is possible."[40]

6.16 ATLAS AND THE HESPERIDES, 1922–25
Ceiling decoration; oil on canvas and architectural framing
Diam. 120 in.
Museum of Fine Arts, Boston, Francis Bartlett Donation of 1912 and Picture Fund

"GIVE ME CREDIT FOR INSIDES"

When Sargent's oeuvre is considered in light of the conflict between his public ambition and personal reticence, its great diversity, tremendous volume, and lapses in quality are easier to comprehend and accept. He worked on numerous fronts with multiple agendas, producing subsets of work that at times seem contradictory.

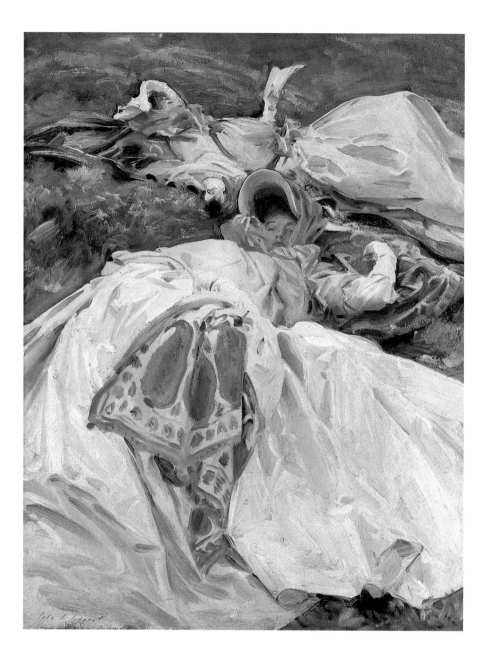

6.17 TWO GIRLS IN WHITE
DRESSES, C. 1910
Oil on canvas
27½ × 21½ in.
Private collection

His alluring people offer a particular paradox. Whether clothed or unclothed, the fetching women and men who parade through his oeuvre send different messages to different viewers. It is a daunting task to make a "real" Sargent stand up, but one way forward is to accept all the complications and give them their due.

The mood and perspective of *Two Girls in White Dresses* (fig. 6.17) allow those who desire women to imagine a sexy narrative. Although yards of fine fabric make the body of the main figure all but invisible, her slack proneness, direct eye contact, and puffy skirt all work to stir the imagination. Two writers recently made steamy interpretations of this young woman. A critic for the *New Yorker* called her "a delicious little scallop in a big striated shell, . . . so dressed up she's nearly naked."[41]

6.18 NUDE STUDY OF THOMAS E.
MCKELLER, C. 1917–20
Oil on canvas
49½ × 33¼ in.
Museum of Fine Arts, Boston,
Henry H. and Zoë Oliver
Sherman Fund

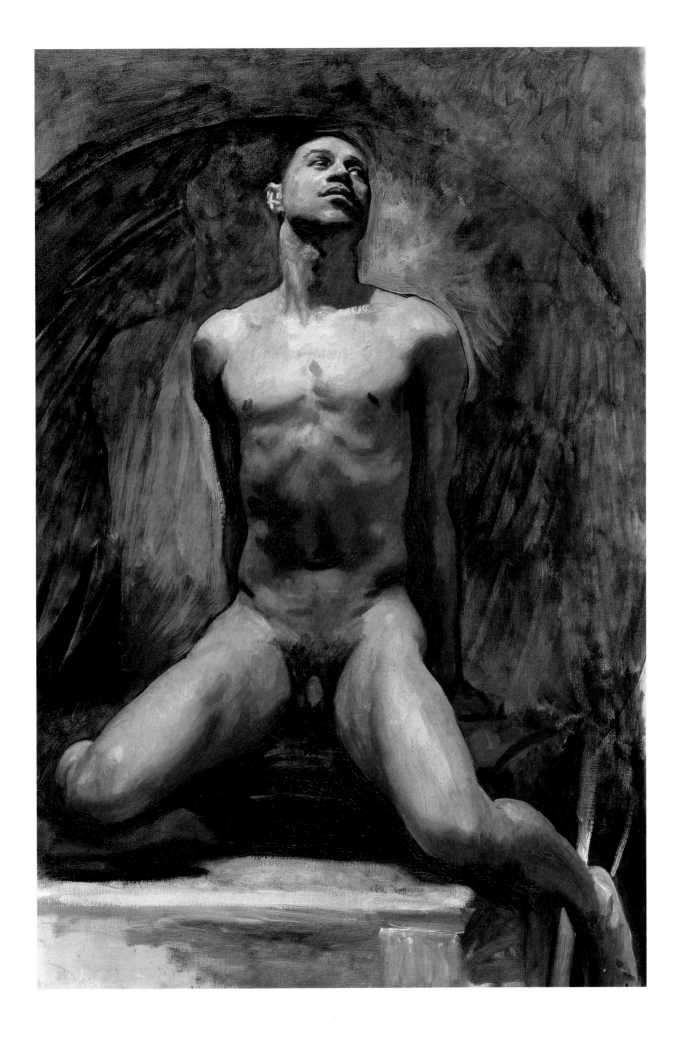

And a Sargent scholar observed: "Our viewing position suggests we [are] . . . ready to crawl onto her dress. . . . Just at her crotch, almost at the center of the composition, a cascade of paisley erupts, spilling towards the viewer."[42] Those who desire men might imagine corresponding narratives when engaging *Nude Study of Thomas E. McKeller* (fig. 6.18). A casual viewer cannot begin to read the man's social guise, since his clothes are gone, but his reverie, his averted eyes, and the "nowhere" setting can kindle fantasies. McKeller was a blue-collar Bostonian who often modeled for Sargent after 1916, and the setting was the artist's Boston studio. In his memorial to Sargent, Thomas Fox explained: "On a hotel elevator he noticed that the operator, a young colored man, was possessed of a physique which he conceived would be of artistic value. Most of those who saw . . . the Museum [murals] in process learned that this young man served as the model for practically all the male figures, and indeed for some of the others [the female figures]."[43]

As a scholar remarked in 1982, "Sargent's murals in the Museum of Fine Arts might be called public art for public art's sake, an exercise in civic virtue with nothing much to offer the ordinary citizen, save the assurance that academic archetypes are somehow good for him."[44] In *Atlas and the Hesperides* (fig. 6.16) Sargent edited and adjusted the body of the African-American to create an uncontroversial image of the mythological Titan. The differences between the palpability of *Nude Study of Thomas E. McKeller* and the blandness of *Atlas* suggest the extent to which Sargent compartmentalized his life. The personal studio experience was radically adjusted to fit the murals created for public consumption. Sargent never painted women displaying the exultant nakedness of McKeller, and he never exhibited his great portrayal of the black model. *Nude Study of Thomas E. McKeller* hung in his Boston studio and was part of his estate, but it did not enter the public realm until it was published in a biography in 1955.[45] It was purchased by the Museum of Fine Arts in 1986 and has since reached a broad audience as part of the museum's permanent collection and in a few special exhibitions.[46]

With much of Sargent's work "truth" is a function of perspective. When we gaze up to the bleeding skeletal figure of Christ in Sargent's *Tyrolese Crucifix* (fig. 6.19) or look across the sea of fresh rubble in *Ruined Cathedral, Arras* (fig. 6.20) we may or may not feel compassion, depending on who we are. These two pictures confront aspects of pain and destruction, and do so under the calm brightness of sunny skies. In 1970 a scholar took cues from Sargent's "I only chronicle" motto and wrote this about *Ruined Cathedral, Arras:* "As usual, it was the play of light and shade which fascinated him, and the picture has almost no emotive overtones."[47] But other readings are possible if we also listen to the words of a younger, less guarded Sargent, who, in the early 1890s, wrote to a critic: "Very

6.19 TYROLESE CRUCIFIX, 1914
Watercolor and pencil on paper
21 × 15¾ in.
The Metropolitan Museum of Art,
New York, purchase, Joseph Pulitzer
Bequest, 1915

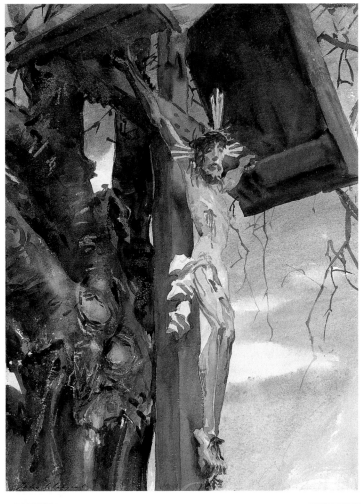

6.20 RUINED CATHEDRAL,
ARRAS, 1918
Oil on canvas
21½ × 27½ in.
Private collection

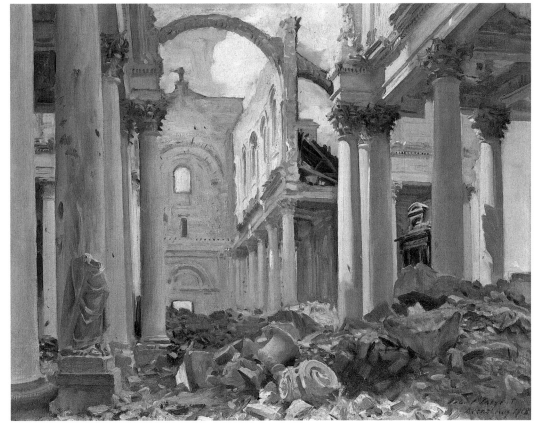

few writers give me credit for insides, so to speak. I am . . . grateful to you . . . especially for feeling in the way you do."[48]

Before Sargent could produce these accurate reports of an outdoor crucifix and the rubble of a bombarded cathedral, it was necessary for him to see, respond to, and choose how to compose each scene. Surely some of the stages in the work of observing, selecting, and painting these poignant images echoed his more general experiences as an "unbelonger"—someone who could position himself both inside and outside society's structures. Sargent's strongest inner conflicts surfaced in the wartime watercolor *"Thou Shalt Not Steal"* (fig. 6.21), which shows two soldiers alone in an orchard, partially concealed in shrubbery, anxiously pilfering the harvest. They are breaking rules and running risks for the sensual pleasure of the forbidden fruit. Sargent's decision to make a voyeuristic and sympathetic image of the two men—offenders afraid of being caught—confirms his connection with their needs. He also finds them an engaging pair, especially the nearer figure, a tall well-built Scot with dappled sunlight playing on his kilt.[49]

Even though Sargent was not committed to religious practice, his background was Episcopalian, his art reflected his fascination with Christian imagery, and he "apparently believed in the existence of a generalized and universalized God and in a noble and idealized and very human Jesus."[50] His watercolor *Tyrolese Crucifix* certainly treated the suffering of Jesus with great compassion, and *Crucifixion*, the sculpture he installed at the Boston Public Library in 1903, was his most ambitious and critically acclaimed three-dimensional work.[51] Although the details are not clear, it is telling that Sargent gave a rare bronze version of *Crucifixion* to Robert Ross, the long-suffering companion of Oscar Wilde.[52] There is also a note of friendship that helps bring Sargent's *Ruined Cathedral, Arras* into the realm of human kindness. The artist gave the picture to his young friend Philip Sassoon, a bachelor and very wealthy collector. Sassoon had helped coordinate Sargent's wartime visit to the front in 1918 and may have been with the artist when he painted the picture. Sassoon built an important collection of his friend's work, including *Two Girls in White Dresses*. Sargent made two portrait drawings of Sassoon in 1912 and 1921, then painted him wearing formal attire in 1923. At about the time of the portrait in oils, Sassoon gave Sargent a charming portrait of two male companions drawn in Rome by Ingres in 1817 (fig. 6.15).[53] Beyond its appeal as an outstanding work, this depiction of friendship between men served as a symbol of the warmth of affection between Sargent and Sassoon during the artist's last years.

By favoring the public image that Sargent carefully constructed, scholars have often sidestepped the discordances and contradictions of his personality. The Sargent-validated legend is important, but, as with any work of history, its skews

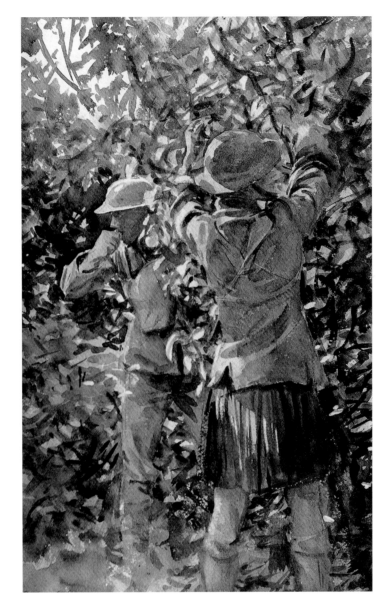

6.21 "THOU SHALL NOT STEAL,"
1918
Watercolor and pencil on paper
20 × 13¼ in.
Imperial War Museum

and omissions need to be registered. It is essential to keep an eye on the differences between the things Sargent presented to the public and those he anxiously kept from scrutiny. He was passionate when observing the world, listening to music, and tasting food, but these were largely private experiences. The masklike propriety of his social persona was mirrored to a great extent by the general suaveness and technical refinement of his art. Art, nonetheless, proves to have been the one public place in which he gave free rein to passion. His images present a vibrant, forceful realism while subtly projecting emotions, desires, and intuitions as their visual subtext. He jabbed, dabbed, smeared, slapped, and scratched his paint surfaces; he deployed brilliant, murky, flashy, peculiar, and ravishing colors. All are the expressions of a man whose instincts and appetites were deeply sensual.

Album of Figure Studies

Fogg Art Museum, Harvard University Art Museums,
Cambridge, Massachusetts, gift of Mrs. Francis Ormond

Unless a precise date is ascribed, the works were probably
produced between 1890 and 1915. With the exception of
folio 30, a collotype, the works in *Album of Figure Studies* are
charcoal on paper. Folio 23 has touches of white chalk.
The papers are all pale; their colors include off-white,
cream, gray, blue, and blue-green.

FOLIO 1
Partial View of a Standing Male Nude
24½ × 18⁹⁄₁₆ in.

FOLIO 2
Reclining Male Nude with Draped Crotch
24⁵⁄₁₆ × 18⁹⁄₁₆ in.

FOLIO 3
*Standing Male Nude with Raised Right Arm, Seen
from Behind*
24¾ × 19 in.

FOLIO 4
Recumbent Male Nude Leaning on His Right Forearm
18¾ × 24⁹⁄₁₆ in.

FOLIO 5
Male Nude Reclining on a Stairway
18¾ × 24⁷⁄₁₆ in.

FOLIO 6
Kneeling Male Nude with Drapery
24 × 18½ in.

FOLIO 7
Male Nude Reclining on Model Stand
18⅝ × 24⅝ in.

FOLIO 8
Male Nude Reclining, Seen from Behind
18⅞ × 24½ in.

FOLIO 9
Standing Male Nude with Arms Akimbo
25 × 19³⁄₁₆ in.

FOLIO 10
Standing Male Nude Seen from Behind
24⁷⁄₁₆ × 18¹¹⁄₁₆ in.

FOLIO 11
Standing Male Nude, Body Facing Right
24½ × 18¹¹⁄₁₆ in.

FOLIO 12
Standing Male Nude, Body Facing Forward
24½ × 18¹¹⁄₁₆ in.

FOLIO 13
Crescenzo Fusciardi
24 × 18⁵⁄₁₆ in.

FOLIO 14
Study for a Bible Illustration (Two Standing Males),
c. 1898
23¾ × 18⅛ in.

FOLIO 15
Two Reclining Male Nudes
20¾ × 25¹³⁄₁₆ in.

FOLIO 16
*Study for a Bible Illustration (Two Reclining Draped
Males),* c. 1898
24¹¹⁄₁₆ × 19 in.

FOLIO 17A
*Study for a Bible Illustration ("David in the Camp of
the Philistines"),* c. 1898
15³⁄₁₆ × 18¹⁵⁄₁₆ in.

FOLIO 17B
*Study for a Bible Illustration (Reclining Draped Male
with Bolster),* c. 1898
12¹¹⁄₁₆ × 19 in.

FOLIO 18
Reclining Male Nude, Left Arm Stretched Forward
18½ × 24⁷⁄₁₆ in.

FOLIO 19
Seated Male Nude with Drapery
24⁷⁄₁₆ × 21¹⁄₁₆ in.

FOLIO 20
Reclining Male Nude, Left Hand behind Head
18⁷⁄₁₆ × 24⁵⁄₁₆ in.

FOLIO 21
Standing Male Nude with Raised Arms
24⁷⁄₁₆ × 18⅜ in.

FOLIO 22
Torso of Seated Male Nude with Right Arm Raised
24⁷⁄₁₆ × 18¹¹⁄₁₆ in.

FOLIO 23
Standing Male Nude, Viewed from Below
24⅞ × 19 in.

FOLIO 24
*Male Nude Seen from Behind, Right Arm Raised over
Head*
24⁵⁄₁₆ × 19 in.

FOLIO 25
Seated Male Nude with Hands behind Head
24³⁄₁₆ × 19 in.

FOLIO 26
Reclining Male Nude with Billowing Drapery
24⁷⁄₁₆ × 19 in.

FOLIO 27
Male Nude Leaning Back on a Ladder
24½ × 18¹³⁄₁₆ in.

FOLIO 28
Reclining Male Nude with Hands behind Head
18¾ × 24⁹⁄₁₆ in.

FOLIO 29
Male Head in Profile
15⅞ × 13¹¹⁄₁₆ in.

FOLIO 30
*Collotype after Drawing by John Singer Sargent (Seated
Male Nude, Study for Sculpted Figure in the Rotunda
of the Museum of Fine Arts, Boston),* c. 1921
19¹⁵⁄₁₆ × 24⅞ in.

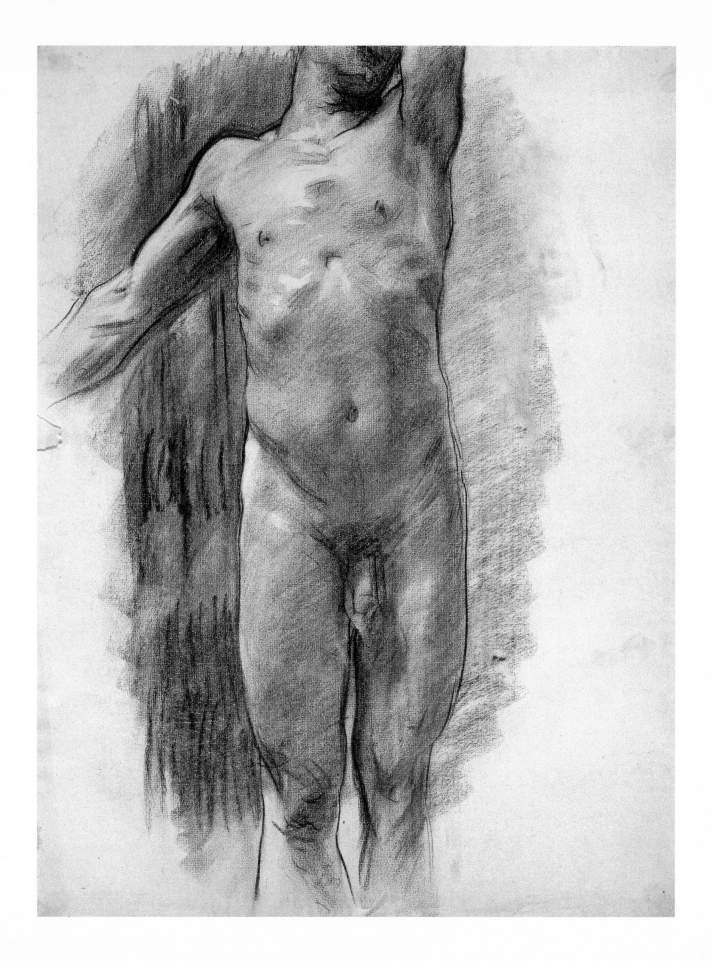

FOLIO I

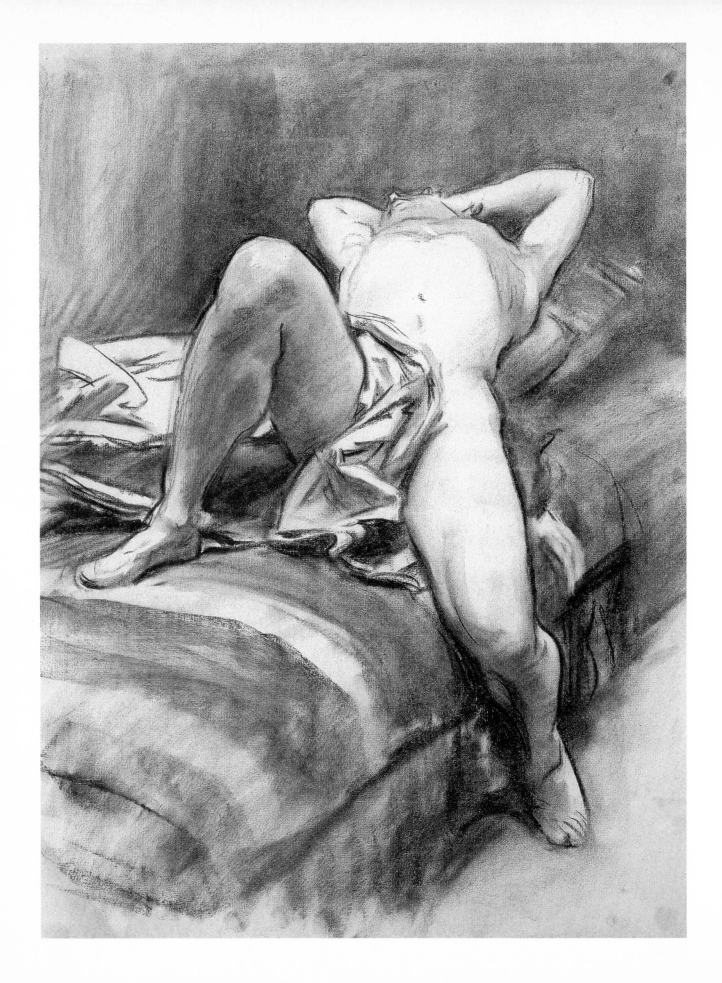

FOLIO 2

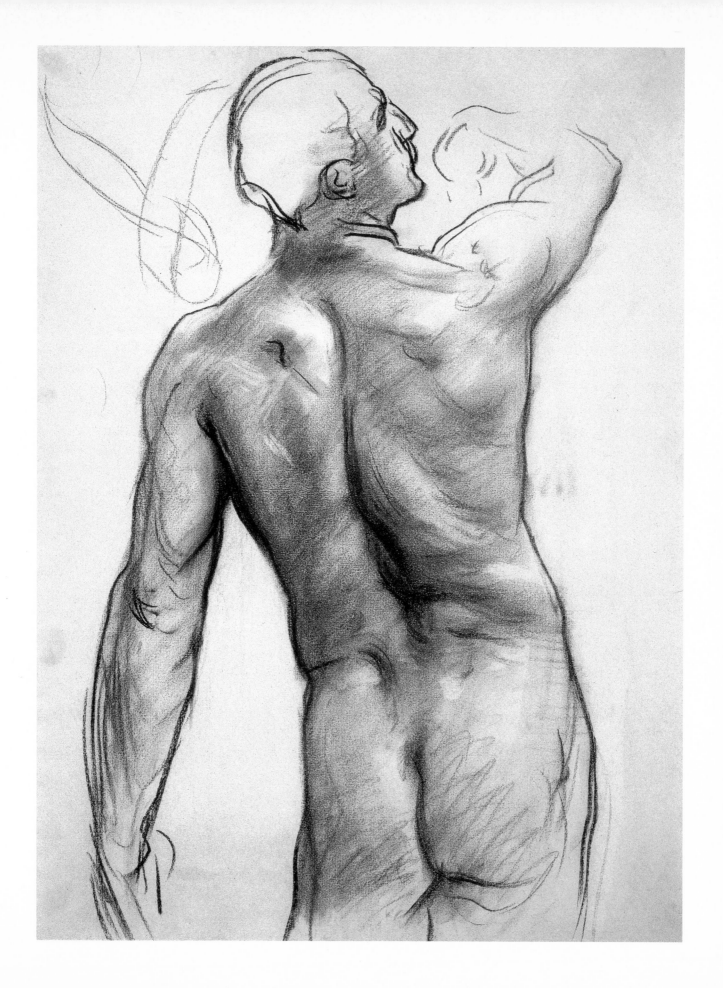

FOLIO 3

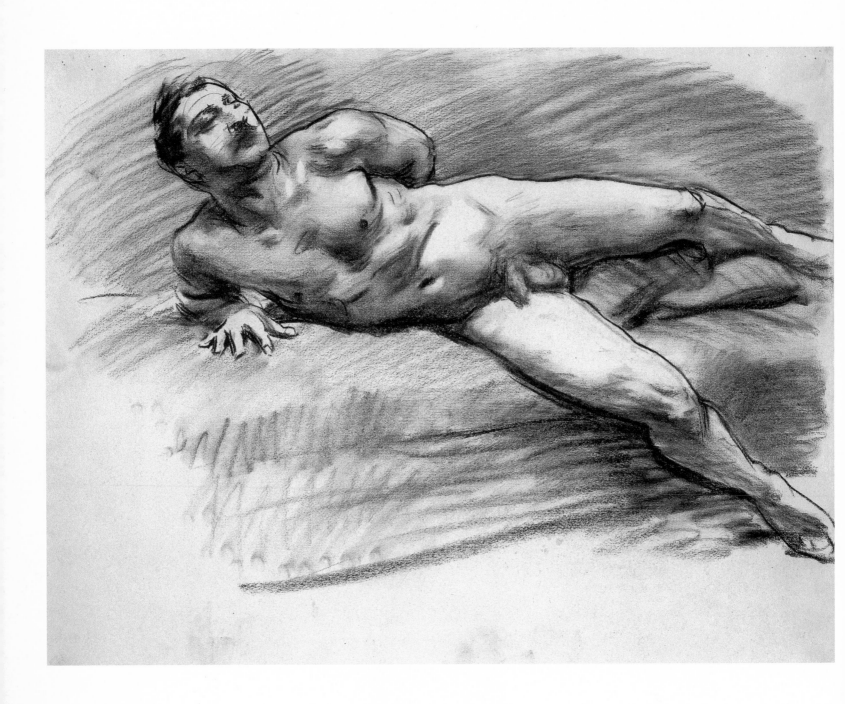

FOLIO 4

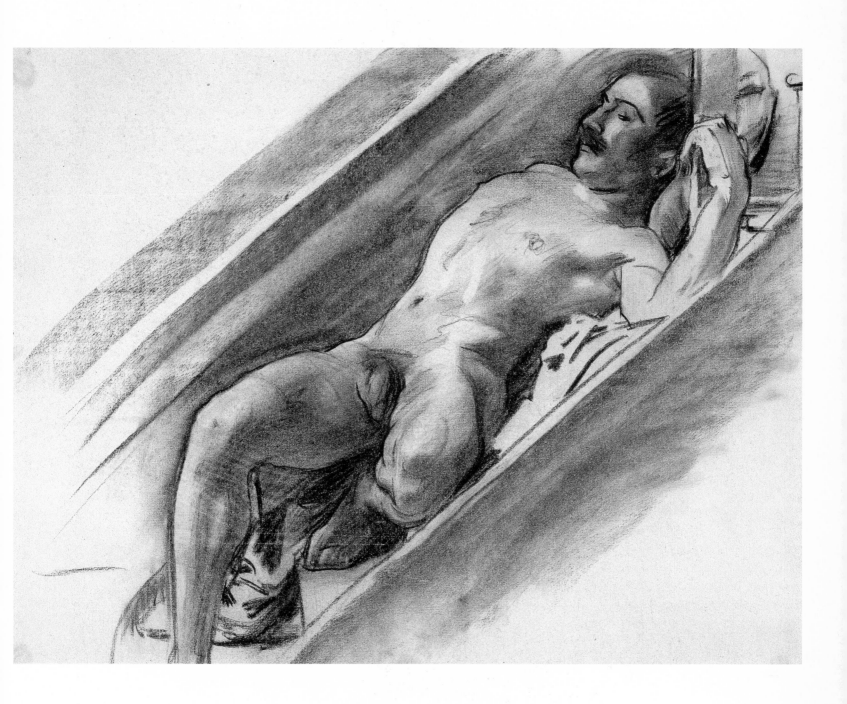

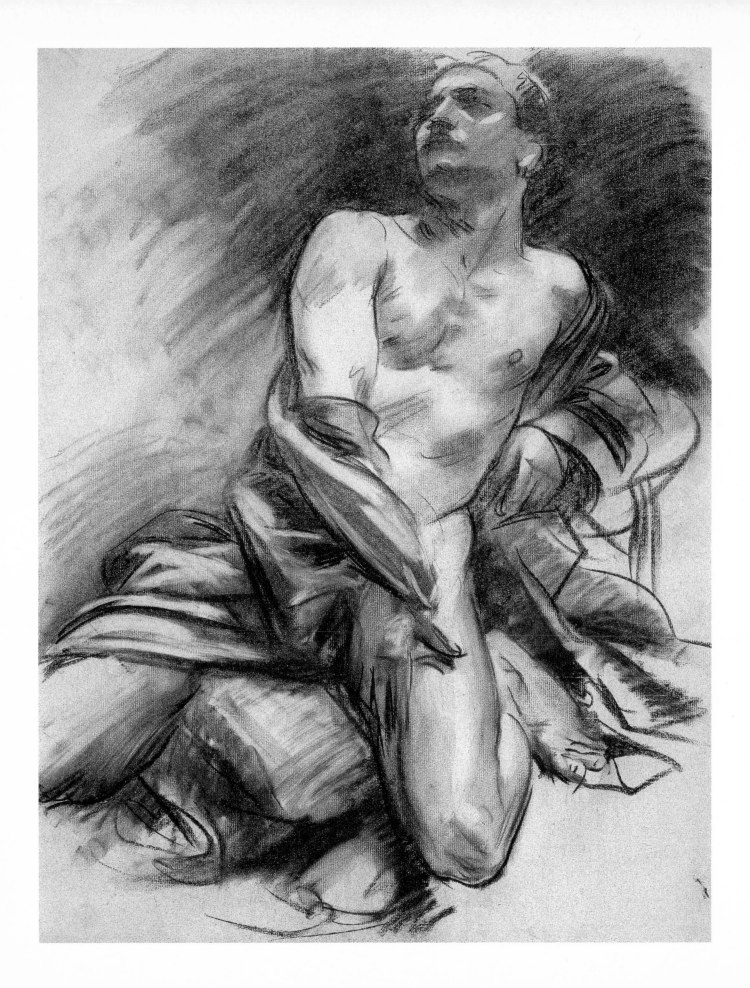

FOLIO 6

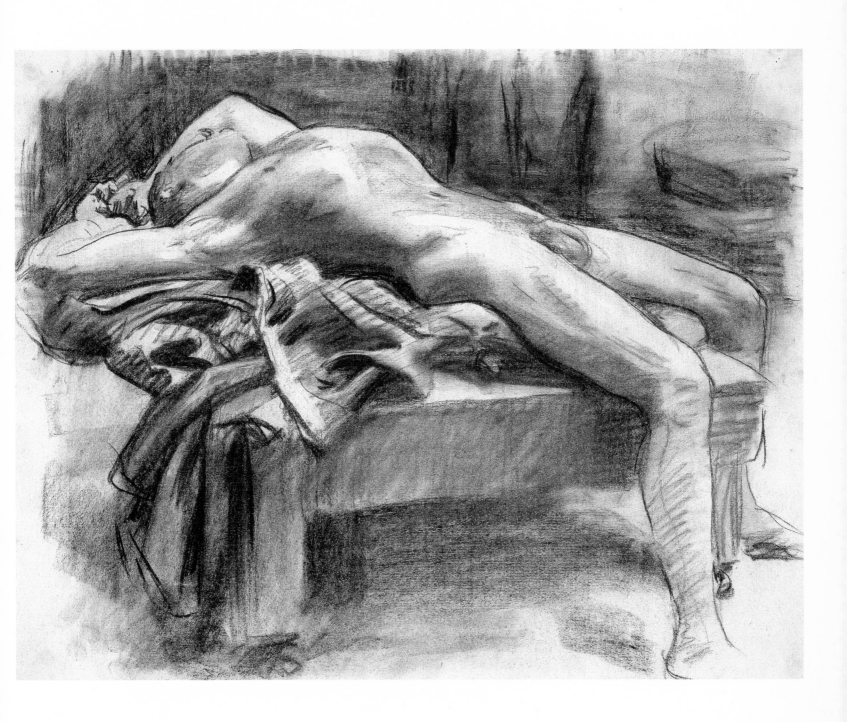

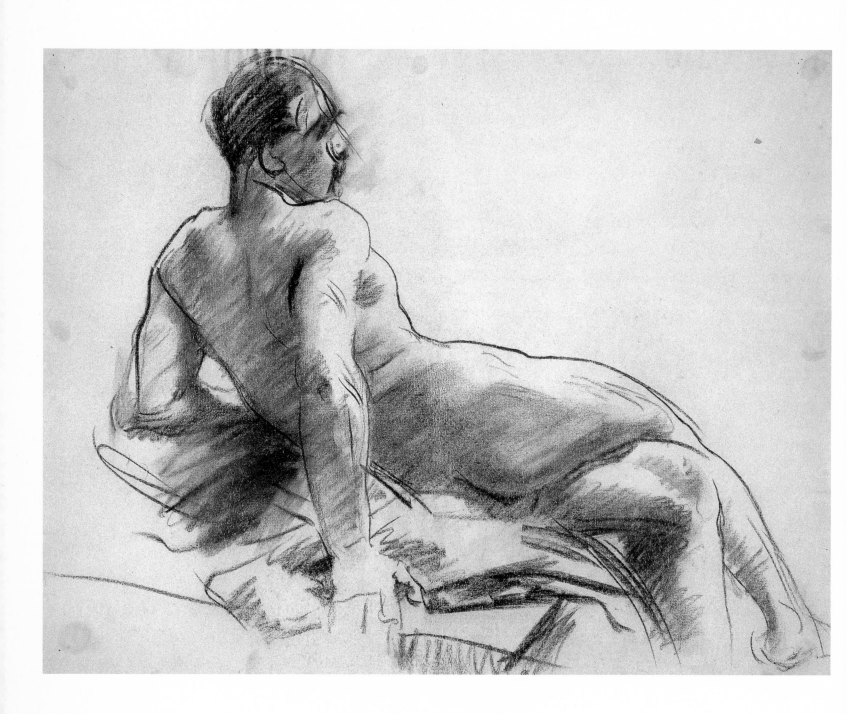

FOLIO 8

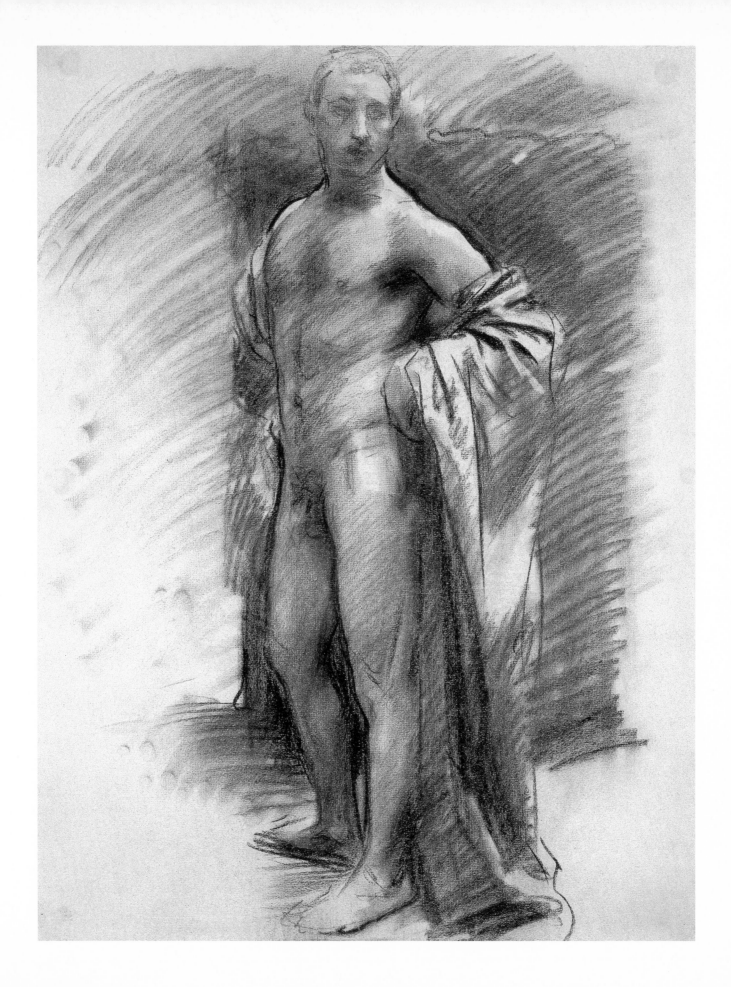

FOLIO 9

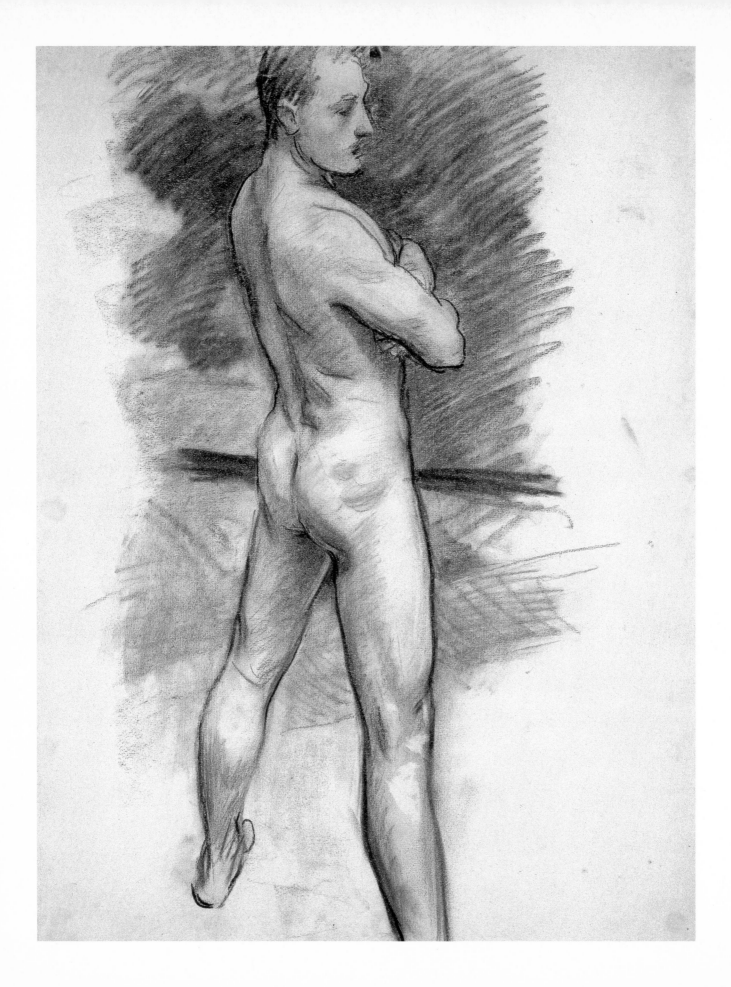

FOLIO 10

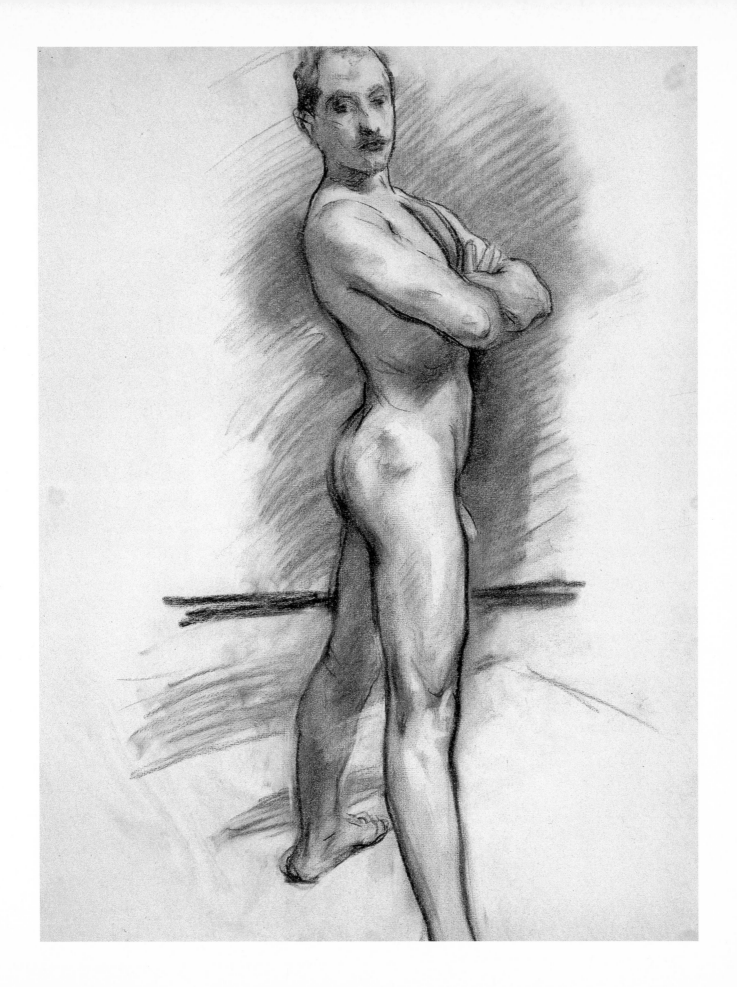

FOLIO II

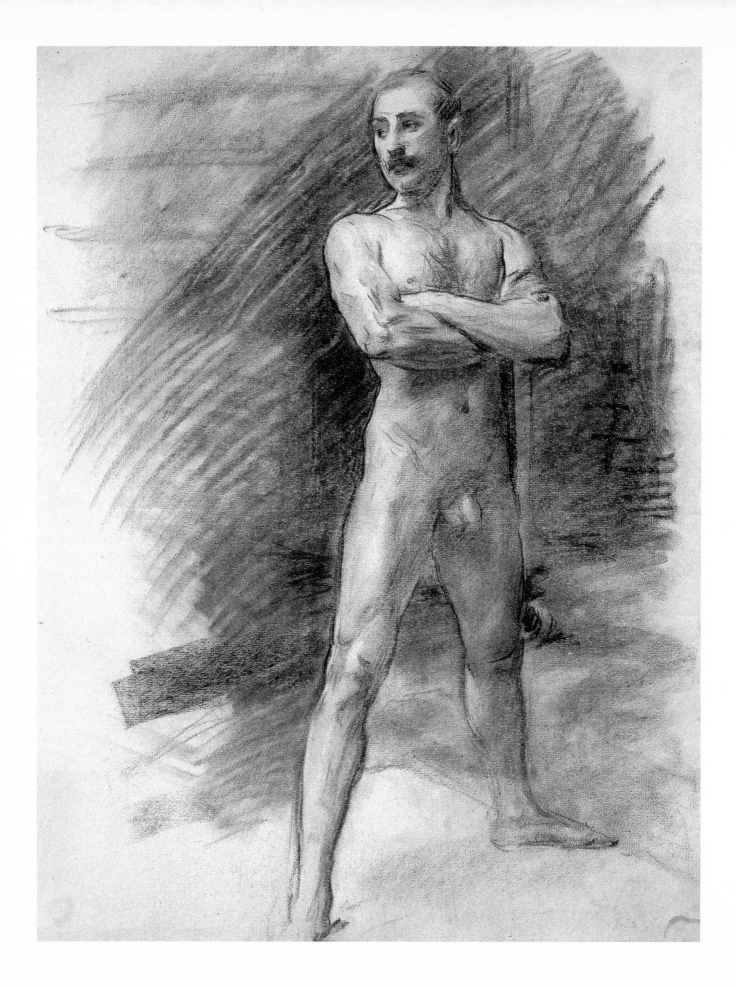

FOLIO 12

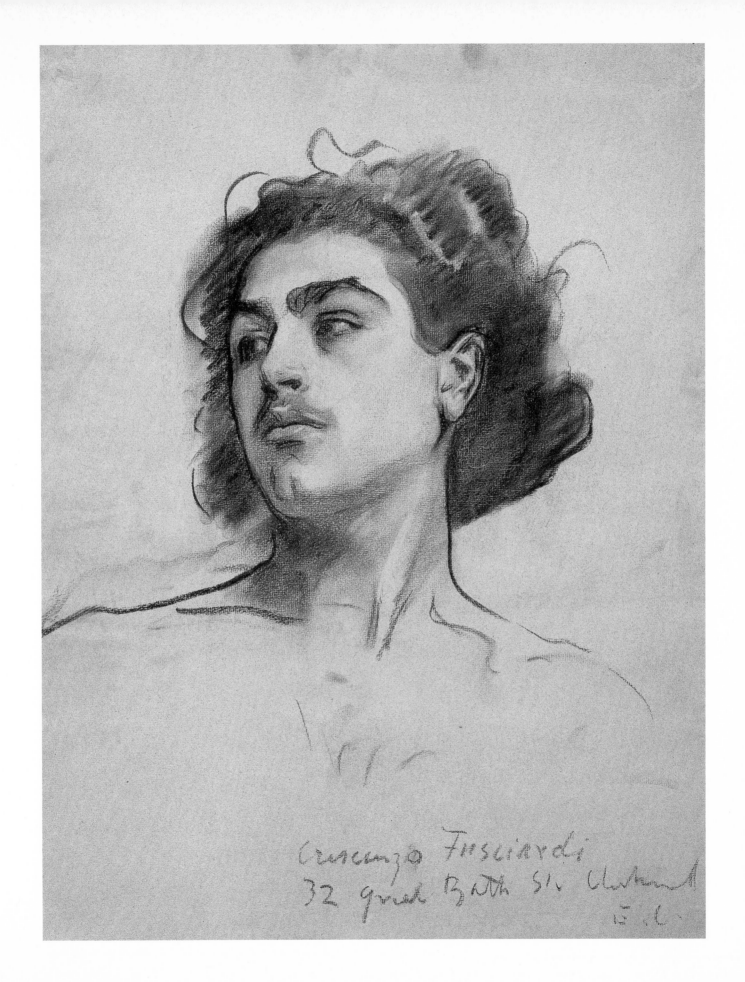

Crescenzo Fusciardi
32 gried Bath St Clerkenwell
J. S. S.

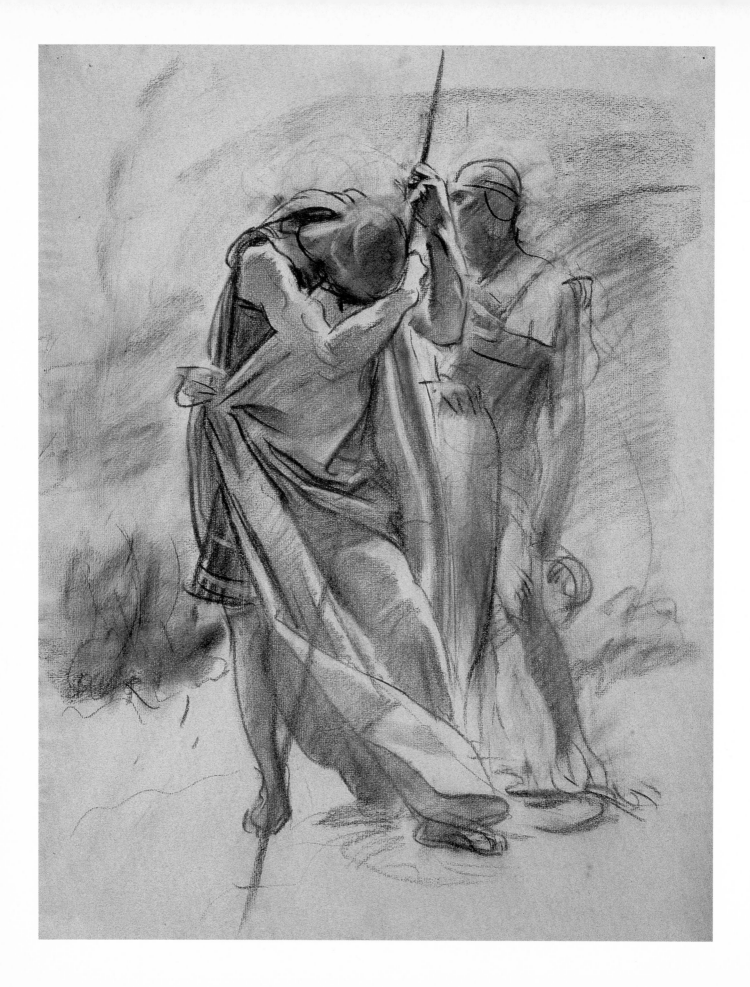

FOLIO 14

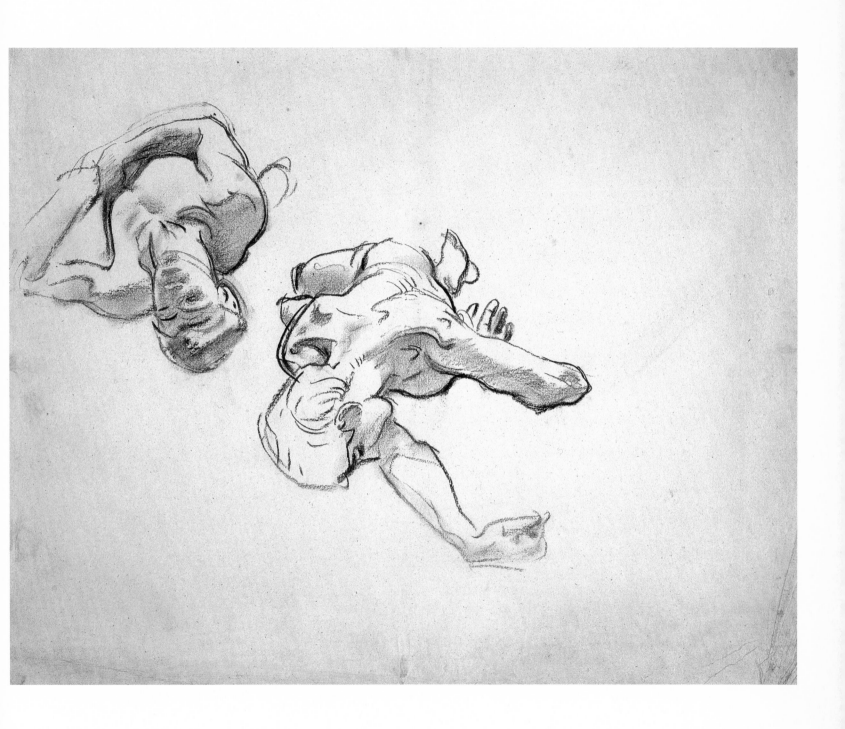

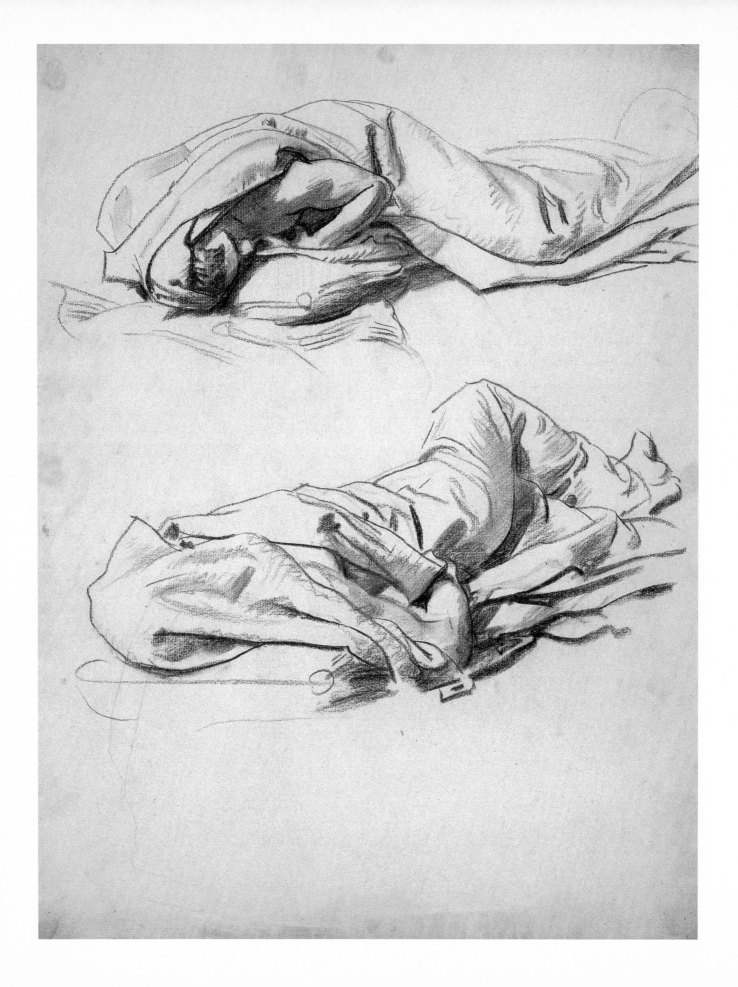

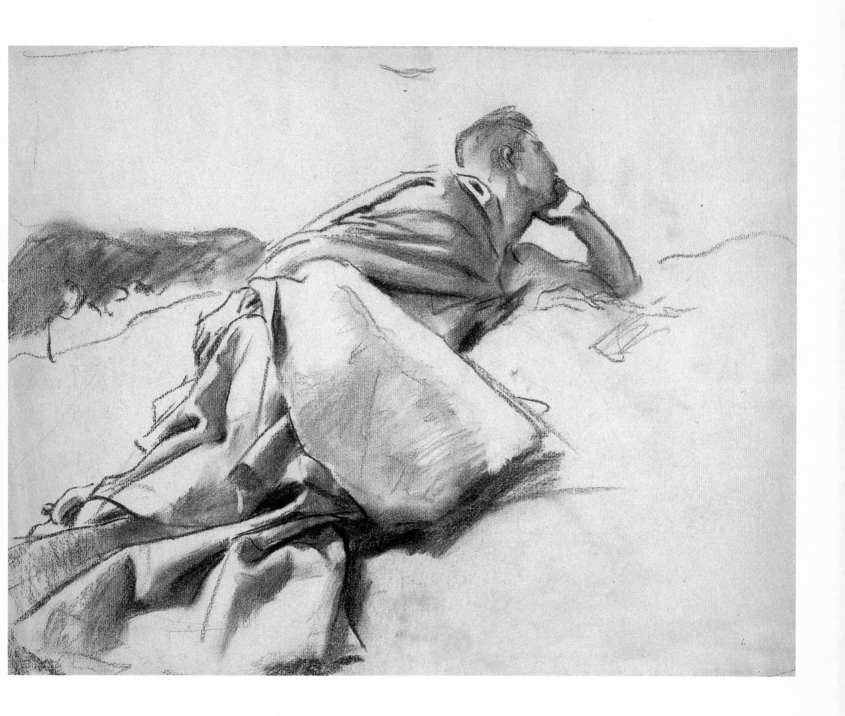

FOLIO 17A

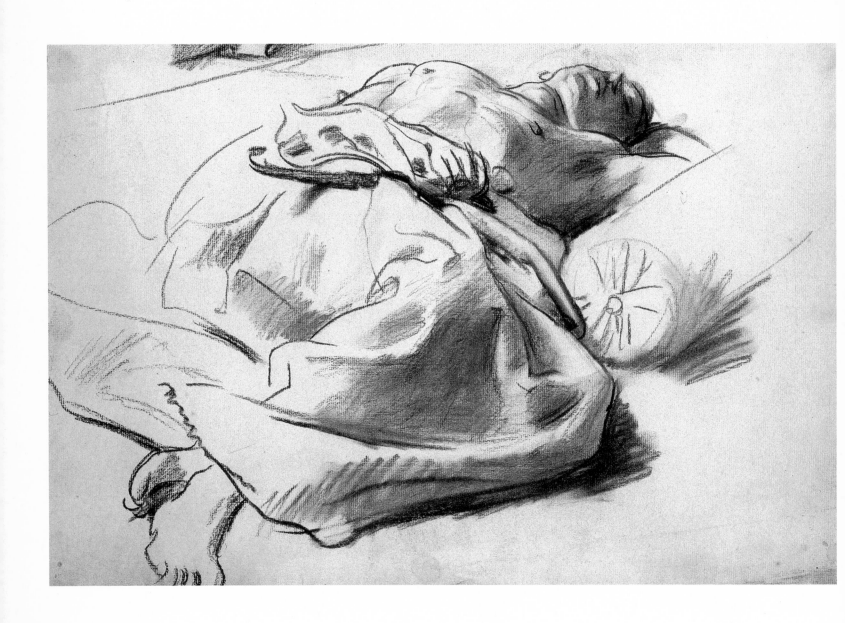

FOLIO 17B

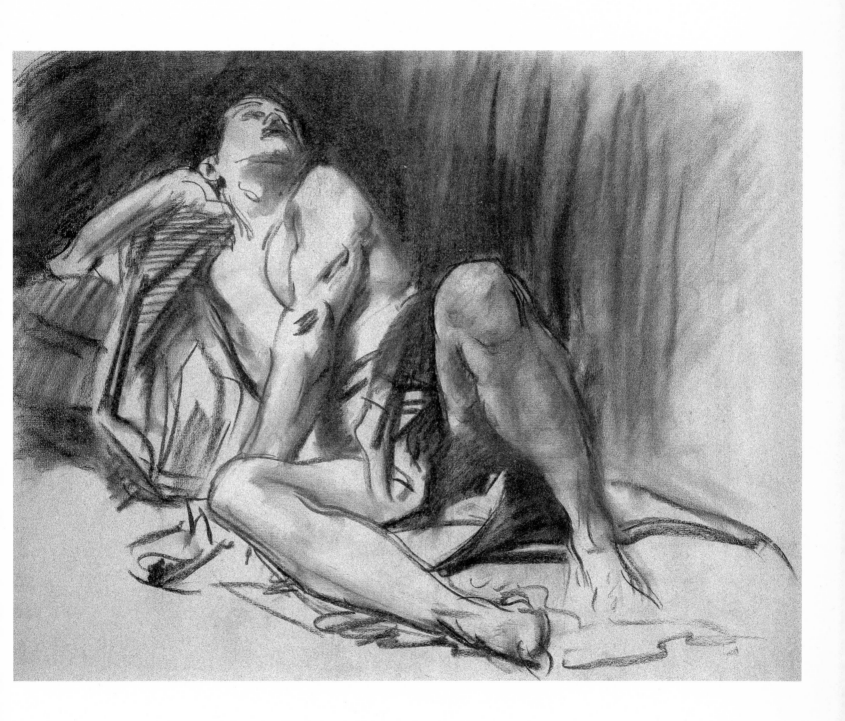

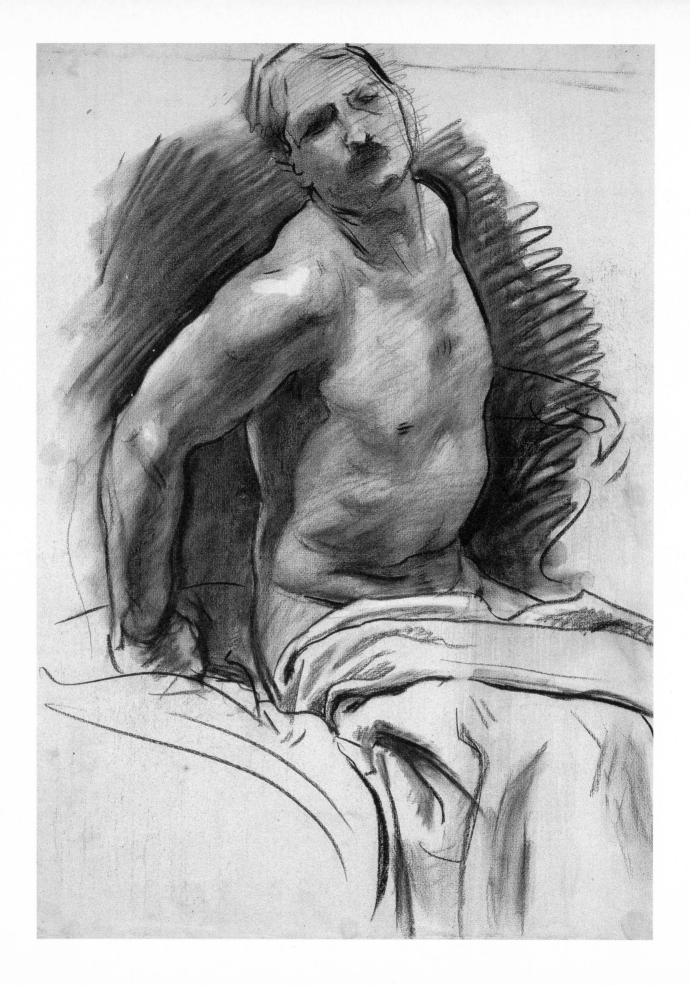

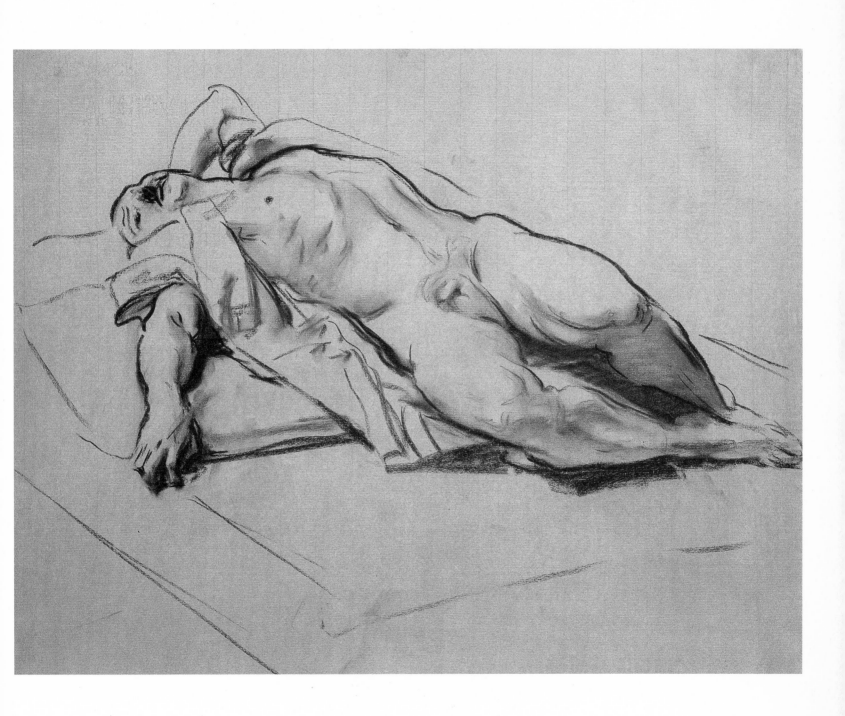

FOLIO 20

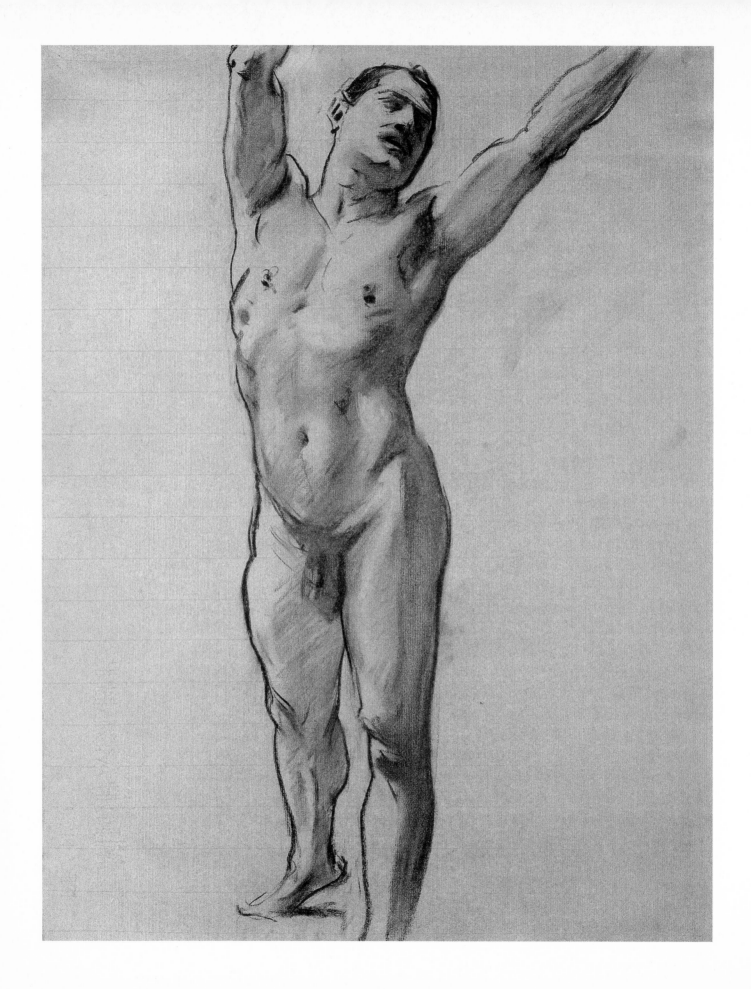

FOLIO 21

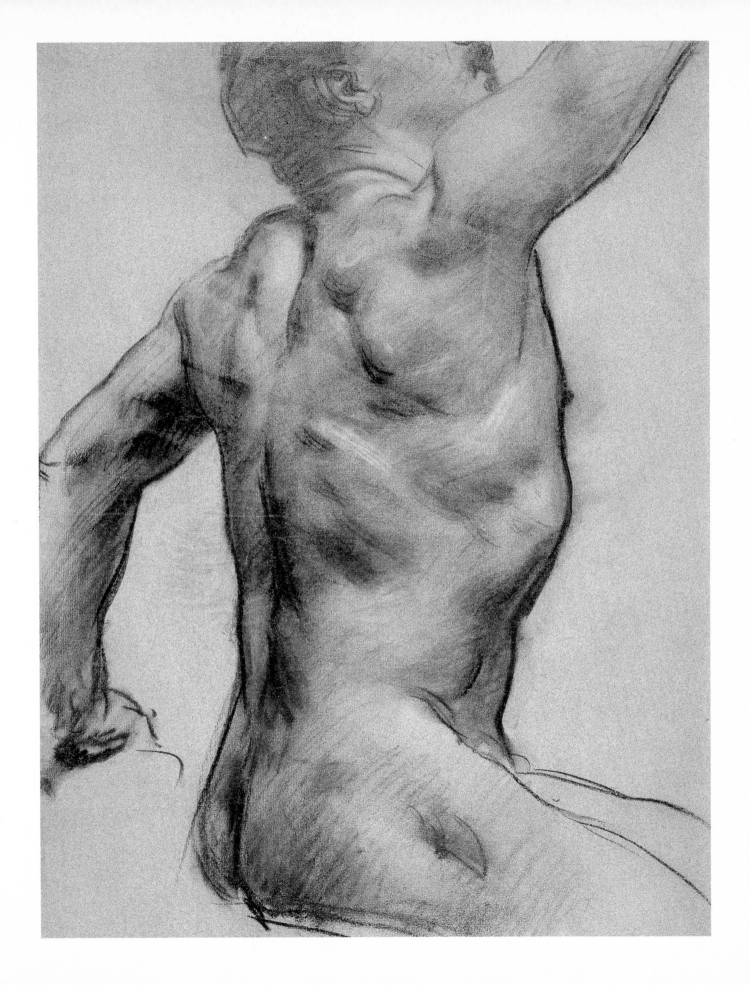

FOLIO 22

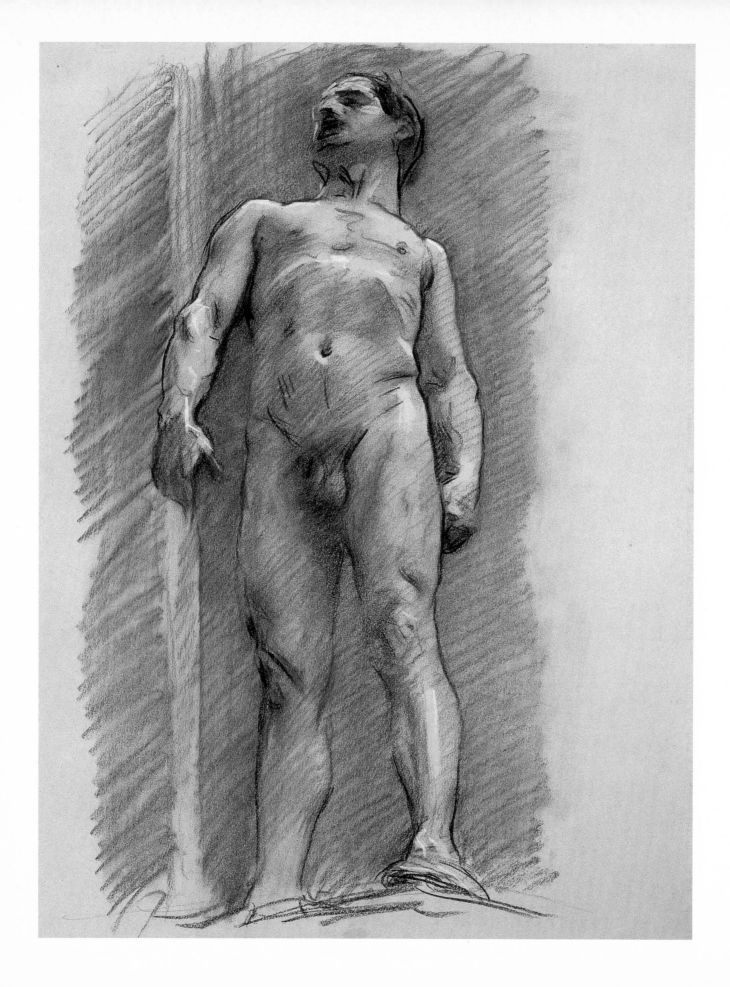

FOLIO 23

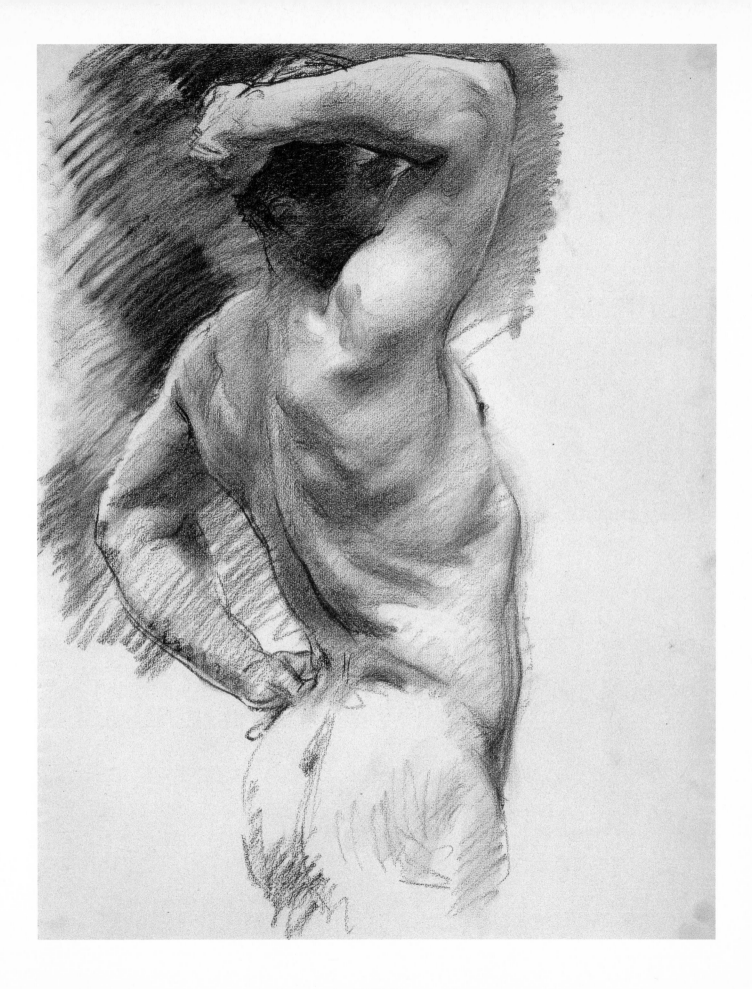

FOLIO 24

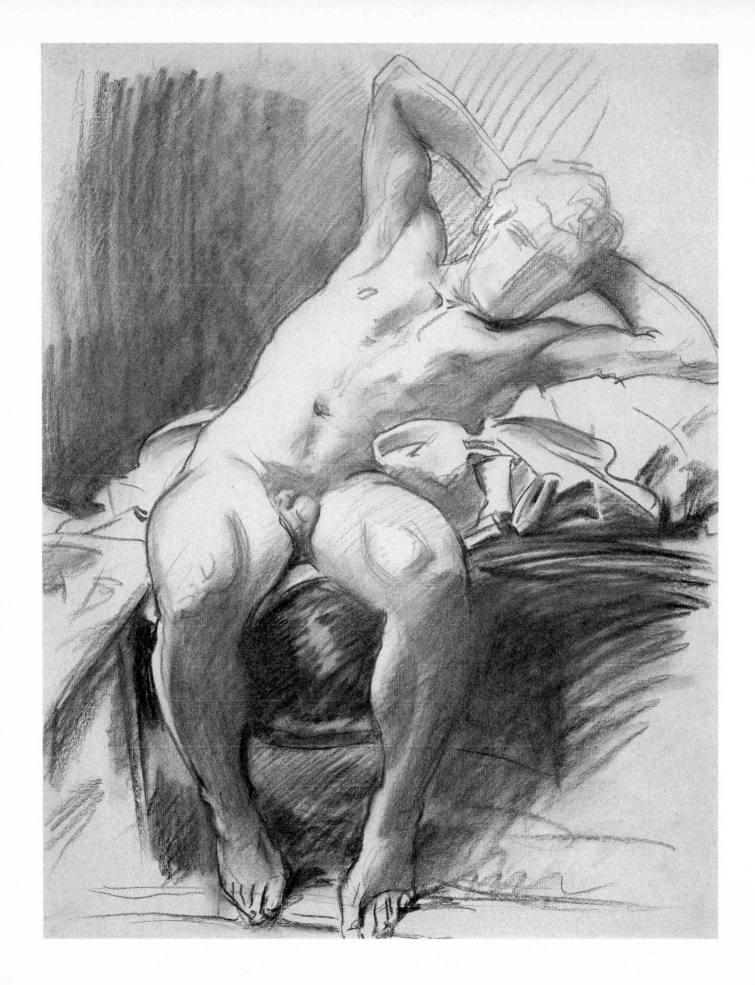

FOLIO 25

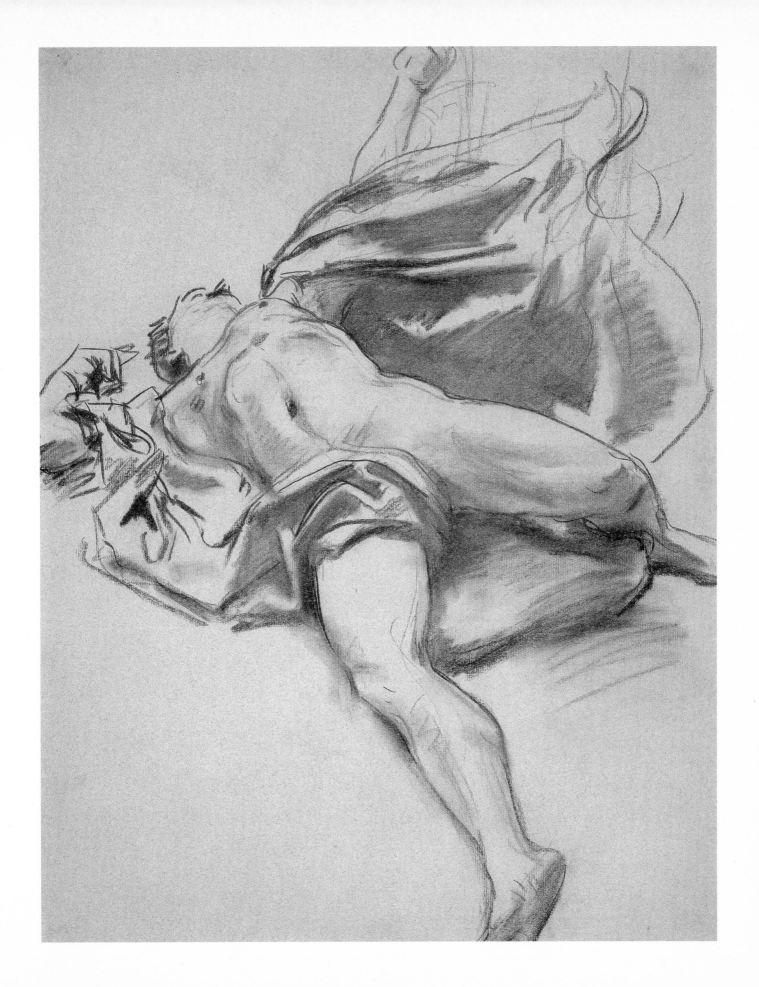

FOLIO 26

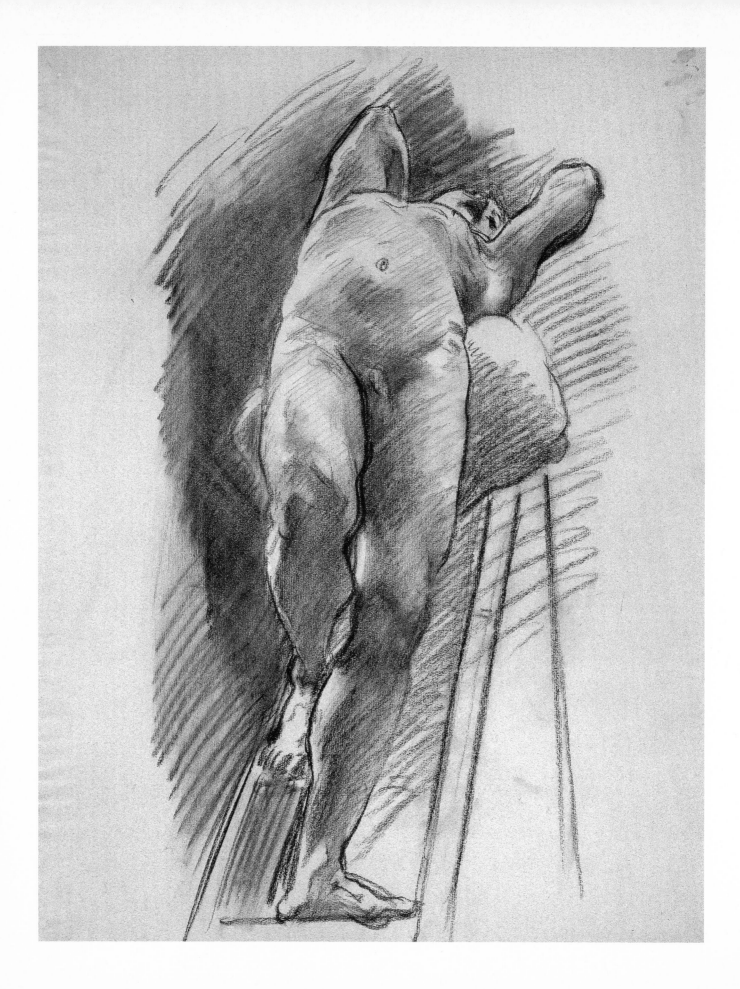

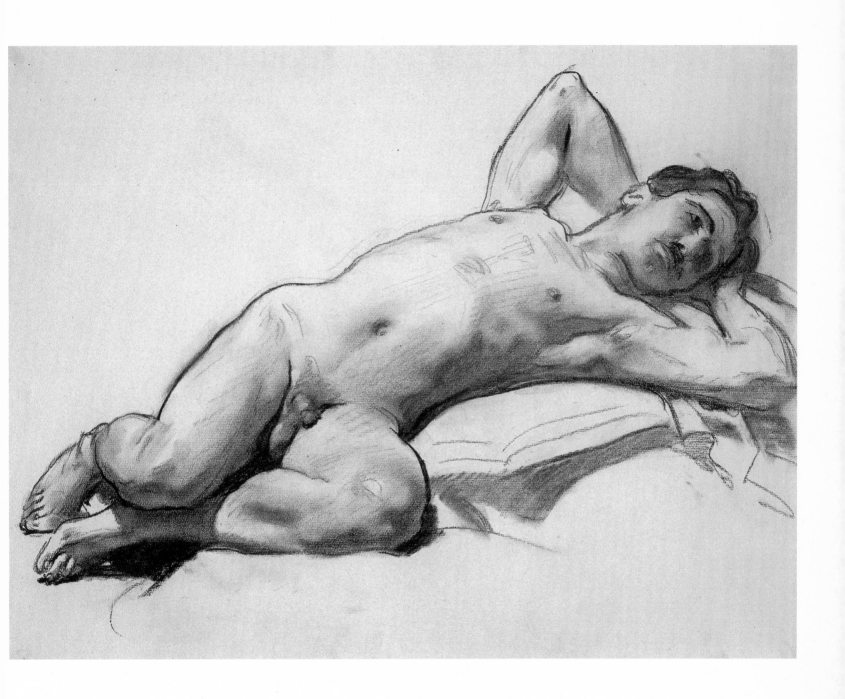

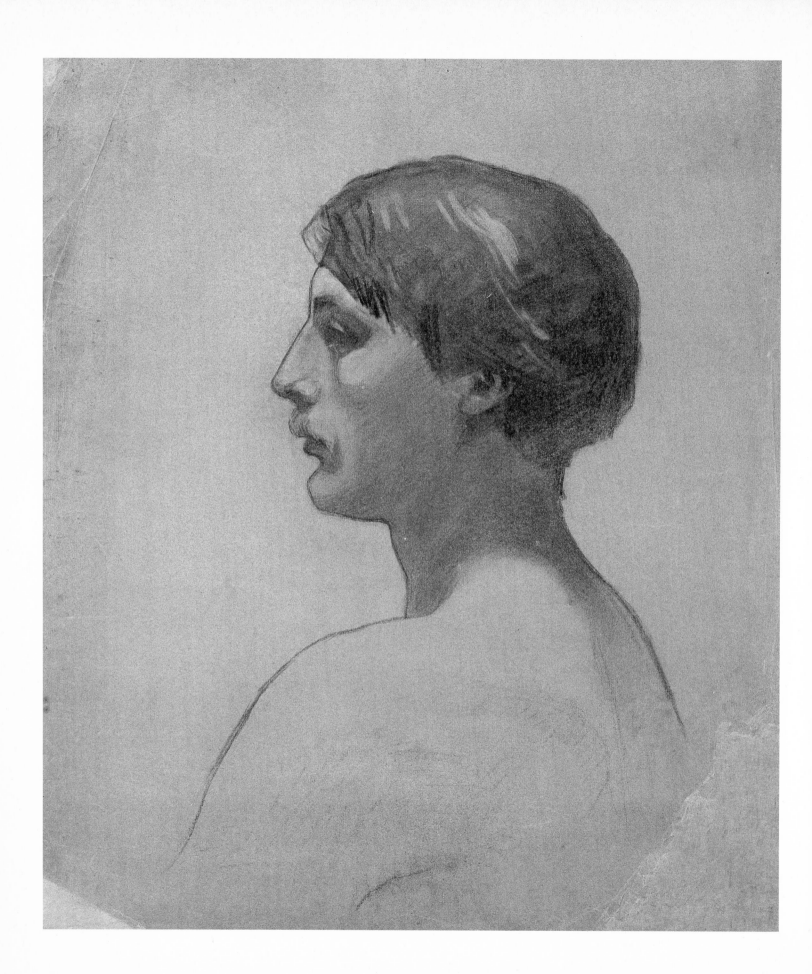

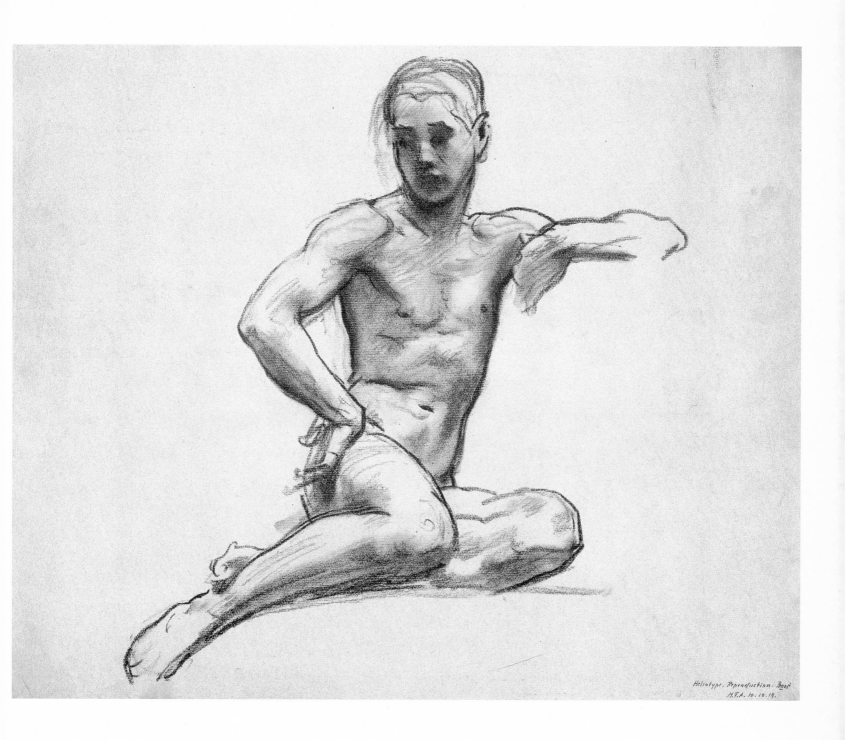

Notes

CHAPTER ONE

1. Nicola d'Inverno, "The Real John Singer Sargent As His Valet Saw Him," *Boston Sunday Advertiser,* Feb. 7, 1926, 3.

2. *Punch,* Jan. 17, 1923, 51. For an illustration, see Sally M. Promey, *Painting Religion in Public: John Singer Sargent's "Triumph of Religion" at the Boston Public Library* (Princeton, N.J.: Princeton University Press, 1999), 33.

3. Promey, *Painting Religion in Public,* 255.

4. Unsigned, "The Royal Academy Exhibition," *Art Journal* 50 (July 1887): 248. For a thorough discussion of Sargent and Impressionism see the essay by William H. Gerdts in Patricia Hills, *John Singer Sargent* (New York: Whitney Museum of American Art, 1987).

5. Clive Bell, "Sargent," *The New Republic* 42 (May 20, 1925): 340. Bell commented further: "[In the 1880s] the influence of Manet and Degas— the good genii in his life—still mitigated that of his official master, Carolus-Duran. . . . Sargent's path should have been along the path that Degas and Lautrec were pursuing. That was the direction in which both his temperament and technical gifts seemed to point. He chose instead to become a professional portrait painter."

6. Roger Fry, *Transformations: Critical and Speculative Essays on Art* (London: Chatto and Windus, 1926), 125–26. Discussing Sargent's *plein air* pictures of the 1880s as "the first feeble echo" of French precedents, Fry wrote: "This new color was only a vulgarization of the new harmonies of the Impressionists; this new twilight effect [of Sargent's *Carnation, Lily, Lily, Rose* was] only an emasculated version of their acceptance of hitherto re-jected aspects of nature." Fry's conclusion was harsh: "Sargent had neither the psychological nor the distinctively artistic vision—he had, one might say, no visual passion at all, scarcely any visual predilections—he had rather the undifferentiated eye of the ordinary man trained to its finest acuteness for observation, and supplied with the most perfectly obedient and skilful hand to do its bidding." Fry's essay on Sargent first appeared in *The Nation* (Jan. 23, 1926).

7. Meyer Schapiro, "The Introduction of Modern Art in America: The Armory Show," in Daniel Aaron, ed., *America in Crisis* (New York: Alfred A. Knopf, 1952), 203–42. For a useful overview of the eclipse and reha-bilitation of the artist's reputation see H. Barbara Weinberg, "John Singer Sargent: Reputation Redivivus," *Arts Magazine* 54 (March 1980), 104–9.

8. Fairfield Porter, "Sargent: An American Problem," *Art News* 54 (Jan. 1956): 30–31.

9. Michael Brenson, "Modern Masters, Ancient Treasures, and New Questions," *New York Times,* Sept. 7, 1986, sec. 2, 43.

10. Michael Kimmelman, "Sargent's Dazzling Sensuality," *New York Times,* Feb. 19, 1999, B 33.

11. The Editor, "The Royal Academy Exhibition: II," *Magazine of Art* 18 (1895): 282. Bernard Berenson, *Sunset and Twilight: From the Diaries of 1947–1958* (New York: Harcourt, Brace and World, 1963), 480. In his entry for May 23, 1957, Berenson notes: "I would not agree with Boston and then London that he [Sargent] was one of the great painters of all times, and by far the greatest of contemporaries, and got myself disliked every-where for standing aside. I did not fail to appreciate his draughtsmanship, his technique, his arrangements, as well as his sensory revelation of char-acter. If he degenerated in London it was due to sitters who would be done by him. As a man he was good company, although not overexpres-sive. A musician, a great and selective reader, an appreciator, a loyal friend."

12. B. Purvis, "Sargent and His Sitters" [letter to the editor], *Sunday Times* (London), Feb. 21, 1926, 7.

13. Quoted by A Friend, "Memories of Sargent," *Living Age* (May 30, 1925), as reprinted in Carter Ratcliff, *John Singer Sargent* (New York: Abbeville Press, 1982), 235.

14. Percy Grainger, "Sargent's Contributions to Music," published in Evan Charteris, *John Sargent* (New York: Charles Scribner's Sons, 1927), 149–51. As inscrutable as Sargent, Grainger was a heterosexual who enjoyed flagellation as part of lovemaking. Concealing "his innermost feelings from the world . . . [Grainger] was skillful at sublimating his true emo-tions and projecting them into his music." See John Baird, *Percy Grainger* (Oxford: Oxford University Press, 1999), 156.

15. Jacques-Émile Blanche, *Portraits of a Lifetime* (London: J. M. Dent, 1937), 156.

16. Beerbohm describes Sargent as the "most sensitive and correct of men" in a letter to Reggie Turner, quoted in H. Mongomery Hyde, *Henry James at Home* (London: Methuen, 1969), 237.

17. Martin Birnbaum, *John Singer Sargent: A Conversation Piece* (New York: William E. Rudge's Sons, 1941), 4.

18. Jane Emmet von Glehn writing to her mother, Mrs. W. J. Emmet, from England (letter postmarked Feb. 10, 1906). I am grateful to Helen Hall for providing a transcript of this letter.

19. Quoted in Peter Wild, ed., *The Autobiography of John C. Van Dyke* (Salt Lake City: University of Utah Press, 1993), 141.

20. Adams in a letter of March 1, 1903, to Elizabeth Cameron, quoted in Worthington Chauncey Ford, ed., *The Letters of Henry Adams* (Boston: Houghton Mifflin, 1938), 398–99. Adams encountered Sargent during the artist's visit to Washington to paint President Roosevelt early in 1903. In the same letter he makes this comment on Americans who "catch English manners" when living abroad: "The generation of Harry James and John Sargent is already as fossil as the buffalo. The British middle-class must be exterminated without remorse."

21. W. Graham Robertson, *Time Was* (London: Hamish Hamilton, 1931), 240.

22. Theodore Robinson, diary entry for Feb. 28, 1890: "[Sargent had] a curious row with Mr. Fairchild. He painted Miss Sally which the father wanted to buy, and on Sargent objecting, he likewise objected, whereupon Sargent destroyed the canvas." I am grateful to Sona Johnston for generously providing a transcript of this entry.

23. Charteris, *John Sargent*, 119–20. See also Stanley Olson, *John Singer Sargent: His Portrait* (New York: St. Martin's Press, 1986), 177. The farmer took legal action for damages and Sargent's lawyer, George Lewis, worked out a private settlement. Lewis, who moved in artistic circles, represented Oscar Wilde on a few occasions. Sargent painted portraits of Lewis and his wife in the 1890s.

24. D'Inverno, "The Real John Singer Sargent."

25. Robertson, *Time Was*, 269. Later that night Sargent made an "eloquent summing up" that revealed his "gift of self-expression in picturesque and impassioned speech." Robertson recalled: "He expressed himself for upwards of half an hour without repeating a phrase or an epithet. It was colossal—I never heard anything like it."

26. Mrs. Claude Beddington, *All That I Have Met* (London: Cassell, 1929), 151.

27. Birnbaum, *John Singer Sargent*, 5. The occasion was a dinner at Edgecliff, the home of Ernest Longfellow, near Manchester, Massachusetts, in 1917.

28. William Rothenstein, *Men and Memories: 1872–1900* (New York: Coward-McCann, 1931), 194, 244.

29. Blanche, *Portraits of a Lifetime*, 154.

30. Mary Newbold Patterson Hale, "The Sargent I Knew," *World Today* (Nov. 1927), as reprinted in Ratcliff, *John Singer Sargent*, 237.

31. A Friend, "Memories of Sargent," as reprinted in Ratcliff, *John Singer Sargent*, 234–35.

32. Quoted in Olson, *John Singer Sargent*, 18.

33. Quoted in Stephen D. Rubin, *John Singer Sargent's Alpine Sketchbooks: A Young Artist's Perspective* (New York: Metropolitan Museum of Art, 1991), 45.

34. For a recent overview of Sargent's friendships with women, see Richard Ormond, "John Singer Sargent: A Biographical Sketch," in Elaine Kilmurray and Richard Ormond, eds., *John Singer Sargent* (London: Tate Gallery, 1998), 14.

35. *Vernon Lee's Letters* (London: privately printed, 1937), 116.

36. Unsigned review in *Art Journal*, 1893, quoted in Kilmurray and Ormond, *John Singer Sargent*, 144.

37. "M. Rodin in London," *Daily Chronicle*, May 16, 1902. I thank Elaine Kilmurray for this citation.

38. Quoted in Olson, *John Singer Sargent*, 220. The commission for the coronation portrait went to Sargent's friend Edwin Austin Abbey.

39. *Art Amateur* 49 (July 1903): 33, 35.

40. James in a letter of Jan. 22, 1901, quoted in Hyde, *Henry James at Home*, 105–6: "The Prince of Wales is an arch-vulgarian . . . [He] is 'carrying on' with Mrs. George Keppel (sister-in-law of Lord Albemarle) in a manner of the worst men for the dignity of things. His succession, in short, is ugly and makes all for vulgarity and frivolity."

41. Unsigned, *American Art News* 3 (Feb. 18, 1905), 1.

42. Unsigned [Roger Fry], "Sargents at the Carfax Gallery," *The Athenaeum*, April 1, 1905, 408–9. Donald A. Laing confirms Fry's authorship in *Roger Fry: An Annotated Bibliography of the Published Writings* (New York: Garland Publishing, 1979), 130.

43. Comte Robert de Montesquiou, "Le Pavé Rouge," *Les Arts de la Vie*, June 1905, 329–48. The author likens the substantial, hardcover red volume to a paving stone, exposing the publication's self-important appearance.

44. Bernard Partridge, "The Jealousies of Art," in *Punch's Almanac for 1907*, unpaginated insert to *Punch* 131 (Dec. 26, 1906).

45. Walter Sickert, "Sargentolatry," *The New Age* 7 (May 19, 1910): 56–57.

46. See Quentin Bell, "John Sargent and Roger Fry," *Burlington Magazine* 99 (Nov. 1957): 380–82.

47. For a review of Sargent's dependence upon the decorations of Michelangelo, Raphael, and other Renaissance artists, and a discussion of his contemporaries' beliefs that Sargent Hall was an "American Sistine Chapel," see Promey, *Painting Religion in Public*, 116–29.

48. Discussed by Kathy Adler in "John Singer Sargent's Portraits of the Wertheimer Family," an essay of 1995 reprinted in Norman L. Kleeblatt, ed., *John Singer Sargent: Portraits of the Wertheimer Family* (New York: The Jewish Museum, 1999), 30–31. Oman was the Member of Parliament for Oxford University and Chichele Professor of Modern History.

CHAPTER TWO

1. Purvis, "Sargent and His Sitters."

2. Sargent to Ben del Castillo, May 23, 1869, quoted in Charteris, *John Sargent*, 12. Sargent, aged thirteen, writes: "Ma gave me a large album of white Roman binding to stick photographs in, and I have stuck in about sixty of Rome and a great many of Naples. I have a good many old Greek and Roman poets, and I am trying to get the first Caesars. I will get some photographs of the Museum at Munich, where there are some very beautiful statues."

3. Sargent to Heath Wilson, May 23, 1874, quoted in catalogue no. 605 of Maggs Bros. Ltd., London (spring 1935), 93.

4. Rothenstein, *Men and Memories,* 192–93.

5. Paul Valéry, "The Triumph of Manet," an essay of 1932 reprinted in *Degas, Manet, Morisot,* trans. David Paul (Princeton, N.J.: Princeton University Press, 1989), 113.

6. Sargent in a letter of 1880, quoted in Richard Ormond, "John Singer Sargent and Vernon Lee," *Colby Library Quarterly* 9 (Sept. 1970): 163. "I shall send you a photograph of a little picture I perpetrated in Tangiers. . . . [It] will give you a general idea of what your 'twin' is about. My compliments, most illustrious twin, for what you are achieving." For a recent discussion of the relationship between Lee's sexuality and her writing, see Kathy Alexis Psomiades, "'Still Burning from This Strangling Embrace': Vernon Lee on Desire and Aesthetics," in Richard Dellamora, ed., *Victorian Sexual Dissidence* (Chicago: University of Chicago Press, 1999), 21–41.

7. Letter of June 25, 1881, *Vernon Lee's Letters,* 65.

8. "Première Exposition de la Société Internationale de Peintres et Sculpteurs," Arthur Baignères, *Gazette des beaux-arts* 27 (Feb. 1883): 190. The exhibition hosted by the Galerie Georges Petit, Paris, opened in late 1882. For an overview, see Marc Simpson, *Uncanny Spectacle: The Public Career of the Young John Singer Sargent* (Williamstown, Mass.: Sterling and Francine Clark Art Institute, 1997), 35.

9. Twain writing in 1867, quoted in MaryAnne Stevens, ed., *The Orientalists: Delacroix to Matisse* (Washington: National Gallery of Art, 1984), 13.

10. Sargent to Vernon Lee, July 9, 1880, quoted in Kilmurray and Ormond, *John Singer Sargent,* 88.

11. Vernon Lee, "J. S. S.: In Memoriam," an essay dated Aug. 13, 1925, first published in Charteris, *John Sargent,* 249.

12. The large colored version of this composition is illustrated in Hills, *John Singer Sargent,* 44.

13. Diaries of James Carroll Beckwith, New-York Historical Society.

14. R. A. M. Stevenson, "J. S. Sargent," *Art Journal* 40 (March 1888): 65–69.

15. Henry James, "John S. Sargent," *Harper's New Monthly Magazine* 75 (Oct. 1887): 683–91.

16. Entry for April 25, 1894, cited in *The Notebooks of Henry James,* F. O. Matthiessen and Kenneth B. Murdock, eds. (New York: Oxford University Press: 1947), 160.

17. Henry James, essay originally published in *Harper's Weekly* (June 26, 1897), and reprinted as "The Guildhall and the Royal Academy," in John L. Sweeney, ed., *The Painter's Eye: Notes and Essays on the Pictorial Arts by Henry James* (Madison: University of Wisconsin Press, 1989), 257.

18. Trevor J. Fairbrother, *John Singer Sargent and America* (New York: Garland Publishing, 1986), 101–6, 366–67. For an overview of Mrs. Gardner's collection, see Hilliard T. Goldfarb, *The Isabella Stewart Gardner Museum* (Boston: Gardner Museum, 1995).

19. For a revisionist biography that portrays Gardner as a socially progressive figure with a gay coterie, see Douglass Shand-Tucci, *The Art of Scandal: The Life and Times of Isabella Stewart Gardner* (New York: HarperCollins, 1997).

1. Vernon Lee to her mother, July 16, 1893: "Lady Agnew [is] a very pretty woman whom John Sargent has just made into a society celebrity by a very ravishing portrait" (*Vernon Lee's Letters,* 352).

2. *L'Illustration* 75 (Jan. 17, 1880), cover image. For a reproduction, see Hills, *John Singer Sargent,* 82. For a well-documented account of early illustrations and caricatures of Sargent's Salon pictures, including *Carolus-Duran,* see Simpson, *Uncanny Spectacle,* 60–64.

3. Unsigned editorial, *Times* (London), Aug. 19, 1886, 7. This commentary was part of the paper's ongoing discussion regarding possible reforms at the Royal Academy, given that the last annual exhibition was "below the mark."

4. Greta, "Art in Boston," *Art Amateur* 18 (April 1888): 110. Cited at length and discussed in relationship to the 1888 exhibition in Fairbrother, *John Singer Sargent and America,* 96–112.

5. Catalogue entry by Richard Ormond, in Kilmurray and Ormond, *John Singer Sargent,* 72.

6. The dissatisfied sitter was Alice Mason, whose portrait is dated 1885. Her comment about her murderous look was reported (and seconded) by Vernon Lee when the portrait was on view at the Grosvenor Gallery, London, in 1885. See Richard Ormond and Elaine Kilmurray, *John Singer Sargent: The Early Portraits* (New Haven: Yale University Press, 1998), 142.

7. Gosse, quoted in Charteris, *John Sargent,* 78.

8. Sargent to Isabella Stewart Gardner, Jan. 1, 1889, quoted in ibid., 101.

9. Beddington, *All That I Have Met,* 153. Sargent probably made this comment in 1914, when he drew Mrs. Beddington. Sybil Sassoon became countess of Rocksavage on her marriage in 1913, and marchioness of Cholmondeley in 1923. Sargent painted her in 1913 (a wedding gift to the nineteen-year-old woman) and in 1922; he drew her on several occasions. See Kilmurray and Ormond, *John Singer Sargent,* 174, and Richard Ormond, *John Singer Sargent: Paintings, Drawings, Watercolors* (New York: Harper and Row, 1970), 256–57 and pl. 112.

10. Pozzi enjoyed flirting with numerous female acquaintances and patients, although it is less certain that he had affairs. See Claude Vanderpooten, *Samuel Pozzi: Chirugien et Ami des Femmes* (Paris: V et O Editions, 1992), 91–93. In the world of the arts, Pozzi had close friendships with Sarah Bernhardt, Judith Gautier, Geneviève Bizet, and Louise Ackermann. The seductive doctor's friendships with various sexually ambiguous males are sketched by Philippe Jullian in *Robert de Montesquiou: A Fin-de-Siècle Prince,* trans. John Haylock and Francis King (London: Secker and Warburg, 1967). In 1884, when Pozzi visited London with Montesquiou and Prince Edmond de Polignac, Sargent encouraged the trio to visit Henry James. Pozzi's homosexual patients included Gabriel Yturri (Montesquiou's secretary) and the writer Jean Lorrain.

11. A Salon review for *Art Journal,* quoted in Simpson, *Uncanny Spectacle,* 92. Note also Margaret Bertha Wright's contemporary Salon review for *Art Amateur:* "Sargent's 'Portrait of Mme. P.' is of the French, Frenchy. One regrets that so much cleverness could give no lovelier picture to the exhibition than that of a modishly dressed and furiously red-headed woman, who looks as if her hair had not been touched for a week, and whose dim eyes are half closed, either from weakness or drowsiness, it matters not which" (ibid., 91). The eagerness with which these two women criticized Sargent's French patron seems to betray their American anxieties about Parisian stylishness.

12. Ibid., 134; Simpson cites the original French version of this review.

13. *Vernon Lee's Letters*, 143. Lee also told her mother that the portrait of Madame Gautreau was "a solemn fiasco in the eyes of the world." She noted that Sargent was proud of the picture and she herself found it "a very grand work," despite aspects that were "bizarre and even unpleasant."

14. The social and political milieu in which Sargent created *Madame X* is detailed by Albert Boime in "Sargent in Paris and London: A Portrait of the Artist as Dorian Gray," in Hills, *John Singer Sargent*, 75–109. Many early critical responses are quoted in Simpson, *Uncanny Spectacle*, 140–41.

15. The story of the repainted shoulder strap was first documented by Trevor J. Fairbrother in "The Shock of John Singer Sargent's *Madame Gautreau*," *Arts* 55 (Jan. 1981): 90–97. According to a report published in *Art Amateur* in 1889, Bouguereau denied Sargent's request to retouch the painting and "took the opportunity to lecture the young artist on the danger of such unconventional practices, which, he pointed out, lead to breaking up of families and other dire consequences" (ibid., 94).

16. There is confusion in the Sargent literature regarding the color of the woman's skin and the color of the makeup she applied to it. I suspect that Madame Gautreau had a delicate bluish-purplish skin (a trait not inconsistent with her bright red-brown hair) and that she applied white rice powder makeup. If she did not put makeup on her ear, then it would have looked a bright pink in contrast to the whiteness of her powdered face, ruddy hair, and deep red lips. When the artist Marie Bashkirtseff saw the painting at the Salon, however, she assumed that Madame Gautreau was in the habit of painting her ears pink, powdering face and shoulders a corpselike chalky white, and coloring her hair a rich mahogany. See *The Last Confessions of Marie Bashkirtseff* (New York: Frederick A. Stokes, 1901), 87.

17. Sargent to Vernon Lee, quoted in Charteris, *John Sargent, 59*.

18. In 1891, the year he painted *Madame Gautreau,* Gustave Cortois exhibited the portrait at the Salon. It entered the Musée du Luxembourg, Paris, before 1912 and is now in the Musée d'Orsay, Paris. For an illustration, see Fairbrother, "Shock of *Madame Gautreau*," 95, or the recent retelling by Hamish Bowles, "The Madame X Files," *Vogue* [American ed.] (Jan. 1999): 174–81, 205.

19. Gabriel-Louis Pringué, *30 Ans de Dîners en Ville* (Paris: Édition Revue Adam, 1948), 211–15; Gabriel-Louis Pringué, *Portraits et Fantômes* (Paris, Raoul Solar, 1951), 89–91.

20. While still working on the portrait, Sargent wrote to Ben del Castillo that he had covered "the former gloomy background" with a "tone of light rose" (see Charteris, *John Sargent*, 60). After seeing the unfinished picture in the artist's Paris studio, Henry James discussed it in a letter to Lizzie Boott and described its palette as "blue, green, white, black" (see Fairbrother, "Shock of *Madame Gautreau*," 93). I am most grateful to Dorothy Mahon, paintings conservator at the Metropolitan Museum of Art, New York, for a verbal summary of her technical examination of *Madame X.* She confirmed that the portrait's first background mixed the colors blue and blue-green; Sargent covered this with a warm rose-colored opaque paint; his final background color was a loosely brushed ochre, which he used to cool the rose tones. Mahon thinks it is likely that Sargent did not apply the final color until he repainted the shoulder strap after the Salon.

21. Quoted in Hyde, *Henry James at Home*, 36.

22. *Vernon Lee's Letters*, 65.

23. Terry's performance of Lady Macbeth is detailed as part of an extensive discussion of Sargent's portrait in Leigh Culver, *Performing Identities in the Art of John Singer Sargent* (Ann Arbor, Mich.: UMI Dissertation Services, 1999), 59–97.

24. Ralph Curtis to Mrs. Gardner, July 23, 1889 (Isabella Stewart Gardner Museum, Boston).

25. Quoted in Robertson, *Time Was*, 151. Before he related Wilde's quip about the improbability of finding such Oriental splendor in Scotland, Robertson praised Ellen Terry and her costume: "As Lady Macbeth her appearance was magnificent: long plaits of deep red hair fell from under a purple veil over a robe of green upon which iridescent wings of beetles glittered like emeralds, and a great wine-colored cloak, gold-embroidered, swept from her shoulders. The effect was barbaric and exactly right."

26. Adams wrote Charles Milnes Gaskell (Nov. 28, 1897): "As for me, I admire Dreyfus; but Sargent has just painted another Jew, Wertheimer, a worse crucifixion than history tells of" (*Letters of Henry Adams,* 137). The comment about *Mrs. Carl Meyer and Her Children* comes from an unattributed clipping (dated Sunday, March 5) in the archives of the Copley Society, Boston. It was probably published when the painting was on view in the large Sargent exhibition at Copley Hall, Boston, Feb. 20–March 13, 1899. The writer maintained that "the handsome young Jewess" became a "craze" after Sargent painted her, although she was "previously unknown in the smart London world."

27. The two surviving paintings of Stevenson are discussed in detail in Ormond and Kilmurray, *John Singer Sargent: The Early Portraits,* 167–69, 179–81.

28. I am grateful to Sargent's great-nephew Richard Ormond for his thoughts on these props. For a discussion of Wertheimer as a collector and dealer, see Michelle Lapine, "Mixing Business with Pleasure: Asher Wertheimer as Art Dealer and Patron," in Kleeblatt, *John Singer Sargent: Portraits of the Wertheimer Family,* 43–53.

29. Richard Ormond recently confirmed that the table and the objects upon it—a blanc-de-chine lion and a crystal vase—belonged to Sargent. He feels the chair looks "too grand" for Sargent's personal taste and suspects that it belonged to the Wertheimers. The table appears as a prop in other portraits, but the chair does not.

30. Noted by Adler in Kleeblatt, *John Singer Sargent: Portraits of the Wertheimer Family,* 29.

31. Wilfred Scawen Blunt, quoted by Trevor Fairbrother, "The Complications of Being Sargent," in Kleeblatt, *John Singer Sargent,* 41.

32. D. S. M. [D. S. MacColl], "The Academy—II: The Rape of Painting," *Saturday Review* 91 (May 18, 1901): 632–33.

33. Robert Ross, "The Wertheimer Sargents," *The Art Journal*, no. 871 (Jan. 1911): 10. Ross gratuitously contrasted Sargent's "health-giving, manly art" with the "mutilated and atrophied talents" of the French art "invading" England. This was an allusion to Roger Fry's recent exhibition "Manet and the Post-Impressionists," shown at the Grafton Galleries, London, late in 1910.

34. Unsigned, "The Academy of Design," *Art Amateur* 24 (Jan. 1891): 31. Sargent's painting of 1890, *Joseph Jefferson in the Part of Dr. Pangloss,* inspired this critic's lengthy protest: "The bright eyes gleaming out from the bricky complexion and obviously artificial wig have almost a weird effect. Woe to Mr. Sargent's sitter who uses pearl powder ever so little, or wears a conventional smile! It is just this mask of the actor, of the diplomatic

personage, or the woman of society that he delights in painting, conveying by some touch about the eyes or mouth the fact that it is a mask, and does not quite suit the wearer. Whether it is the province of a portrait painter to constitute himself a censor of the toilette we will not discuss here; but we once more enter a protest against Mr. Sargent's unintelligent trick of representing actors and actresses in their 'make up'—legitimate and absolutely necessary for the view before the footlights, but never intended to be seen off the stage." See Fairbrother, *John Singer Sargent and America*, 166, and Culver, *Performing Identities in the Art of John Singer Sargent*, 1–2.

35. D. S. M. [D. S. MacColl], "The New Gallery," *Saturday Review* 91 (April 27, 1901): 535. For an illustration and discussion of *Lord Dalhousie*, see Kilmurray and Ormond, *John Singer Sargent*, 152–54.

CHAPTER FOUR

1. James, "John S. Sargent," 691: "Mr. Sargent handles these [delicate feminine] elements with a special feeling for them, and they borrow something of nobleness from his brush. This nobleness is not absent from . . . [the portrait] of Lady Playfair and that of Mrs. William White; it looks out at us from the erect head and frank animation of the one, and the silvery sheen and shimmer of white satin and white lace which form the setting of the slim tallness of the other."

2. Walt Whitman, "A Backward Glance o'er Travel'd Roads," in *Whitman: Poetry and Prose* (New York: The Library of America, 1982), 669.

3. Sargent contributed $20 to the "Whitman Cottage Fund" organized by the Bostonian writer Sylvester Baxter. The fund raised about $800 to build the poet a small country retreat; one of the largest donations ($50) came from Sargent's friend and patron Mrs. Charles Fairchild. I thank Sally Promey for sharing this information, which she gleaned from the Baxter holdings at the Boston Public Library.

4. Horace Traubel, *With Walt Whitman in Camden, Vol. 6: September 15, 1889–July 6, 1890* (Carbondale: Southern Illinois University Press: 1982), 315, 333–34. Traubel notes that Sargent's requests to paint Whitman's portrait were communicated by "Williamson (N.Y.)," whose letters arrived on March 3 and March 21, 1890. The go-between was probably George M. Williamson, a collector of rare manuscripts.

5. Holbrook Jackson, *The Eighteen Nineties: A Review of Art and Ideas at the Close of the Nineteenth Century* (New York: Alfred A. Knopf, 1923), 30–31. The first edition of this book, which was dedicated to Sargent's acquaintance Max Beerbohm, was published in London in 1913.

6. From Gosse's *Aspects and Impressions* (1922), as quoted and interpreted in Hyde, *James at Home*, 180.

7. Gosse in a letter to Bliss Perry, March 6, 1907, quoted in Evan Charteris, *The Life and Letters of Sir Edmund Gosse* (New York: Harper and Brothers, 1931), 300.

8. Sargent to his distant cousin Mrs. Ivers Austin, April 25, 1874, quoted in Charteris, *John Sargent*, 19–20.

9. Spinelli was the subject of Beckwith's 1878 painting *The Falconer*. For an illustration, see Pepi Marchetti Franchi and Bruce Weber, *Intimate Revelations: The Art of Carroll Beckwith* (New York: Berry-Hill Galleries, 1999), fig. 7. In his diary Beckwith called Spinelli "the handsomest Italian in Paris" (ibid., 20).

10. Sargent to Vernon Lee, quoted in Ormond, "John Singer Sargent and Vernon Lee," 163. Sargent wrote that Andalusian chants "are something between a Hungarian czardas and the chant of the Italian peasant in the fields, and are generally composed of five strophes and end stormily *on the dominant,* the theme quite lost in strange fiorituras and gutteral roulades."

11. Unsigned, "American Art in the Paris Salon," *Art Amateur* 7 (Aug. 1882): 46. The reviewer noted: "[Sargent's] 'Gypsy Dance' attracted considerable attention last spring—from artists as an extraordinary artistic 'tour de force,' from the general public as the ugliest picture in the whole exhibition. . . . Sargent disdains finish for ostentatious cleverness, and the result is a rough splash of hideous forms, and of faces more like Japanese masks than Spanish countenances, with the light thrown up from invisible footlights upon the ugliest angles of a very ugly central figure. . . . This may prove a genius for 'chiaroscuro' and a brilliant contempt for Academic rules, but its result is certainly far from . . . artistic beauty and grace."

12. James, "John S. Sargent," 686–88.

13. Sargent's solo exhibition at the Carfax Gallery, London, in 1905 included forty-four watercolors and three oil paintings: *Madame X* (fig. 1.6), *Egyptian Girl* (fig. 6.1), and *Javanese Dancer*. As one critic hinted, the artist had exhibited the last two pictures at the New English Art Club in 1891 (Unsigned [Fry], "Sargents at Carfax," 408). For an overview of the Javanese pictures, see D. Dodge Thompson, "John Singer Sargent's Javanese Dancers," *Antiques* 138 (July 1990): 125–33.

14. Abbey in a letter of 1890 to Charles F. McKim, quoted in E. V. Lucas, *The Life and Works of Edwin Austin Abbey, R. A.* (New York: Scribner's, 1921), 231. Abbey was probably referring to Sargent's temporary studio in New York.

15. Anton Kamp, one of the artist's Boston models, recalled posing for a female figure in Sargent's Harvard murals: "Securing several wads of cheesecloth he began to build up enough of a protrusion on my chest in the form of two lumps secured with adhesive tape to give the impression of the female bosom." (Kamp also explained that he was modeling for a detail of drapery worn by a woman and not for an anatomical study.) See Anton Kamp, "John Singer Sargent—As I Remember Him," unpublished memorandum, Feb. 23, 1973, 22 (courtesy Sargent catalogue raisonné project, c/o Adelson Gallery, New York). Drawings of male models in the roles of female characters are shown in Fairbrother, *John Singer Sargent*, 134–35, and in Jane Dini, *Public Bodies: Form and Identity in the Work of John Singer Sargent* (Ann Arbor, Mich.: UMI Dissertation Services, 1998), 89–90.

16. For a contrast to Sargent's male-directed gaze see the photographs taken recently by David Finn for Charles Avery, *Giambologna: The Complete Sculpture* (London: Phaidon, 1993), figs. 23, 24, 104–7. Finn's images devoted to the entire sculpture pay strong compositional attention to the woman's breasts; his close-up shots feature the woman's face, her buttocks, and her right breast hanging over the face of one of the male rapists. In fairness to the debate, it should be noted that Sargent made informal paintings of the bare-breasted mermaids at the base of Giambologna's *Fountain of Neptune* in Bologna. Leaning back astride dolphins, these sensual mermaids hold up their breasts, which function as spouts for the fountain. See Warren Adelson et al., *Sargent Abroad: Figures and Landscapes* (New York: Abbeville Press, 1997), figs. 135–39.

17. The sheets without glue marks are 1937.9.29 (a drawing of a male head in profile) and 1937.9.30 (the collotype reproduction). It is not known when or how these loose sheets came to reside in the album. It should also be noted that some sheets glued into the album have yet to be examined fully. Folio 25, for example, has a drawing of a male nude on the verso.

18. The other large-format albums donated by Violet Ormond in 1937 were *Album of Ornamental Detail: Drawings, Stencils, and Photographs* (1937.10) and *Album of Studies for "Israel and the Law"* (1937.11). The latter binding may have been made to order, but the albums used for the former and for *Album of Figure Studies* could have been purchased in a stationery or artists' supply store. Sargent's drawings are affixed to the sheets that came with these commercially produced albums. The sheets in *Album of Figure Studies* have four holes along one side for attachment to the binder; seventeen of these sheets have never had drawings affixed to them. There is room for more sheets within the album, suggesting that some were removed. I thank Miriam Stewart and Dennis Marnon for this information. See also Miriam Stewart and Kerry Schauber, *Sargent at Harvard* (Cambridge, Mass.: Harvard University Art Museums, 2000), 35–38.

19. Trevor J. Fairbrother, "A Private Album: John Singer Sargent's Drawings of Nude Male Models," *Arts Magazine* 56 (Dec. 1981): 70–79. This article published eleven of the drawings (folios 1, 2, 10–12, 18, 23–25, 27, and 28. Prior to that, two (folios 13 and 19) had been published in Charles Merrill Mount, *John Singer Sargent: A Biography* (New York: W. W. Norton, 1955); Mount's caption referred to them as "charcoal studies for murals" and did not mention the owner or indicate that they are part of an album.

20. The Whitney's Sargent exhibition of 1986 included folios 4, 6, 10, 13, and 19. All five were illustrated in the catalogue, along with folios 11 and 12: Hills, *John Singer Sargent.* Sheets from the album also were included in exhibitions at the Fogg Art Museum, Cambridge, in 1994 and 1999; see Stewart and Schauber, *Sargent at Harvard,* 36.

21. It was recently suggested that "the album may well have been put together posthumously," although no evidence exists to confirm a maker or a date; see Dini, *Public Bodies,* 113. If Sargent did not assemble the album, it must have been the work of someone very close to him, possibly his Boston aide for the mural projects, Thomas Fox. Until evidence to the contrary is found, it seems most likely that the artist did the assembling.

22. The collotype reproduces the charcoal drawing *Sketch for Architecture, Painting and Sculpture (Museum of Fine Arts, Boston, rotunda): Figure under Sculpture* (21.2517), one of fifty mural-related drawings that Sargent donated to the Museum of Fine Arts, Boston, in 1921. An inscription (in Thomas Fox's hand) on the reproduction in *Album of Figure Studies* indicates that it was made as a proof. The Museum of Fine Arts sold collotype reproductions of this drawing, but, in contrast to the proof, the images are printed on vertically oriented sheets. The museum's collotypes were commercial items produced when Sargent installed his rotunda decorations. A preparatory drawing for *Music* was used for another collotype reproduction; the model for that drawing recalled: "Later that year [1921] it became one of the favorite items in facsimile reproduction to be sold in the museum's print shop" (see Kamp, "John Singer Sargent—As I Remember Him," 13). According to David McKibbin, the Guild of Boston Artists made a reproduction of a drawing related to the rotunda decorations in 1922 (letter of May 26, 1947, to Eleanor Sayre, Museum of Fine Arts, Boston). I am grateful to Sue Reed for researching the works at the Museum of Fine Arts, Boston.

23. Kamp, "John Singer Sargent—As I Remember Him," 14–15. Kamp noted that Sargent made "several studies in charcoal" during their first session together in the summer of 1921, and all were diversions rather than preparatory works: "To the best of my memory [none] contributed to the final paintings" (ibid., 6).

24. Some scholars have interpreted these aspects of my article of 1981 (Fairbrother, "A Private Album") in ways that I did not anticipate. Not surprisingly, perhaps, they focused on what was new (a serious discussion of homoeroticism in a subset of Sargent's work) and overlooked several statements indicating that the artist's mural projects "encouraged the creation" of the drawings in the album. My attempt to demonstrate the sensuality of the drawings by comparing them to contemporary erotic photographs apparently led some readers to imagine, wrongly, that I believed the drawings to have been inspired by or copied from such photographs. When I discussed the album as a private work, I hoped to draw attention to the fact that Sargent possessed a few outstanding works of art which he did not exhibit regularly, and thereby they did not contribute to his public image. While I argued that Sargent followed a private and pleasurable motivation in compiling the album, I did not intend to suggest, as some readers' minds leapt to assume, that he created the album for prurient use.

25. Encouraged by his mother, Sargent acquired the habit of sketching famous works of art as a teenager. When he was fourteen, he made a drawing of Michelangelo's tomb sculpture *Night,* in Florence; for an illustration see Rubin, *John Singer Sargent's Alpine Sketchbooks,* 44. As an adult he sketched two of Giambologna's great monuments, the marble group *Rape of a Sabine* in Florence and the bronze and marble *Fountain of Neptune* in Bologna; a copy of Giambologna's *Venus of the Grotticella* is shown in the background of Sargent's *Villa Torre Galli: The Loggia* and *Breakfast on the Loggia,* both painted in 1910 (see Adelson, *Sargent Abroad,* 129). Cellini's *Perseus,* which is a neighbor of Giambologna's *Rape of a Sabine* on the Loggia dei Lanzi, inspired numerous works on paper, an oil painting, and perhaps a photograph (ibid., 122, 141–44).

26. Jane Dini, for example, noted the parallels between folio 2 in *Album of Figure Studies* and Sargent's oil painting *Study for "Prometheus Tondo," Museum of Fine Arts* ([1916–22], Harvard University Art Museums) and argued that the drawing was a preparatory study for the canvas (Dini, *Public Bodies,* 111). While the poses of the legs in these pictures are indeed close, the positions of the torso, head, and arms differ. Dini does not indicate that the drawing might have been made at least ten years before Sargent was invited to plan the murals for the Museum of Fine Arts, Boston, the site for which he created *Prometheus.* Despite similarities between the poses, it need not be assumed that Sargent drew the model on the bed because he was planning a painting. It is possible, however, that the image in the midcareer charcoal drawing eventually served as inspiration for the late painting.

27. Birnbaum, *John Singer Sargent,* 33. This album is untraced and probably no longer extant.

28. Thomas A. Fox, "As Sargent Goes to Rest," *Boston Evening Transcript,* April 24, 1925, 12.

29. Birnbaum, *John Singer Sargent,* 22.

30. A good sense of Sargent's formal priorities in his later years can be gathered from a letter of 1919 quoted in Charteris, *John Sargent,* 215: "I have just come from the Canadian Exhibition [at Burlington House, London], where there is a hideous Post-Impressionist picture, of which mine [*Gassed*] cannot be accused of being a crib. Augustus John has a canvas forty feet long, done in his free and script style, but without beauty of composition. I was afraid I should be depressed by seeing something in it that would make me feel that my picture is conventional, academic, and boring.—Whereas."

31. This argument is pursued in Trevor Fairbrother, "Sargent's Genre Paintings and the Issues of Suppression and Privacy," in Doreen Bolger and Nicolai Cikovsky, Jr., eds., *American Art around 1900: Lectures in Memory of Daniel Fraad* (Washington: National Gallery of Art, 1900), 29–49.

CHAPTER FIVE

1. Sargent to Sally Fairchild, letter of Jan. 2, 1897, Boston Athenaeum.

2. Vernon Lee, *The Sentimental Traveler: Notes on Places* (London: John Lane, 1908), 10–12.

3. Lee, "J. S. S.," in Charteris, *John Sargent,* 251.

4. Patricia Hills pointed out the two failed attempts to pay expenses for a traveling companion in Hills, *John Singer Sargent,* 182. There seems to be no evidence to indicate whether the artist regularly made such offers, although his generosity was broadly acknowledged by his acquaintances.

5. Jane Emmet von Glehn to Mrs. W. J. Emmet, from England (letter postmarked Feb. 7, 1906). I am grateful to Helen Hall for providing a transcript of this letter.

6. Sargent in a letter of April 7, 1908, to Miss Popert. See Fairbrother, "Sargent's Genre Paintings," 47.

7. Fitzwilliam Sargent to George Bemis, Aug. 20, 1867, as quoted in Olson, *John Singer Sargent,* 19.

8. For an overview of Sargent's holidays and some of his traveling companions see Adelson, *Sargent Abroad.* Information about Purtud is contained therein (64–68).

9. Noted in Richard Ormond's essay "In the Alps" (ibid., 110).

10. For an illustration of *Princess Nouronihar,* see ibid., 111.

11. O. D., "The Royal Academy and the New Gallery," *The Pilot* 5 (May 10, 1902): 499.

12. Charteris, *John Sargent,* 95: "But it was away from portraits . . . that his spirit was most at ease and serene—anywhere, in fact, where he could 'make the best of an emergency,' as he called painting a watercolor."

13. Elizabeth Prettejohn, *Interpreting Sargent* (London: Tate Gallery Publishing, 1998), 51. Gainsborough's *The Morning Walk* (c. 1785) is a portrait of Mr. and Mrs. William Hallett; it is one of the more popular British portraits in the collection of the National Gallery, London.

14. Both reviews of 1890 quoted in Fairbrother, *John Singer Sargent and America,* 150–51. On the same occasion, the critic of the *New York Tribune* wrote this about *Paul Helleu Sketching with His Wife* (fig. 1.8): "Much may be claimed for the rendering of the grasses and boat . . . , but the coloring seems a little forced, save in the absolutely colorless faces, which are the faces of the dead."

15. "About John S. Sargent," a text in a privately owned unpublished notebook by Frederick S. Pratt. I am grateful to Susan E. Strickler and the Worcester Art Museum for sharing this information.

16. For photographs and information about Caccini's sculpture, see Francesco Gurrieri and Judith Chatfield, *Boboli Gardens* (Florence: Editrice Edam, 1972), 50–51 and figs. 107 and 111; fig. 102 is a vista of the Viottolone, the avenue on which *Prudence* is situated.

17. In her discussion of another watercolor made in the Boboli Gardens, Elaine Kilmurray points out that Wharton dedicated *Italian Villas* to Sargent's friend Vernon Lee. See Kilmurray and Ormond, *John Singer Sargent,* 223.

18. Charteris, *John Sargent,* 95. Charteris makes this description of the artist on vacation: "He would arrive at the station loaded with canvases and sketchbooks, bristling with the equipment for *plein air* sketching, and with these piled up round him in a fly [horse-drawn wagon] he would draw up at his destination dominant and smiling. No infatuated fisherman, arriving beside a chalk stream on a summer evening, could be more on the tiptoe of expectation than Sargent on these occasions" (ibid., 95).

19. Sargent in a letter of 1920 to his friend and fellow London artist Henry Tonks, quoted in Ormond, *John Singer Sargent,* 69.

20. Adrian Stokes, "John Singer Sargent, R.A., R.W.S.," *The Old Water-Colour Society's Club, 1925–1926, Third Annual Volume* (London, 1926), 60: "[Sargent] once—half jokingly—told me what he could not do. Italian friends had begged him to go to a certain place whence there was a beautiful *veduta* (view). He said afterwards, 'I can't paint *vedute.* I can paint objects. I can't paint *vedute.*'"

21. Sargent in a letter of Sept. 16, 1916, to Carroll Beckwith (Archives of American Art, microfilm roll 1418). He also notes: "Our hands and feet [were] very cold most of the time, and [it was] hard to keep warm at night." Rebecca W. Karo wrote the first overview of this topic: "Ah Wilderness! Sargent in the Rockies, 1916," in *Fenway Court* (Boston: Isabella Stewart Gardner Museum, 1976), 20–29. The most recent discussion is Bruce Hugh Russell, "John Singer Sargent in the Canadian Rockies," *The Beaver* 77 (Dec. 1997): 4–11. Russell draws useful connections between Sargent's British clients, investors in the Canadian Pacific Railroad, and the Imperial administration of Canada. Even though the artist kept his visit a private affair, the fact that he made the long train journey to western Canada and painted the landscape subsequently helped popularize tourism to the region.

22. Stevenson, "J. S. Sargent," 69.

23. For a contemporary photograph of the oxen at Villa Torre Galli (probably taken by Sargent or Nicola D'Inverno), see Adelson, *Sargent Abroad,* 122. In addition to these workaday scenes relating to the household's wine production, Sargent created many more works of art in the villa's loggia and walled garden. Here he depicted his elegant male and female guests reading, resting, breakfasting, sketching, and strolling (ibid., figs. 115–17). These two distinct bodies of work broadly confirm that Sargent was interested in the differently coded social spaces: the more macho outer courtyard of the Italian male workers and the more feminized *dolce far niente* realm of upper-class London-based guests at the villa.

24. Henry James, "Venice: An Early Impression" (1872), reprinted in *Italian Hours: Travel Essays by Henry James* (New York: Grove Press, 1979), 54.

25. Henry James, *Roderick Hudson* (1875, revised 1909; London: John Lehmann, 1947), 74. For a discussion of homoeroticism in this novel, see Hugh Stevens, *Henry James and Sexuality* (Cambridge: Cambridge University Press, 1998), 61–89.

26. Henry James, "Venice" (1882), reprinted in *Italian Hours,* 15.

CHAPTER SIX

1. See Charteris, *John Sargent,* 107; Promey, *Painting Religion,* 253; Ormond, *John Singer Sargent,* 53.

2. Kilmurray and Ormond, *John Singer Sargent,* 14. For an insightful critique of the cipherlike treatment of Sargent in this catalogue, see Christopher Capozzola's review in *American Quarterly* (forthcoming, fall 2000).

3. "The Portrait of Mr. W. H." (1889), in Oscar Wilde, *Complete Shorter Fiction,* ed. Isobel Murray (Oxford: Oxford University Press, 1980), 139.

4. Charteris, *John Sargent,* 227.

5. Blanche told his British acquaintances that Sargent was a "frenzied bugger" who was most active in Paris and Venice. See Fairbrother, "The Complications of Being Sargent," 39.

6. Betty Wertheimer told her niece that the artist "was only interested in Venetian gondoliers" (ibid.).

7. McKibbin made the comments to Susan Sinclair during an interview at the Boston Athenaeum in the 1970s (letter from Sinclair to author, 1999). At that time McKibbin owned Sargent's *Nude Study of Thomas E. McKeller* (fig. 6.18). McKibbin's main publication was *Sargent's Boston* (Boston: Museum of Fine Arts, 1956).

8. The first comment was made in conversation with Berenson, Feb. 7, 1952, recorded in the diary of George Biddle, and quoted in "George Biddle in Italy," *Archives of American Art Journal* 33, no. 2 (1993): 15. I am most grateful to Susan Sinclair for bringing this to my attention. For Berenson's second comment ("Was he a lover of women?"), see Berenson, *Sunset and Twilight,* 480.

9. Abbey in a letter of 1890 to Charles F. McKim, quoted in Lucas, *Edwin Austin Abbey,* 231–32.

10. Quoted in Fairbrother, *John Singer Sargent and America,* 217.

11. In 1890 Sargent made overt references to seventeenth-century art in his portrait of a New York child, Beatrice Goelet (illustrated in Kilmurray and Ormond, *John Singer Sargent,* 33). The little girl's dress seems to be made of old brocade, and its design recalls those worn by the aristocratic children painted by Van Dyck and his contemporaries. Sargent's brushwork also brings Velásquez immediately to mind. While the portrait was on view at the Society of American Artists exhibition in New York in 1891, *Harper's Weekly* published statements by five local artists: William M. Chase, J. Alden Weir, Kenyon Cox, J. W. Alexander, and Frank D. Millet. The issue that all the contributors circled was whether or not Sargent was the modern American peer of Velásquez. Weir, an exponent of Impressionism, wrote: "Sargent has painted his impression of the subject as he saw it, and not as he thought it ought to be, therefore it is distinctly an impression of nature and not a mere imitation of nature. In this regard the picture recalls Velásquez." The magazine called *Beatrice Goelet* the picture of the year and said it was "attracting a notice which was never given before to any American work in New York" ("What the Artists Think of Sargent's *Beatrice,*" *Harper's Weekly* 35 [May 9, 1891]: 346–47). See also Fairbrother, *John Singer Sargent and America,* 171–74.

12. Theodore Robinson, diary entry for Feb. 28, 1890. Robinson heard this from "Lathrop" who was "just back from Boston." I am grateful to Nicolai Cikovsky, Jr., for directing me to this reference, and to Sona Johnston for providing a transcript.

13. See Lucas, *Edwin Austin Abbey,* 210. In a letter of 1889 to his future wife, Mary Gertrude Mead, Abbey writes: "[Sargent] may paint a nude in New York, if he can find any good figure, and thinks I ought to do the same—that it would widen me out to paint—rather over life size—a large, pale, fattish, nude woman with no particular drawing in her. I never painted from the nude at all—*think of that!*"

14. [Fry], "Sargents at Carfax," 408.

15. William A. Coffin cites this quotation from the library's handbook (1895) in "Sargent and His Painting," *Century Magazine* 52 (June 1896):

169: "The worship of Astarte was degraded by the Phoenicians into a lascivious and wanton rite. She is depicted, therefore, not as the kindly and abundant mother of fruits and grains, like Ceres, but as the goddess of sensuality." Coffin followed with his own description of Sargent's *Astarte,* underscoring her allure: "The insinuating charm of the face, the vague, inscrutable enticement of the figure, with its diaphanous veiling of tender, gas-like blue, fascinate the eye. The dexterity of the work is amazing, its grace is irresistible." Vernon Lee, "Imagination in Modern Art: Random Notes on Whistler, Sargent, and Besnard," *Fortnightly Review* 62 (Oct. 1, 1897): 516.

16. For an overview, see Albert Belleroche, "The Lithographs of Sargent," *Print Collector's Quarterly* 13 (Feb. 1926): 30–45. Belleroche lists a total of six prints, two of which show draped male nudes; he evidently did not know about *Young Man in a Cloak.* Sargent made his first lithographs (the three images of male models) at the invitation of the printer Frederick Goulding, who helped commission new works for an exhibition in celebration of the centenary of the discovery of lithography. The exhibition, "Centenaire de la Lithographie," opened at Galerie Rapp, Paris, in October 1895. See Karen F. Jones, *Quarterly Journal of the Library of Congress* 23 (Jan. 1966): 56–59.

17. W. E. Henley (1849–1903) was a poet, playwright, critic, and editor. He probably knew Sargent in his role as editor of the *Magazine of Art* in the 1880s. Given that he also shared Sargent's passion for music, it is fitting that Henley's poems and Sargent's art should have been united by Korbay's music. Henley endured much hardship: he suffered from tubercular arthritis, which necessitated the amputation of part of his left leg when he was sixteen; he lost his only daughter to illness in 1893. Sargent's sheet music design reached a large audience when its publication was announced with an illustration in *The Critic* 34 (Feb. 1899): 111.

18. According to Mrs. Abbey, five London-based artists—Abbey, Alma-Tadema, Leighton, Millais, and Sargent—were invited to produce five drawings for the illustrated Bible; they were contacted by the president of the Amsterdam society of arts, Ars et Amicitia, in November 1895 (see Lucas, *Edwin Austin Abbey,* 288). The three-volume Bible of 1899, "illustrated by modern artists," was published by the Illustrated Bible Society in London, New York, Paris, Berlin, and Amsterdam. Sargent did not contribute, but many artists were represented, including Abbey, Alma-Tadema, Gérôme, Liebermann, Puvis de Chavannes, Repin, Segantini, and Tissot.

19. Lene Østermark-Johansen, "The Apotheosis of the Male Nude: Leighton and Michelangelo," in Tim Barringer and Elizabeth Prettejohn, eds., *Frederic Leighton: Antiquity, Renaissance, Modernity* (New Haven: Yale University Press, 1999), 121: "Wilde defined 'the love that dare not speak its name' with an explicit reference to . . . this friendship [between David and Jonathan]." Wilde's complete speech was reported in the trial coverage by London's *Daily Telegraph* on May 1, 1895.

20. In 1900 an important, extensively illustrated two-part essay on Sargent reproduced two drawings and two paintings related to his Bible illustrations. See A. L. Baldry, "The Art of J. S. Sargent, R.A.," *The Studio* 10 (March/April 1900): 3–21, 107–19. The previous year Sargent sent one of those paintings, *David in Saul's Camp,* to his large solo exhibition in Boston ("Sargent Exhibition," presented by the Boston Art Students' Association, Copley Hall, Boston, Feb. 20–March 13, 1899). This exhibition also included three drawings for Bible illustrations—*David and Jonathan Swear a Covenant between Them and Their Seed Forever; David in the Wilderness; David Enters Saul's Camp at Night and Takes His Spear and Cruse*—and the group titled *Ten Charcoal Studies of Drapery* may have featured some related images.

21. I Samuel 18: 1–3, and I Samuel 20: 41–43. See also Ward Houser, "David and Jonathan," in Wayne R. Dynes, ed., *Dictionary of Homosexuality* (New York: Garland Publishing, 1990), 296–99.

22. According to Philippe Jullian, Proust introduced Delafosse to Montesquiou in 1894; the count soon "paraded his friendship with the pianist"; Jean Lorrain alluded to their association in *Monsieur de Phocas,* a novel of 1902, but by that time Montesquiou had turned against the handsome pianist; in Proust's *Remembrance of Things Past* the characters of Baron de Charlus and Charles Morel (an ambitious violinist) were partly based on the count and Delafosse. See Jullian, *Robert de Montesquiou,* 164–69, 172–73, 274. (Proust intimated that Charlus and Morel both engaged in same-sex liaisons.) In addition to the warmth evident in his oil painting of Delafosse, Sargent sealed their friendship with the gift of a watercolor of the Grand Canal, Venice, which he inscribed "à Léon Delafosse en toute admiration et amitié" (c. 1902, Fogg Art Museum, Harvard University Art Museums); for an illustration see Carl Little, *The Watercolors of John Singer Sargent* (Berkeley: University of California Press, 1998), 34–35.

23. Sargent to Mrs. Gardner, letter of March 9 [1899], Isabella Stewart Gardner Museum, Boston.

24. Unsigned [possibly by Charles A. Caffin], "The Sargent Exhibition at Copley Hall, Boston," *The Artist* 24 (March 1899): xlvi. This writer stressed the "quality of vitality" that is conspicuous in most of Sargent's portraits and argued that it revealed the artist as well as the subject: "[The portraits] are alive not only with the presentment of the sitter but with the personality of the painter. The sign manual of himself is impressed upon them, and what an amazing versatility that self is found to possess" (ibid., xliv).

25. Editor, "Royal Academy," *Magazine of Art* (1895): 282. Another critic described Robertson as "a young man of slender figure and somewhat unusual type"; see Claude Philips, "Fine Art. The Royal Academy. I," *Academy* 47 (May 11, 1895): 407–8. I thank Elaine Kilmurray for these citations.

26. Marion Hepworth Dixon, "Mr. John S. Sargent as a Portrait-Painter," *Magazine of Art* 23 (1899): 118–19.

27. Louise Hall Tharp, *Mrs. Jack* (Boston: Little, Brown, 1965), 110, 242.

28. *Catalogue of Decorative Furniture, Objects of Art and Tapestry, the Property of John Singer Sargent, R.A., D.C.L., LL.D, Deceased, and removed from 31 and 33 Tite Street, Chelsea, S.W., and The Studio, 12 The Avenue, Fulham Road, S.W.,* Christie, Manson and Woods (London), July 28, 1925.

29. Sargent's Giambologna, a later cast of *Architecture* (c. 1580), was probably made in the eighteenth century. For the original, see Avery, *Giambologna,* fig. 97. For Sargent's collection of Monets, see Erica E. Hirshler, "'Huge Skies Do Not Tempt Me': John Singer Sargent and Landscape Painting," in Hilliard T. Goldfarb et al., *Sargent: The Late Landscapes* (Boston: Isabella Stewart Gardner Museum, 1999), 56–59 and 73 n. 18.

30. Blanche, *Portraits of a Lifetime,* 156–57.

31. Birnbaum, *John Singer Sargent,* 8–10, 14, 16–17.

32. Harold Acton, *Memoirs of an Aesthete* (London: Methuen, 1948), 88. Acton (1904–1994) was a teenager when he was taken on visits to Sargent and to Wilson Steer, another bachelor artist of Chelsea: "both large, full-blooded men, equally shy and reserved" (ibid., 88).

33. R. E. F. [Roger Fry], "The New Gallery," *The Pilot* 1 (May 5, 1900): 291: "Mr. Sargent shows no desire to transcend the mood of ordinary life; his interest is not in the personality of the sitter as it really is, but in the impression it makes on an acute observer when seen under the ordinary conditions of social life. Mr. Sargent has the humility to regard himself as a précis-writer of appearances. . . . The summary nature of the statement he makes compels . . . [him] to emphasize the accidental as opposed to the more fundamental traits of character; his rendering is, in fact, a glorified caricature, and I confess, for my part, I cannot see . . . [the sitter] for the likeness."

34. Roger Fry, "Royal Academy," *The Pilot* 1 (May 12, 1900): 321. Fry had virtually no praise for anything in the exhibition and, despite his reservations, readily admitted that Sargent was the "one performer who alone saves the situation." He called *The Acheson Sisters* "the most marvelous *tour de force* he has yet accomplished."

35. D. S. MacColl discussing Sargent's watercolors at the Carfax Gallery in "Museums and Exhibitions," *Saturday Review* (April 1, 1905), 412, as cited by Barbara Dayer Gallati, "Controlling the Medium: The Marketing of John Singer Sargent's Watercolors," in Linda S. Ferber and Barbara Dayer Gallati, *Masters of Color and Light: Homer, Sargent, and the American Watercolor Movement* (Brooklyn: Brooklyn Museum of Art, 1998), 127. MacColl writes: "All are wonderful in the power of summary expression of architecture and other forms with a few dashes of the brush. It is not the work of a brooder or dreamer; it is more like an athletic exercise with shape and space and light."

36. Martin Birnbaum recalled the following instances of Sargent's skepticism about modernist tendencies: "When he visited an exhibition of modern art at the Metropolitan Museum in the company of Welles Bosworth . . . he saw only defects in drawing, vulgarity, lack of grace and charm, or form sacrificed to color. Their solutions to artistic problems aroused his suspicions, and the complacency of their defenders irritated him. He told his companion that in his opinion many of the exhibits were 'rubbish.' Van Gogh's 'distortions' were merely the result of 'myopia, obvious myopia.' He pointed to the ugly enormous feet of Gauguin's women and contrasted such work with an Ingres drawing. . . . [On the other hand,] his sanity and immense tolerance were exhilarating. He surprised Artur Rubinstein by saying that an artist like Picasso had established his right to make any experiments that he pleased, but when the distinguished pianist spoke rather slightingly of Rubens' vast canvases filled to overflowing with ample nudes, he aroused Sargent's passionate indignation. The importance of such contributions as Monet's and Seurat's to the study of color was freely, almost gratefully admitted." See Birnbaum, *John Singer Sargent,* 17–18, 20.

37. Forbes Watson, "Sargent—Boston—and Art," *Arts and Decoration* 7 (Feb. 1917): 197.

38. Sargent to Thomas Fox, 1922, as quoted in Walter Muir Whitehill, *Museum of Fine Arts, Boston: A Centennial History,* vol. 1 (Cambridge: Belknap Press of Harvard University Press, 1970), 350.

39. Letter of Oct. 28, 1921, quoted in Fairbrother, *John Singer Sargent and America,* 264. See also Carol Troyen, *Sargent's Murals in the Museum of Fine Arts, Boston* (Boston: Museum of Fine Arts, 1999), 21.

40. Preserved Smith (March 1922), quoted by Troyen, ibid., 28.

41. Adam Gopnik, "Sargent's Pearls," *New Yorker,* Feb. 15, 1999, 71.

42. Leigh Culver, *Performing Identities in the Art of John Singer Sargent,* 206–7.

43. Fox, "As Sargent Goes to Rest," 12. Clearly Sargent scrutinized the hotel employee sufficiently to surmise that he had a good "physique." While it might be argued that this act was strictly professional, Fox's memoir effectively confirms that Sargent was in the habit of looking at men's bodies in public.

44. Ratcliff, *John Singer Sargent,* 154.

45. Mount, *John Singer Sargent,* illustration facing p. 145. Mount titled the painting *Figure Study* and did not indicate that it was privately owned at the time; he did not mention McKeller in the text, but quoted a quip that Sargent made to Lady Speyer in Boston in 1916: "I'm only painting mountains [the Canadian Rockies] and niggers" (ibid., 337). It is not clear how *Nude Study of Thomas E. McKeller* left Sargent's estate. It was privately owned in Boston from the late 1920s until the Museum of Fine Arts purchased it in 1986.

46. The portrait of McKeller was included in "Figuring the Body," a contemporary art project of 1989 organized by Kathy Halbreich and Trevor Fairbrother at the Museum of Fine Arts, Boston. A year later it was part of an exhibition curated by Guy McElroy at the Corcoran Gallery of Art, Washington, D.C., "Facing History: The Black Image in American Art, 1710–1940." The Museum of Fine Arts, Boston included the painting in its 1999 showing of the Tate Gallery's 1998 Sargent retro- spective; the accompanying catalogue did not publish the picture.

47. Ormond, *John Singer Sargent,* 260.

48. A letter to Mariana Griswold Van Rensselaer of New York, quoted in Charteris, *John Sargent,* 110. Van Rensselaer was an articulate exponent of Aestheticist principles in art and architecture. A cultural historian recently stressed the eclecticism and "sensual, exotic imagery" that characterized Van Rensselaer's writing; see Mary Warner Blanchard, *Oscar Wilde's America: Counterculture in the Gilded Age* (New Haven: Yale University Press, 1998), 182.

49. I am grateful to Neil Bartlett for his comments on this watercolor: "The desiring gaze of the artist melts the figures into an all-over surface of interlaced brushwork instead of isolating the male forms—the glimpse of an illicit pleasure snatched by two men in wartime—the threat of an onlooker—guilt—the inversion of the 'Garden of Eden' imagery—two Adams stealing forbidden fruit—the refusal to obey the injunction of the title—and always, the mesmeric swing of that kilt" (letter of 1999 to the author).

50. Promey, *Painting Religion,* 30. It is worth noting that Sargent may have adhered to private quietist and pantheistic philosophies rather than prac- tice Christian worship. In 1911 he made the following comment to an American museum director about a 1908 painting that he had titled *Il Solitario:* "*The Hermit* is alright . . . [as an English translation, but] I wish there were another simple word that did not bring with it any Christian association, and that rather suggested quietness or pantheism" (see Promey, ibid., p. 258). The painting and Sargent's thoughts about its title shed light on the fact that he was a spiritual and tender man who was also a loner and something of a social oddity.

51. Fairbrother, *John Singer Sargent and America,* 246–248; 275 n. Whistler, who was openly critical of Sargent's bravura Realism, evidently admired this sculpture, for Sargent sent him this note: "It is kind of you to write, and your approbation does me great honor. . . . Since you like my cruci- fix perhaps you would come [to Fulham Road] to see the rest of my decoration and give me your counsel" (Sargent to Whistler, 1899, collec- tion of Glasgow University Library). For a recent discussion of *Crucifixion,* see the entry by Mary Crawford Volk in Kilmurray and Ormond, *John Singer Sargent,* 192–94.

52. Ross was a writer, art critic, and literary executor of Oscar Wilde. In 1900 he purchased the Carfax Gallery, a three-year-old London art busi- ness; in that role he presented Sargent's first European solo exhibition in 1903. Because of his association with Wilde, Ross remained a target for British homophobia. In 1918 the British artist Charles Ricketts wrote a friend: "To this day he [Ross] is subject to persecution from ignoble quarters, a little uncertain in mental and bodily health, . . . [and] an old man before his time." See Margery Ross, ed., *Robert Ross: Friend of Friends* (London: Jonathan Cape, 1952).

53. See entry by Hans Naef in Gary Tinterow and Philip Conisbee, eds., *Portraits by Ingres: Image of an Epoch* (London: National Gallery, 1999), 218–20. Von Stackelberg was a German painter, poet, musician, and scholar.

Index

B-II 1/01